FLOWER DESIGN

BRIGITTE VON BOCH

teNeues

Der Jahreskreislauf: Ein Fest der Sinne
The Annual Cycle: A Celebration for the Senses
Le rythme des saisons : une fête pour les sens

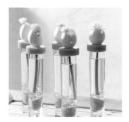

Frühling
Spring
Le printemps

Das Erwachen der Natur ist Balsam für die Seele. Die Zeit der zarten Gefühle beginnt. Mit den Schneeglöckchen fängt das Blumenjahr sanft an, dann steht die Tulpe im Mittelpunkt der Blumenkunst und schließlich explodiert alles zu einer überbordenden Farbenfülle. Den Frühling muss man einfach mit dem Herzen sehen.

Nature's awakening soothes the soul. The time of tender feelings begins. The flower year gently commences with the snowdrops, then the tulips take centre stage, and eventually everything explodes into an overly extravagant wealth of colours. The spring simply has to be seen with the heart.

L'éveil de la nature est un baume pour l'âme. C'est le temps de la tendresse. L'année florale commence tout en douceur avec les perceneige. Ensuite la tulipe s'impose dans les compositions florales, enfin la saison nous amène une explosion des couleurs exubérantes. Ce printemps, il faut tout simplement le voir avec les yeux du cœur.

Sommer
Summer
L'été

Die Fülle der Düfte betört. Die Rose dominiert alle Arrangements. Sie ist an Vielfalt und Schönheit kaum zu überbieten. Der Zenit des Jahres hat seine Königin, die Königin der Formen und der Düfte.

The richness of fragrances captivates. Roses dominate all arrangements. They are hard to outdo in diversity and beauty. The year's zenith has its queen, the queen of forms and fragrances.

L'abondance des parfums nous enivre. La rose domine tous les arrangements. Presque infinies sont ses variétés et sa beauté est difficile à égaler. C'est elle la reine de cette saison et c'est elle la reine des formes et des parfums.

Herbst
Autumn
L'automne

Ein Fest für die Augen. Die Natur verabschiedet sich, will sich unvergesslich machen. Sie versprüht noch ein letztes Mal ihr Feuerwerk der Farben. Die Dahlie zeigt wie keine andere, welche Leuchtkraft möglich ist. Alles präsentiert sich in einer Intensität, die noch lange nachwirken wird.

A celebration for the eyes. The nature takes leave, wants to make itself memorable. For the last time it sparkles with a tremendous play of colours. First and foremost the dahlia shows what brightness is possible. Everything presents itself in an intensity that has a lasting effect.

Une fête pour les yeux. La nature dit au revoir et veut rester inoubliable. Pour la dernière fois, elle nous offre une explosion de couleurs. Le dahlia n'a pas d'égal pour l'intensité lumineuse. Toute la nature se présente avec une intensité appelée à durer encore longtemps.

Winter
Winter
L'hiver

Die Zeit des Hörens. Stille, Kargheit und Rückzug prägen die dunklen Monate. Ganz leise nur kommt die Natur ins Haus, manchmal kühl und karg, manchmal aber auch warm und anheimelnd. Denn das Fest der Feste kündigt sich an, was auch in den Dekorationen seinen Ausdruck findet.

The time of hearing. Silence, scantiness, and retreat shape the dark months. Only very silently nature enters the house, sometimes cool and scanty, but sometimes also warm and homey. Christmas draws nearer, which is also expressed in the decorations.

La saison de l'ouïe. Silence, parcimonie et retrait marquent ces mois où manque la lumière. La nature s'introduit dans la maison sans faire de bruit, parfois froide et simple, mais parfois aussi chaude et familière. Car la fête de Noël nous annonce la Bonne nouvelle qui trouve aussi un moyen d'expression dans les décorations.

Liebe Leserinnen und Leser,
Dear readers,
Chères lectrices, chers lecteurs,

„Man muss die Pflanzenwelt nur betrachten, die Arten in ihrer Eigenheit respektieren und sie in ihrem natürlichen Wesen annehmen. Sie nicht bezwingen, sondern entdecken. Sie nicht verfälschen. Sie nicht in einen Sonntagsstaat zwängen. Sie einfach nur zum Leben erwecken." So wie Christian Tortu, der berühmte Pariser Blumenkünstler, seine Philosophie beschreibt, so würde ich auch meinen Stil definieren. Denn in der Blumenkunst gilt vor allem, den Charakter der Pflanzen zu erfassen, um so ihren speziellen Zauber sprechen zu lassen.

Mit meinem Flower Design möchte ich zeigen, wie vielfältig diese Aufgabe gelöst werden kann. Schließlich kann man nur mit Harmonie und Kontrasten Arrangements eine Seele verleihen. Es kommt dabei auf vieles an: auf die Komposition der verschiedenen Blumenarten, auf die Formen, die Farbverläufe, die Texturen und Materialien der Gefäße, in denen sie arrangiert, sowie das Interieur, sozusagen die Bühne, auf der sie platziert werden. Und schließlich auf die Prise Humor, den kleinen Kick, das Spiel mit dem Unerwarteten.

Ich liebe die natürliche Harmonie, wie man sie draußen erleben kann. Aber ich mag auch ungewöhnliche Begegnungen: Maßliebchen trifft Zitronenthymian, Osterei trifft Nelke, Hortensie trifft Himbeere. Ich mag die Dynamik, wenn sich zum Beispiel eine zarte Blüte unter den Schutz eines kräftigen Blattwerks stellt, Transparenz auf festes Grün und Stacheligkeit auf Weichheit stoßen. Am Ende steht immer ein Stillleben für die Ewigkeit.

Ihre
Yours
Cordialement

"One only needs to behold the flora, respect the species' uniqueness, and accept their natural essences. Not to subdue, but discover them. Not to distort them. Not force them into Sunday clothes. Only bring them to life." I would define my own style in the same way Christian Tortu, the famous Parisian flower-artist, describes his philosophy. Because in flower art it is primarily essential to grasp the plants' character, so their special magic can shine.

With my Flower Design I intend to show how the multifaceted approaches to this taks. After all, only harmony and contrasts can breathe life into arrangements. This is dependent on various components: the composition of the different flowers, the form, the colour gradient, the texture and material of the vessels in which they are arranged, as well as the interior, the stage, so to speak, upon which they are placed. And finally, it depends on the hint of humour, the slight kick, the play with the unexpected.

I love the natural harmony, which can be experienced outdoors. But I also like unexpected encounters: daisy meets lemon thyme, Easter egg meets carnation, hydrangea meets raspberry. I like the dynamism of a delicate blossom, protected by a robust foliage, transparency juxtaposed to luscious green, and thorniness to softness. The result is always a still life, which is made for eternity.

« Il suffit d'observer le monde des plantes, de respecter les variétés dans leur personnalité et les accepter dans leur nature. Il ne faut pas vouloir les vaincre, mais chercher à les découvrir. Il ne faut pas les dénaturer ni leur mettre un costume du dimanche. Il faut tout simplement les éveiller. » C'est ainsi que le plus célèbre fleuriste parisien, Christian Tortu, résume sa philosophie et c'est ainsi que je définirais moi-même mon style. Car dans l'art floral il faut avant tout capter le caractère des plantes afin de laisser parler leur magie si spécifique.

Avec mon Flower Design, j'aimerais vous montrer qu'il y a de nombreuses solutions pour cela. C'est avec le sens de l'harmonie et l'utilisation des contrastes que l'on peut donner une âme aux arrangements floraux. Beaucoup d'éléments sont à prendre en compte : la composition des différentes variétés, les formes, couleurs et matières des vases dans lesquelles on les arrange ainsi que l'intérieur où elles prennent place comme sur une scène. Et pour finir, cette petite note d'humour, ce petit je ne sais quoi, ce jeu avec l'inattendu.

J'aime l'harmonie naturelle telle qu'on peut la découvrir à l'extérieur. Mais j'aime également des rencontres inédites : des pâquerettes avec du thym citron, des œufs de Pâques avec des œillets, l'hortensia avec la framboise. J'aime la dynamique qui se crée, par exemple, lorsqu'un pétale tendre vient se placer sous la protection d'une feuille robuste, lorsque la transparence vient rencontre la verdure opaque et la douceur le piquant. Au bout du compte, nous avons toujours devant nous une « nature vivante » qui semble éternelle.

Brigitte von Boch

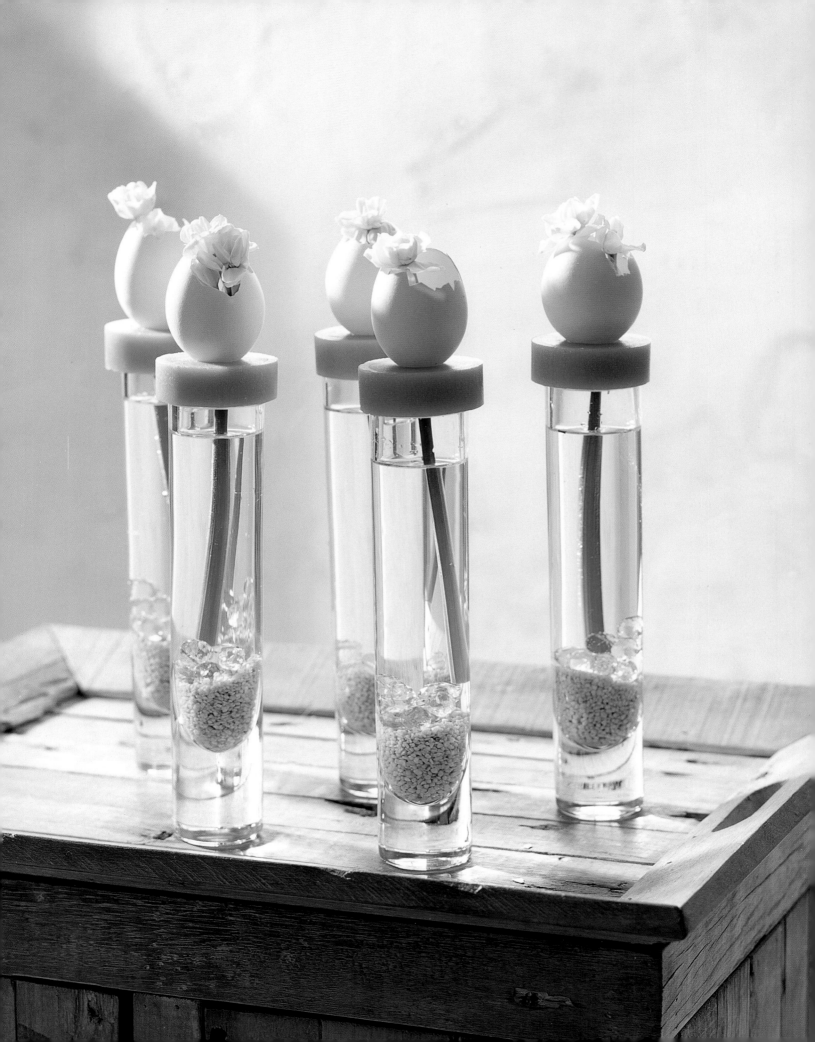

Frühling
Spring
Le printemps

Höchste Zeit, unsere allerschönste Empfindung auszupacken: die Lust zu leben und zu lieben. Schließlich ist Frühling. Und noch mehr als eine Jahreszeit ist dieser ein Gemütszustand. Wie sollte es auch anders sein, wenn über das weißgraue Einerlei des Winters wieder die Farben siegen?

Schneeglöckchen, Krokusse, Tulpen und Narzissen beenden alle Tristesse. Die Frühlingsblüher prophezeien nicht nur draußen in der Natur das Ende der Winterzeit, sondern auch drinnen. Cremefarbene Franzosentulpen in einer edlen Glasvase oder feine aristokratisch anmutende Osterdekorationen deuten zart auf das nahende Fest hin. Sie wirken auf jedem Tisch elegant und sprechen für eine feinsinnige Wahl. Kraft und Energie dagegen versprühen Vergissmeinnicht in ihrem charaktervollen Blaulila. Auch ein in Rottönen gehaltenes Tulpenbouquet fordert alle Aufmerksamkeit.

Jedem Anfang wohnt ein ganz besonderer Zauber inne. Und damit übertrifft der Frühling alle anderen Jahreszeiten. Er kommt jedes Jahr wieder, aber zu seiner besonderen Magie gehört, dass er stets flüstert: „Es ist das allererste Mal."

It is about time that we turn out our most beautiful feelings: the desire to live and love. After all it is spring. And more than a season, spring is a frame of mind. What else can be expected, when winter's greyish white monotony is finally replaced by colours?

Snowdrops, crocuses, tulips, and daffodils end all melancholy. Both outdoors and indoors, spring flowers announce the end of wintertime. Cream-coloured French tulips in a noble glass vase, or seemingly aristocratic, delicate Easter decorations suggest the approaching holiday. They look elegant on every table and indicate a sensitive choice. The bluishpurple forget-me-nots, however, are full of character, and spread strength and energy. A bouquet of tulips, combining different hues of red, most certainly demands plenty of attention.

Every beginning implies a very special magic. With this merit the spring triumphs over all the other seasons. It returns every year, but its particular charm also derives from the fact that it whispers: "It is the very first time."

Il est grand temps de faire place à notre plus beau sentiment : l'envie de vivre et d'aimer. Le printemps est enfin là. Et beaucoup plus qu'une saison, il est un état d'âme. Comment pourrait-il en être autrement lorsque les couleurs reprennent leurs droits sur le gris-blanc de l'hiver ?

Perce-neige, crocus, tulipes et narcisses mettent un terme à la tristesse. Les fleurs printanières annoncent la fin de l'hiver – non seulement dehors au sein de la nature, mais aussi à l'intérieur. Des tulipes françaises dans les tons crème placées dans un vase en verre élégant ou des décorations pascales raffinées nous préparent en douceur à la fête qui approche. Leur élégance met toutes les tables en valeur, créant ainsi un arrangement subtil. Quant aux myosotis, ils dégagent force et énergie avec leur ton bleu lilas soutenu. Un bouquet de tulipes dans les rouges attire tous les regards.

Tout commencement a son charme propre. Et le printemps surpasse en cela toutes les autres saisons. Il revient chaque année, mais sa magie particulière est de nous murmurer à chaque fois : « C'est la toute première fois. »

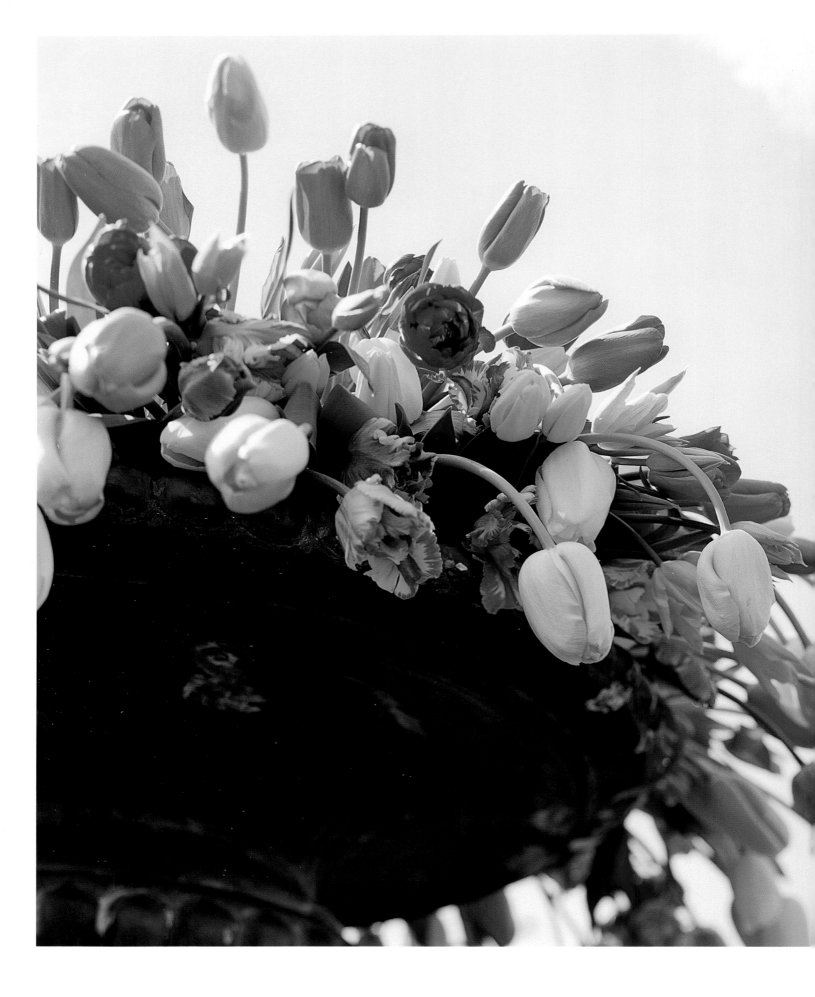

Kein Frühlingserwachen ohne Tulpen. Dieses üppige Bouquet in Rot-, Rosa-, Orange- und Gelbtönen kommt im eleganten Pokal mit schöner Patina vollendet zur Geltung.

No first flush of spring without tulips. This opulent bouquet in hues of red, pink, orange, and yellow stands out in an elegant goblet with beautiful patina.

Pas de réveil du printemps sans tulipes. Ce bouquet exubérant dans les tons de rouge, de rose, d'orange et de jaune trouve son accomplissement dans une coupe élégante avec une belle patine.

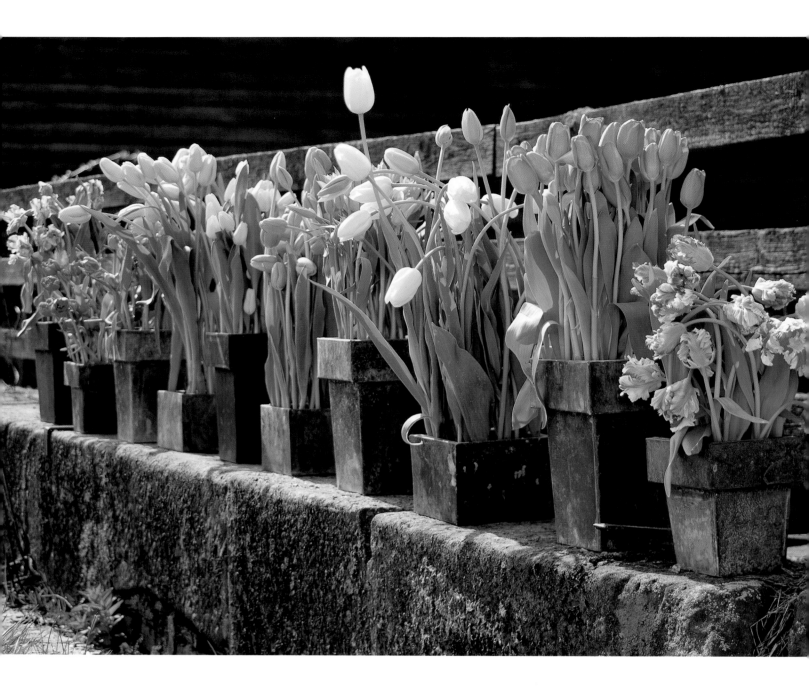

Tulpenparade in schlichten Zinktöpfen: die langstielige Franzosentulpe „Blanc de Blanc", der lilienblütige Vertreter „Harlekin", die goldgelbe „Yokohama", der lachs-bis apricotfarbene Spätblüher „Avalon" und die Papageientulpe „Parrot" mit pittoresken Blütenblättern von Grün bis Rosa.

Parade of tulips in simple tin pots: the long-stemmed French tulip "Blanc de Blanc", the lily-flowered representative "Harlekin", the yellow golden "Yokohama", the salmon or apricot coloured late flowerer "Avalon", and the parrot tulip "Parrot" with its picturesque petals from green to pink.

Parade de tulipes dans des pots en zinc tout simples : la tulipe française « Blanc de Blanc » à longue tige, la variété liliacée « Harlequin », la jaune dorée « Yokohama », la tardive « Avalon » aux tons saumon et abricot et la tulipe perroquet « Parrot » aux pétales pittoresques dans une palette de vert et de rose.

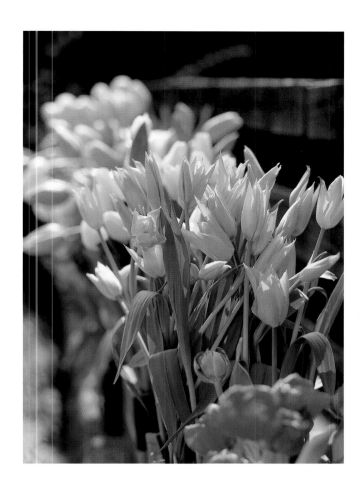
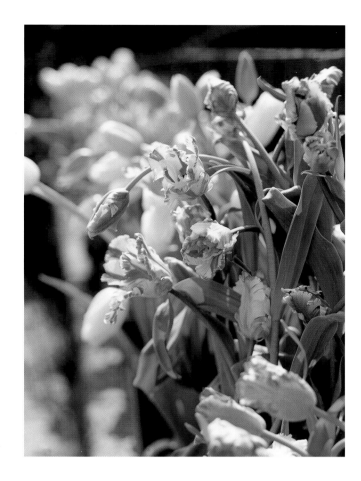
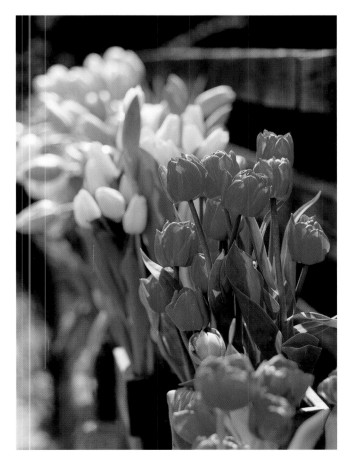
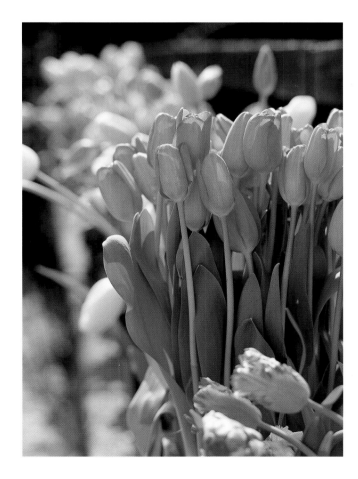

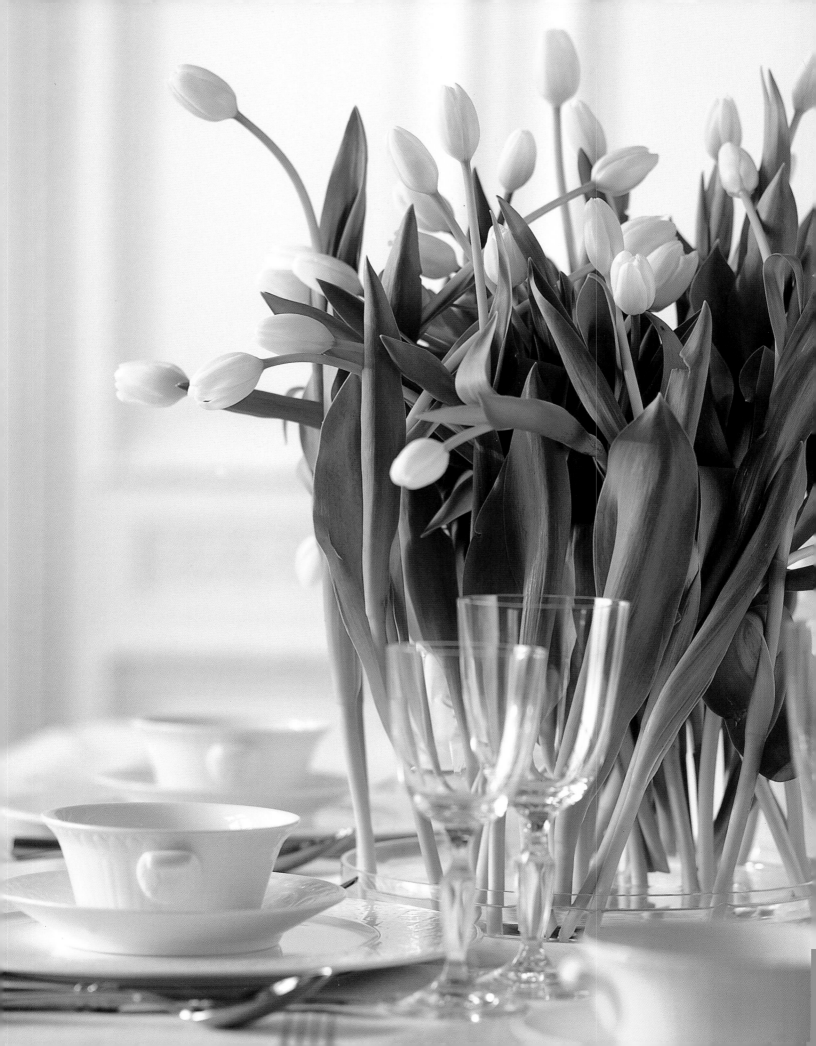

Eine Sinfonie in Weiß, die Fingerspitzengefühl erfordert: Die Tulpen balancieren freistehend in einer flachen Glasschale – allein die kräftigen Blätter bieten Halt.

A symphony in white, which requires a delicate touch: free-standing the tulips balance in a plane bowl—only the strong leaves offer support.

Une symphonie en blanc qui exige un peu de doigté : les tulipes sont naturellement inclinées dans un vase de faible hauteur – elles sont maintenues uniquement grâce à leurs feuilles épaisses.

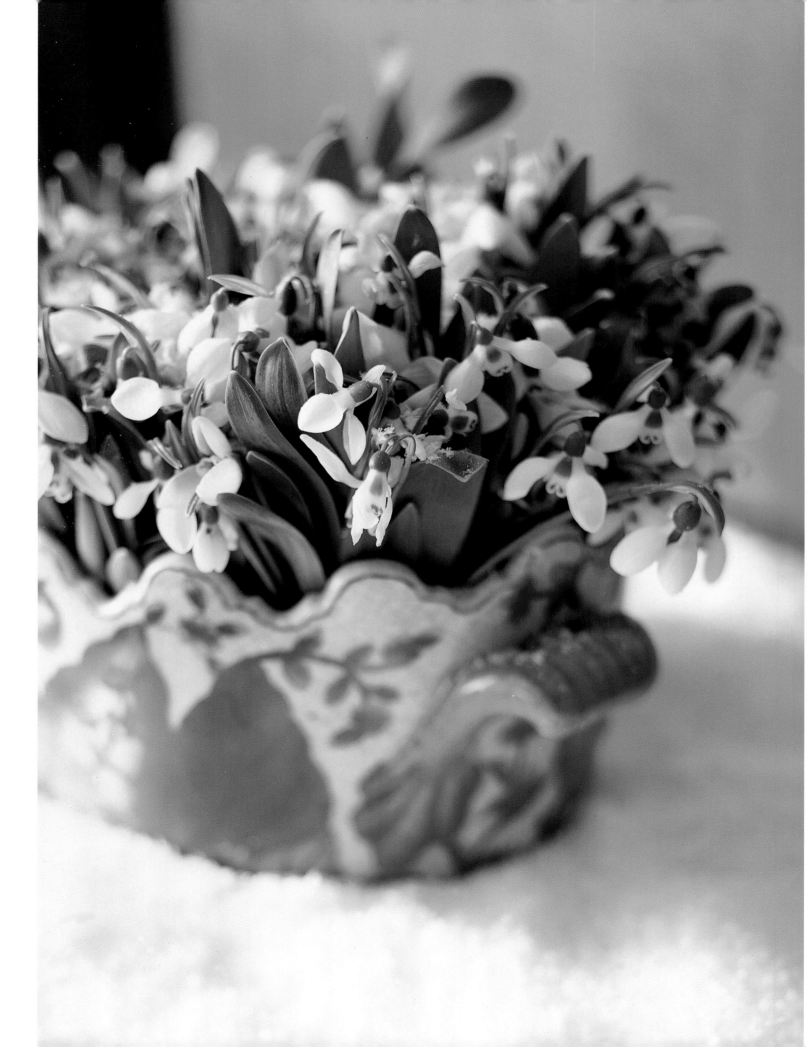

Weiß bleibt Trumpf. Schneeglöckchen oder kleine Kugelsträuße aus Bellis und Zitronenthymian ziehen mit ihrer filigranen Schönheit alle Aufmerksamkeit auf sich.

White remains trump. Snowdrops or small globular bouquets of bellis and lemon thyme attract much attention with their filigree beauty.

Blanc – beauté suprême. Perce-neige et petits bouquets de bellis et thym citron attirent tous les regards avec leur beauté fragile.

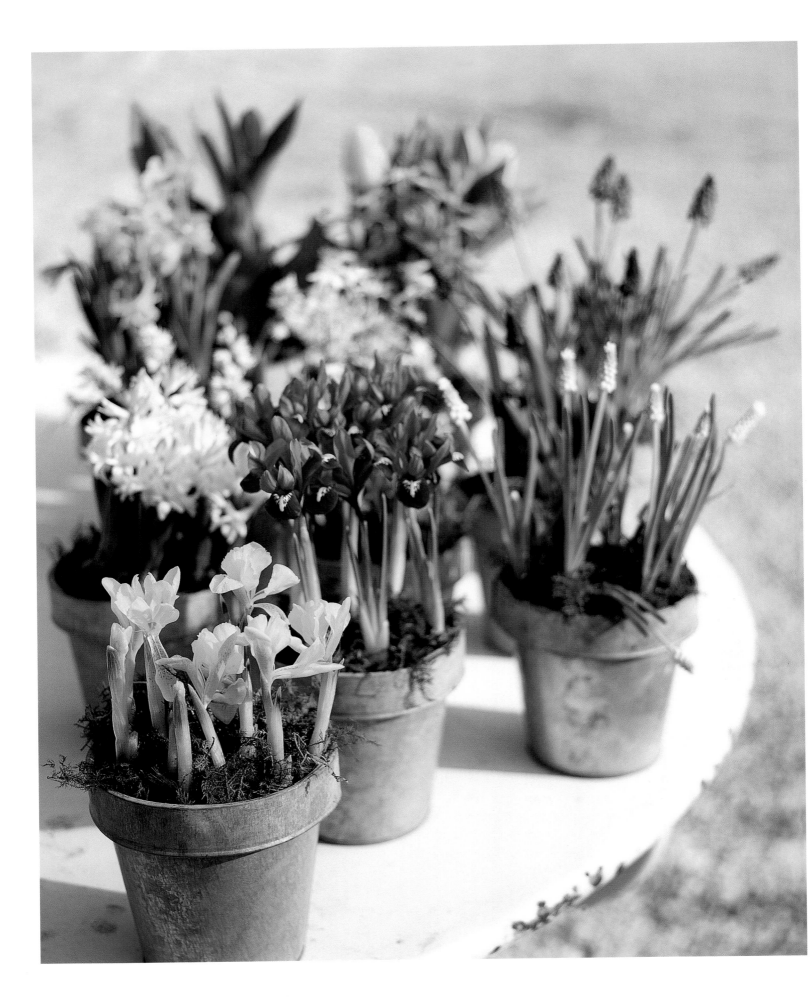

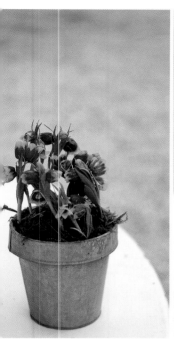 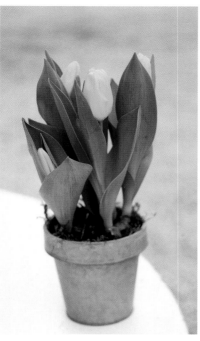 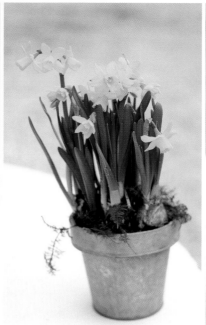 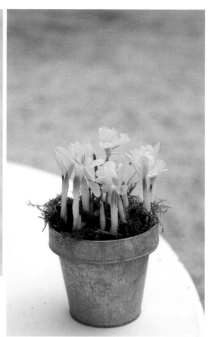

Ein bunter Vorfrühlingsreigen: Seltene Schachbrettblumen blühen neben Tulpen, Miniosterglocken, der sonnengelben Iris sowie der azurblauen „Iris reticulata", Hyazinthen und Tazetten.

A colourful spring composition: rare snake's head bloom next to tulips, small daffodils, bright yellow irises, as well as azure "Iris reticulata", hyacinths and tazetta daffodils.

Une ronde pré-printanière riche en couleurs : les rares fritillaires damiers fleurissent à côté des tulipes, des petites jonquilles, de l'iris jaune soleil et de l'« iris reticulata » bleu azuré, des jacinthes et des narcisses tazette.

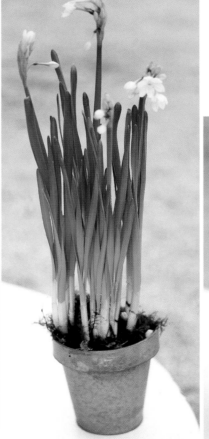

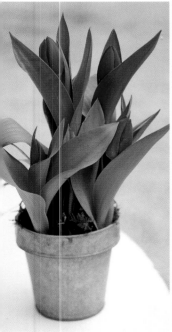 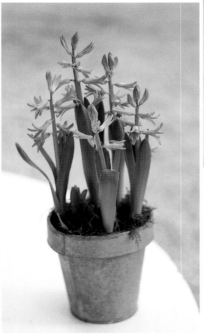 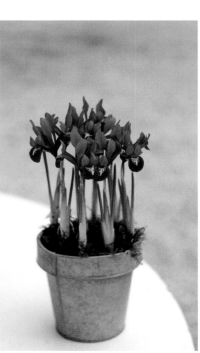

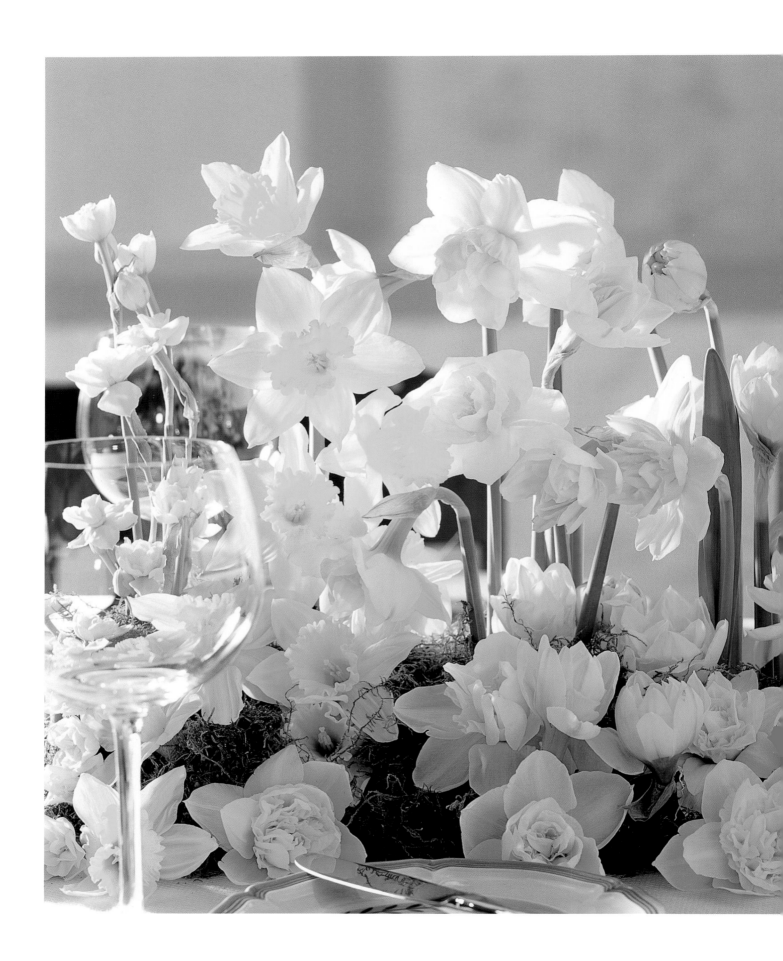

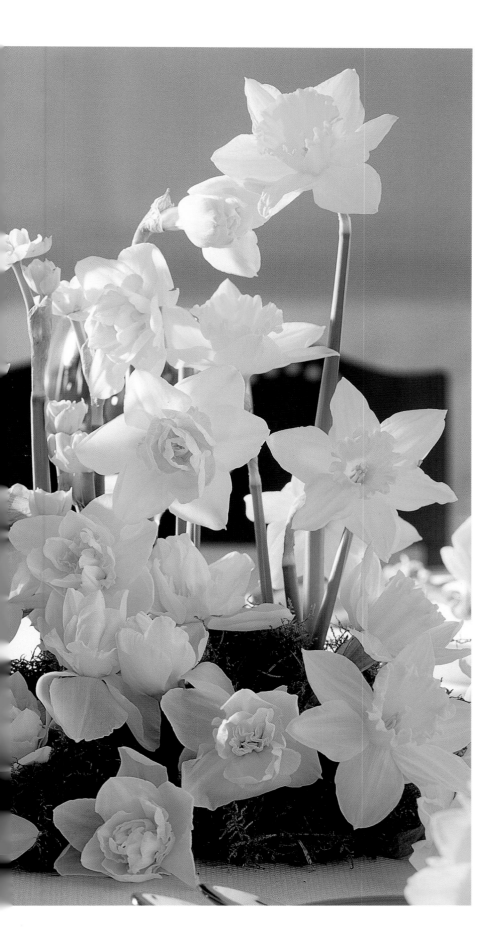

Stillleben mit Narzissen: Dichternarzissen, einfache und gefüllte Sorten und die sonnengelbe Osterglocke „Carlton".

Still life with daffodils: poet's narcissus, simple and doubled species, and the bright yellow "Carlton".

Nature morte avec narcisses : narcisses des poètes, variétés simples et bien fournies, et le narcisse jaune soleil « Carlton ».

Pop trifft Poesie: Dicht an dicht stehen Traubenhyazinthen, Dichternar-
zissen, Anemonen, Ranunkeln, Tulpen und Vergissmeinnicht in quadratischen
Glasvasen.

Pop meets poetry: shoulder to shoulder grape hyacinths, poet's narcissus,
anemones, buttercups, tulips and forget-me-nots gather in a square glass
vase.

Pop et poésie : muscaris, narcisses des poètes, anémones, renoncules, tulipes
et myosotis se pressent les unes contre les autres dans des vases carrés.

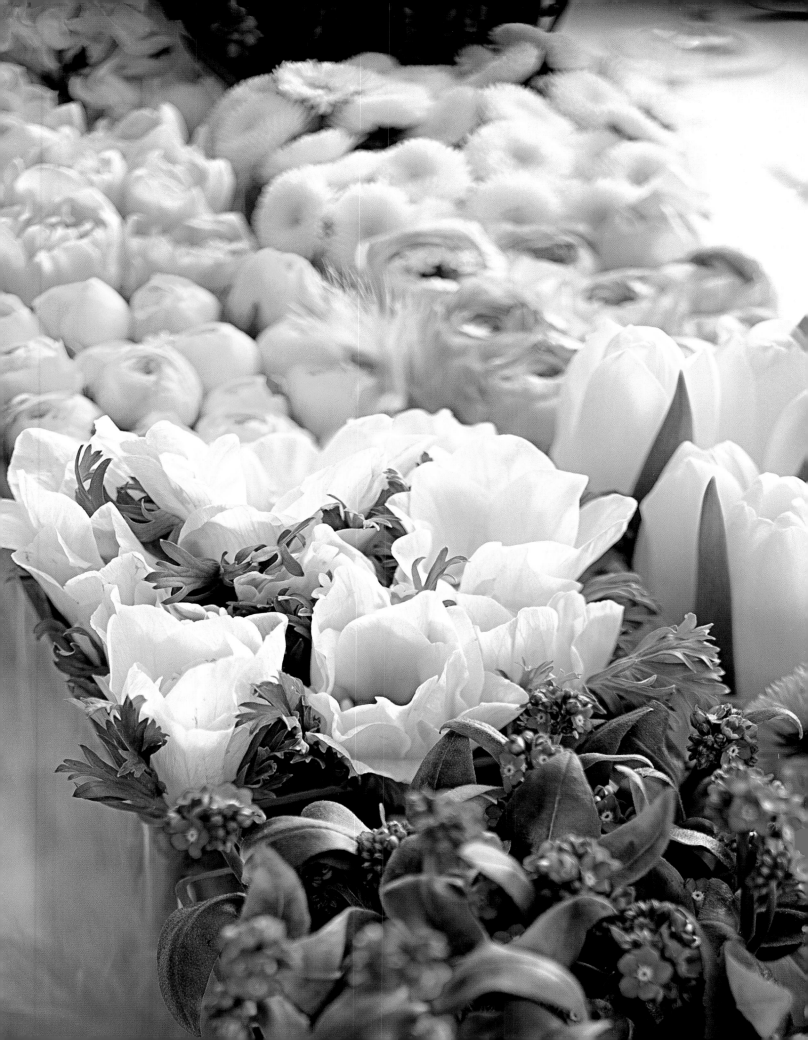

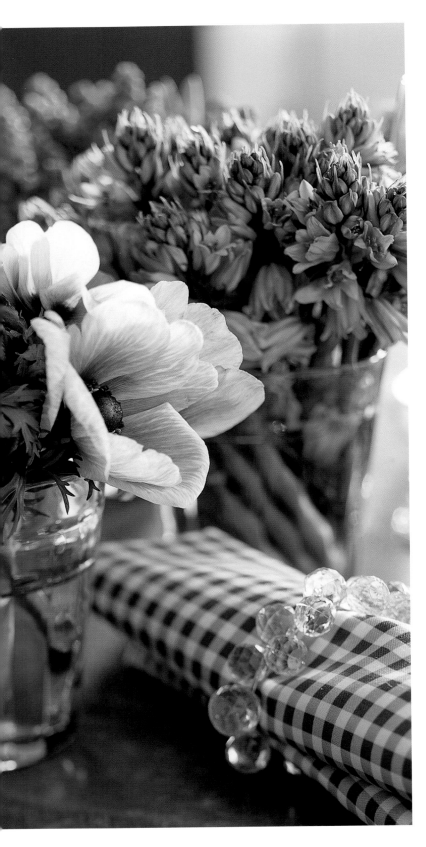

Mehr ist doch nicht weniger: Trauben- sowie Wildhyazinthen, Anemonen und veilchenfarbenes Vergissmeinnicht haben dicht gedrängt ihren Auftritt.

The more the merrier: grape and wild hyacinths, anemones, and violet coloured forget-me-nots attract attention when densely packed.

La beauté de la plénitude : muscaris et jacinthes sauvages, anémones et myosotis se mettent en scène bien serrés les uns contre les autres.

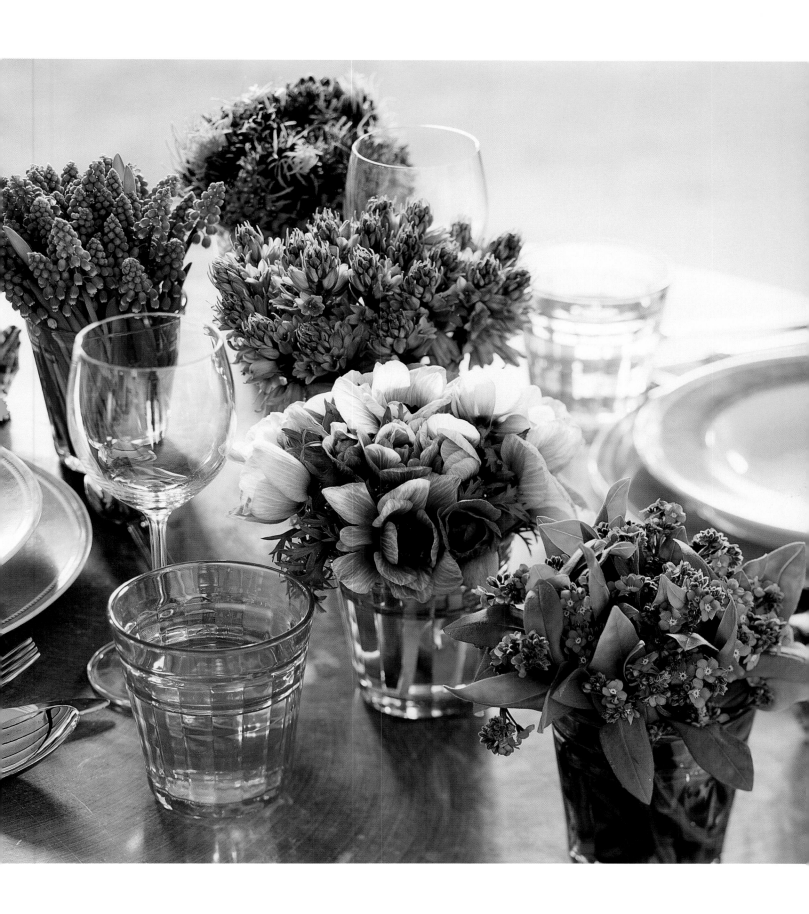

Pure Osterschönheit: feine Dekorationen mit Ostereiern in besonderen Gefäßen. Die Frühblüher Traubenhyazinthen, wilde Hyazinthen, Allium, Dichternarzissen, Schachtelhalme, Pfingstrosen und Tulpen.

Pure Easter beauty: delicate decorations with Easter eggs in special vessels. The early flowering grape, and wild hyacinths, allium, poet's narcisssus, horsetails, peonies, and tulips.

La pure beauté de Pâques : des décorations avec des œufs de Pâques dans des récipients inattendus. Fleurs printanières : muscaris, jacinthes sauvages, allium, narcisses de poètes, prêles, pivoines et tulipes.

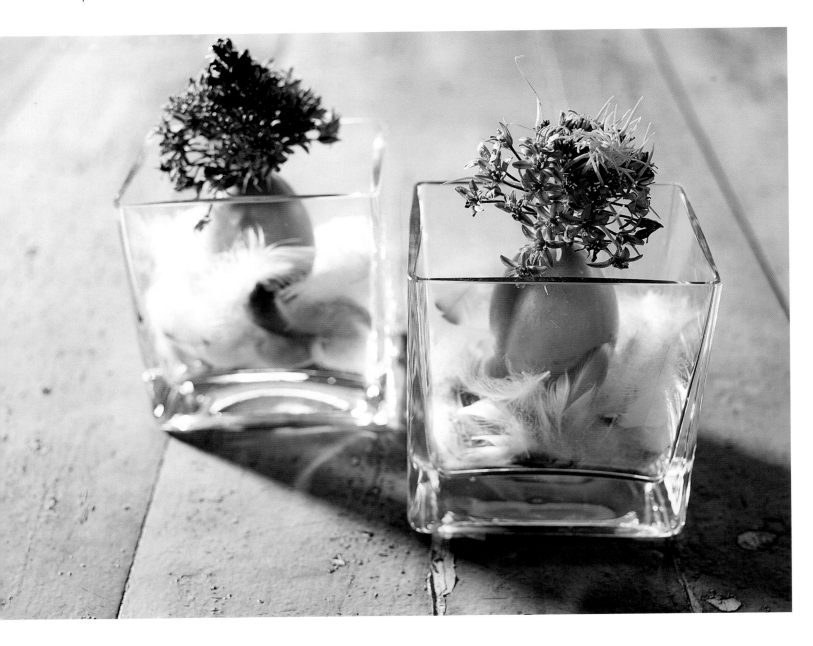

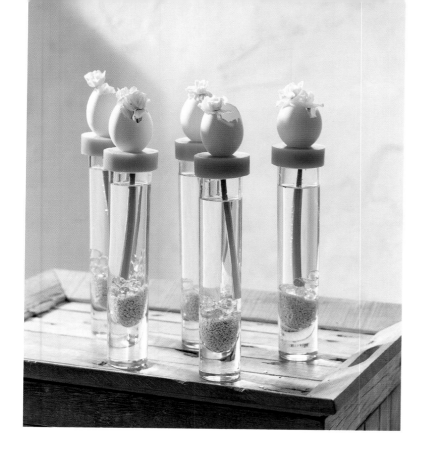

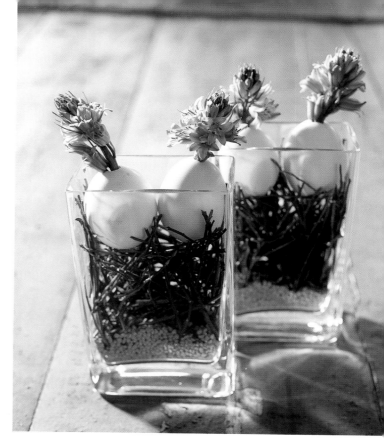

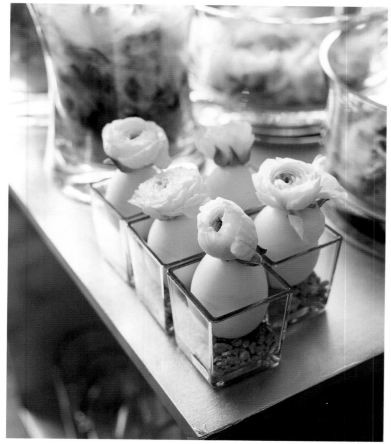

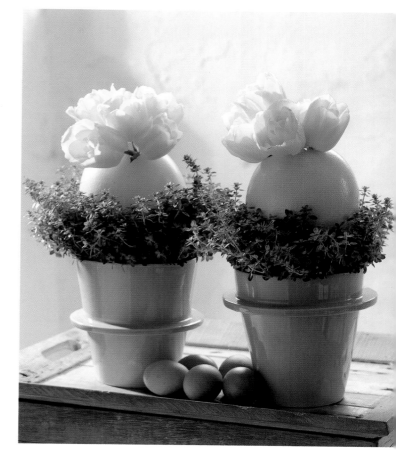

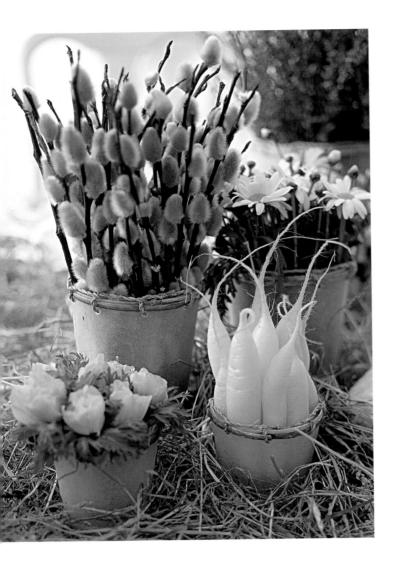

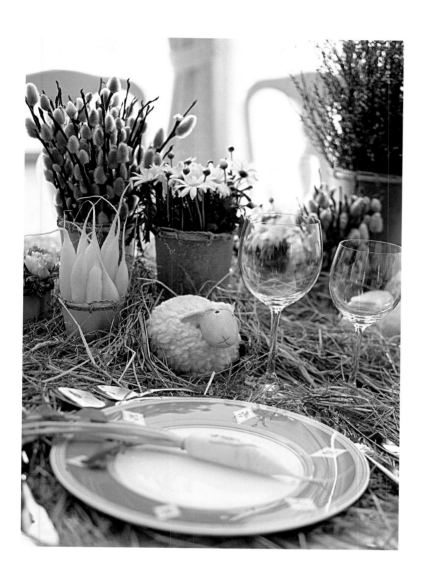
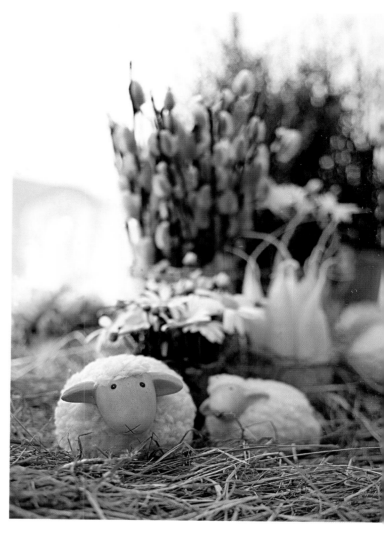

Weidenkätzchen, Margeriten und Anemonen brauchen die rustikale Bühne.

Willow catkins, marguerites, and anemones need the rustic stage.

Chatons de saule, marguerites et anémones font appel à un décor rustique.

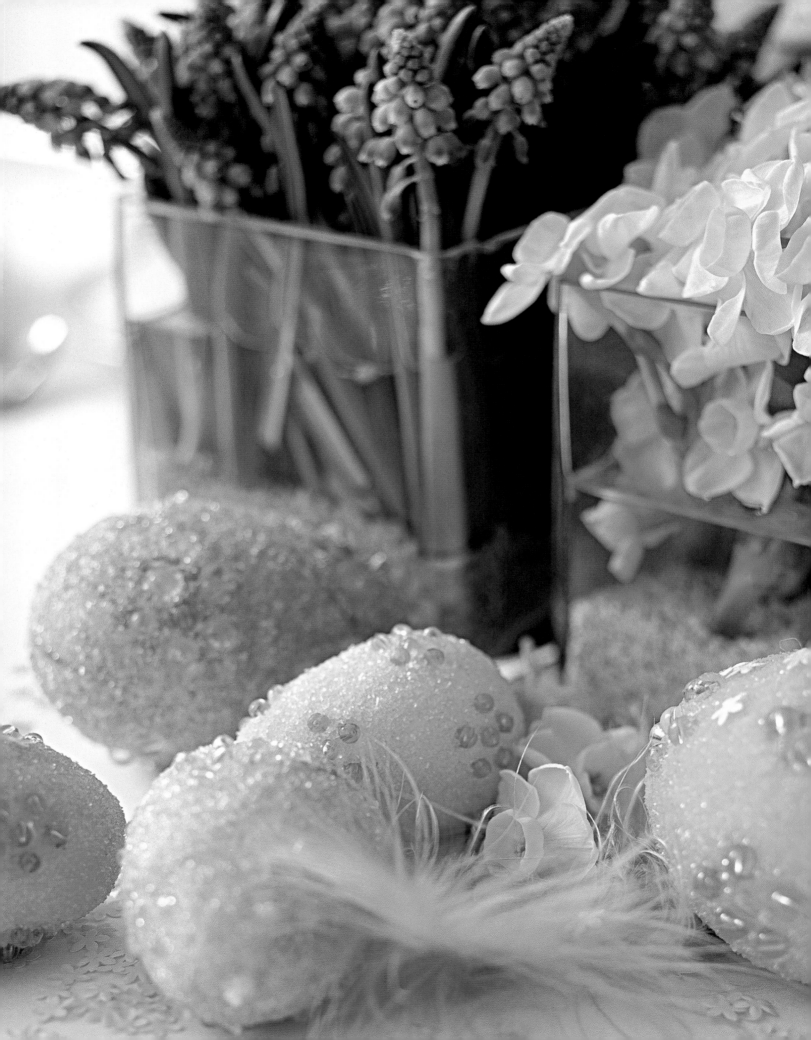

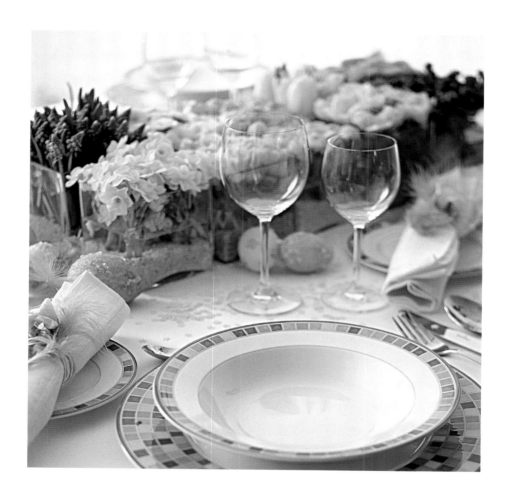

Glamouröser Auftritt: Mit Pailletten besetzte Ostereier präsentieren sich neben Traubenhyazinthen, Osterglocken, Ranunkeln, Tulpen und Vergissmeinnicht.

Glamorous entrance: sequined Easter eggs present themselves next to grape hyacinths, daffodils, buttercups tulips, and forget-me-nots.

Entrée en scène glamour : des œufs de Pâques embellis de paillettes se présentent à côté des muscaris, narcisses, renoncules, tulipes et myosotis.

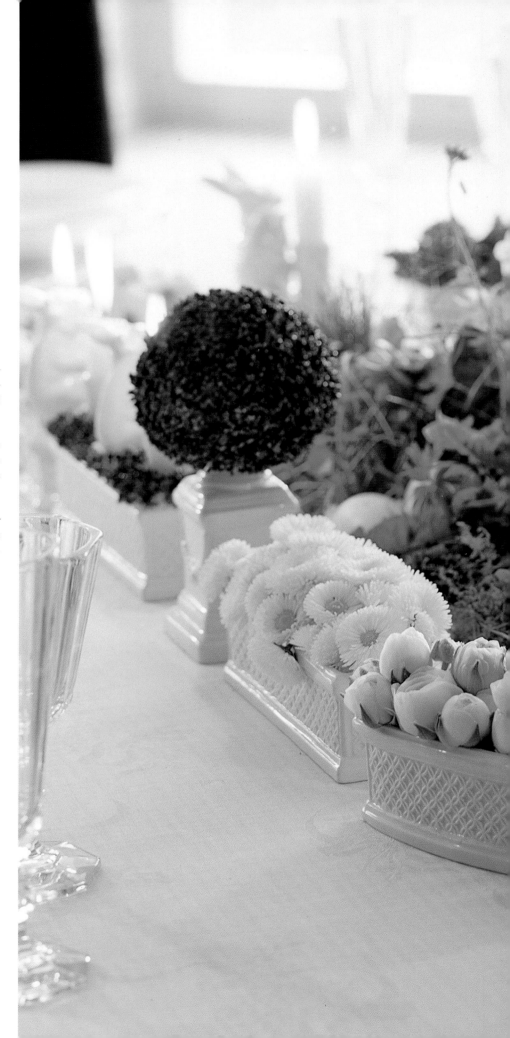

Die aristokratische Schönheit eines Renaissance-gartens auf den Tisch gebracht: Zwischen Trauben-hyazinthen, Bellis, Anemonenknospen, Hirtentäschel und Löwenzahn finden Ostereier leicht ihr Versteck.

The aristocratic beauty of a renaissance garden captured on a table: Easter eggs are hidden between grape hyacinths, bellis, anemone buds, shepherd's purses, and dandelion.

La beauté aristocratique d'un jardin Renaissance sur la table : les œufs de Pâques trouvent facilement des cachettes parmi les muscaris, bellis, anémones, bourse-à-pasteur et pissenlit.

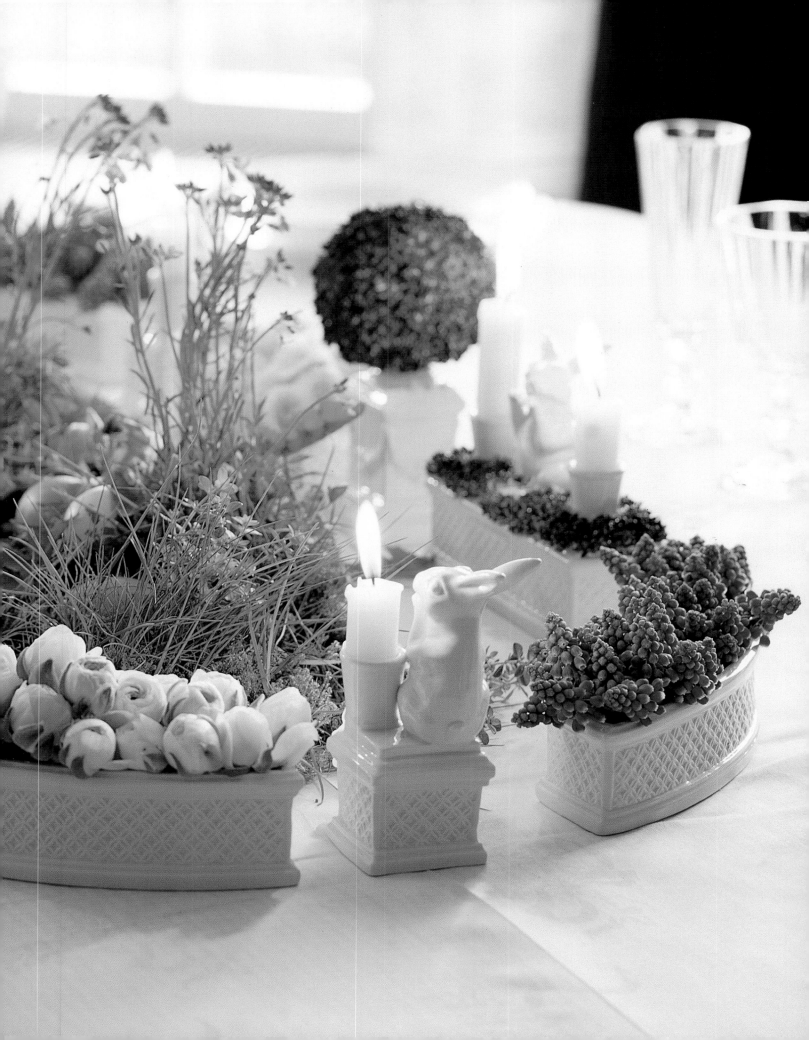

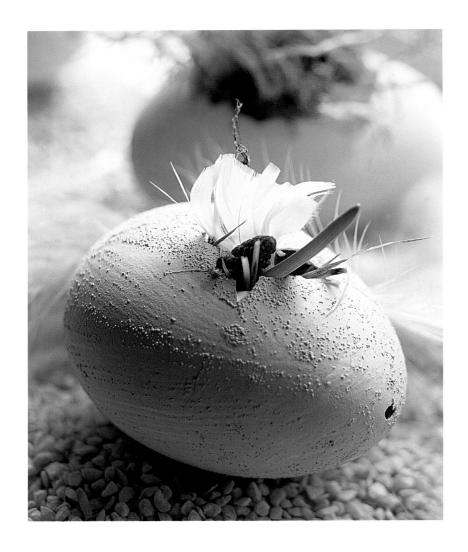

Aus diesen blauen Gänseeiern erblicken Traubenhyazinthen das Licht der Welt.

Grape hyacinths hatch from these blue goose eggs.

Naissance inhabituelle : ces muscaris voient la lumière du jour dans des œufs d'oie bleus.

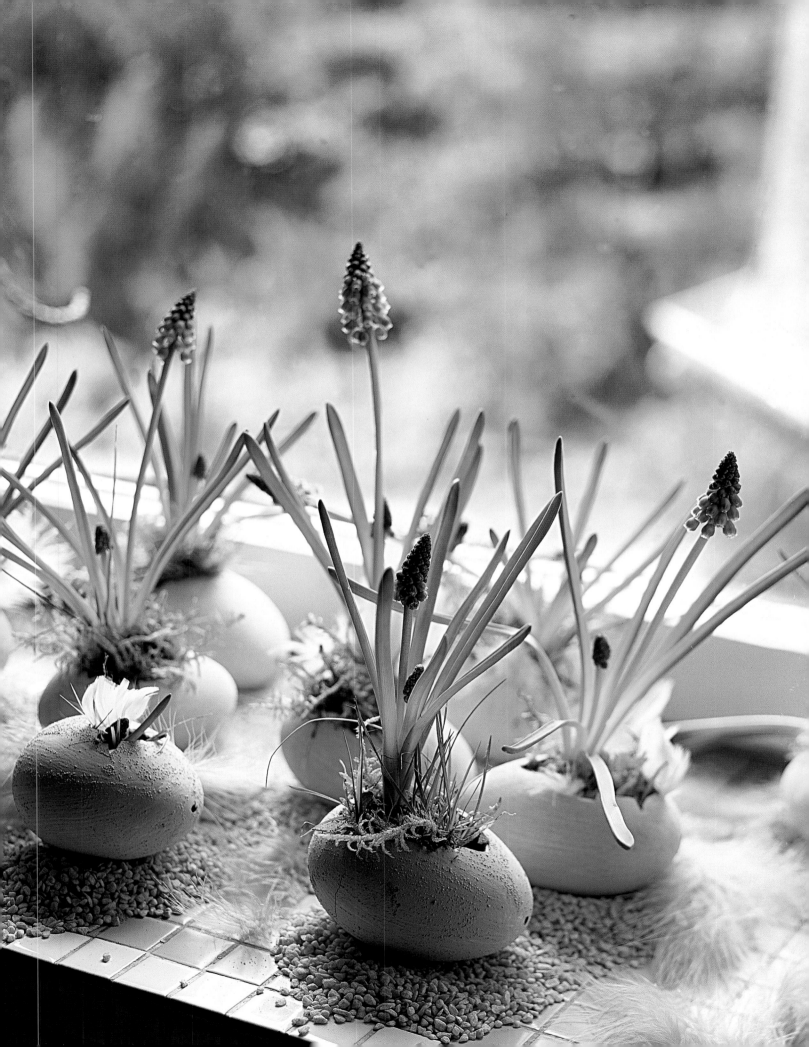

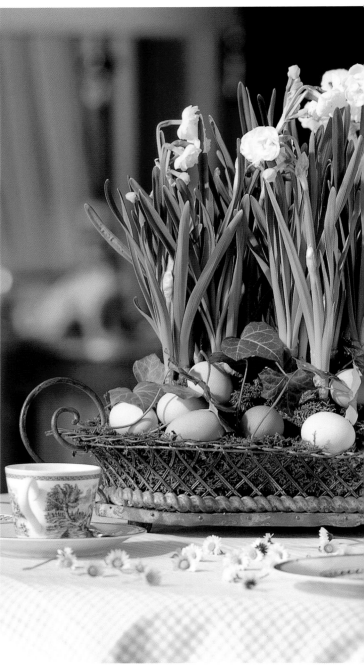

Die ovale Schale im Zentrum des stimmungsvollen Ostertischs vereint kleinblütige Narzissen, braune und weiße Ostereier sowie Efeuranken auf einem weichen Moosbett. Ein Meer von Gänseblümchen unterstreicht die Zartheit des Arrangements.

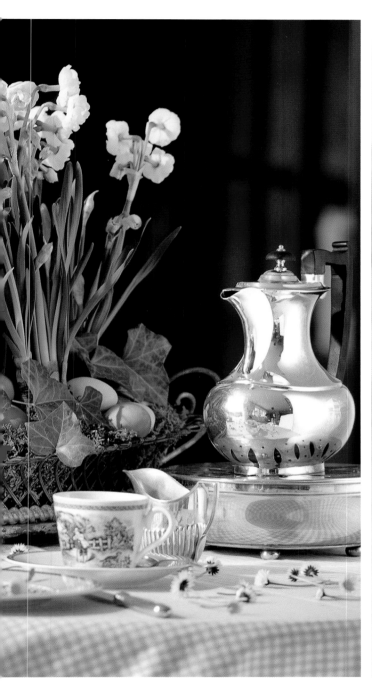

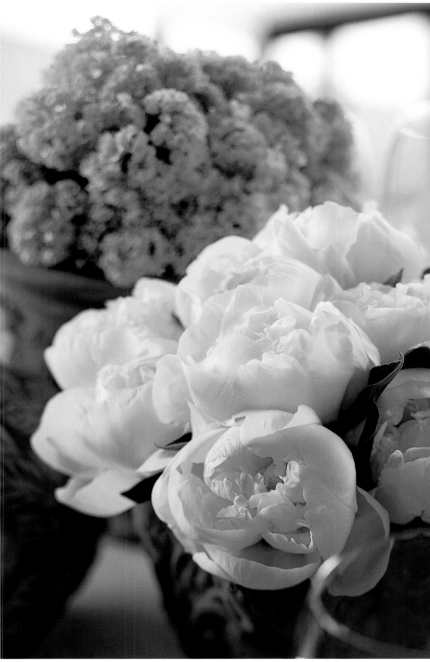

The oval dish positioned in the centre of the impressive Easter table combines small-flowered narcissus with brown and white Easter eggs, as well as ivy twines on a soft bed of moss. A sea of daisies underlines the delicate nature of the composition.

La coupe ovale placée au centre de la table de Pâques superbement arrangée réunit les narcisses à petites fleurs, les œufs de Pâques marrons et blancs ainsi que le lierre sur un doux lit de mousse. La mer de pâquerettes fait ressortir la douceur de l'arrangement.

Es müssen nicht immer Nester aus Moos sein: Auch in gelbgrüne Edelnelken können Ostereier dekorativ eingebettet werden.

Nests needn't always be made out of moss: yellow-green clove carnations qualify as well to decoratively house Easter eggs.

Alternative aux nids de mousse classiques : des œillets raffinés dans les tons jaune vert offrent un lit décoratif aux œufs de Pâques.

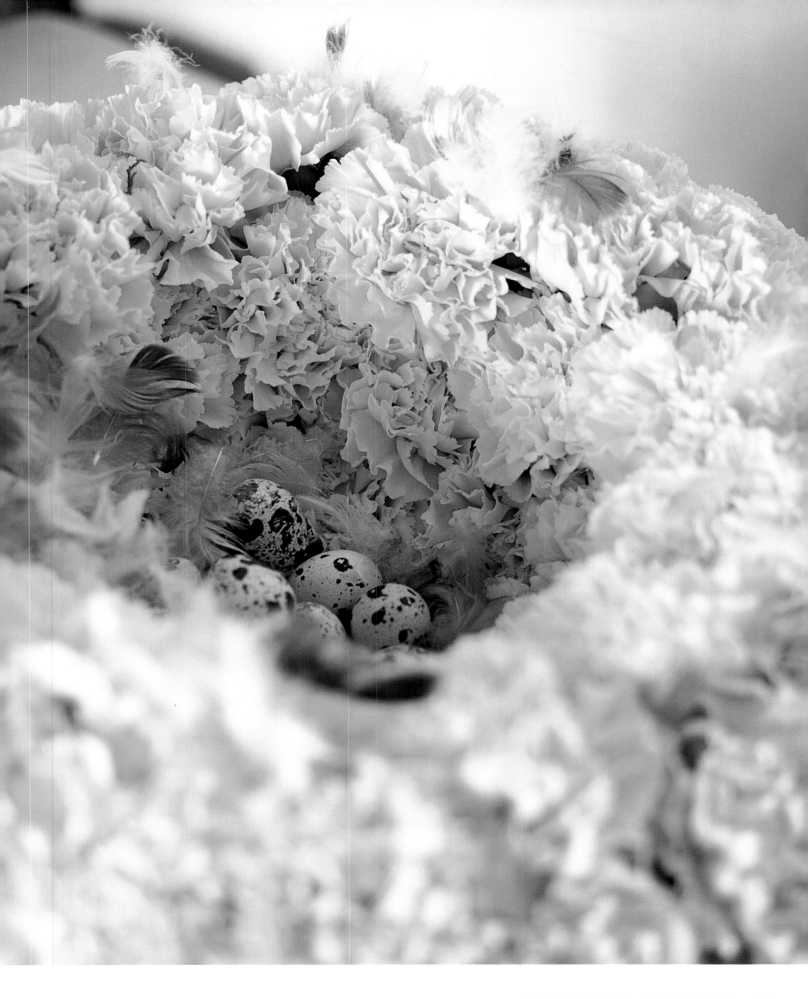

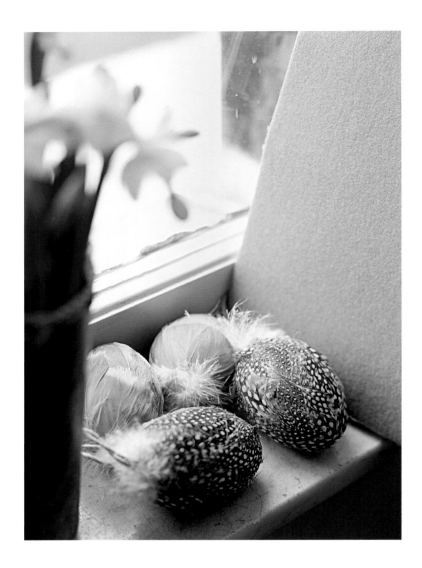

Elegante Eier mit einem weichen Kleid aus Perlhuhnfedern und den ersten zarten Blättern der Weidenkätzchen schmücken mit weißen Tazetten und kleinen Weidenruten das österliche Fensterbrett.

Elegant eggs with a soft dress out of guinea fowl feathers and the first delicate willow catkin leaves, join with white tazetta daffodils and small willow rods to grace the Easterly windowsill.

Des œufs élégamment revêtus de plumes de pintades et des premières pousses tendres du chaton de saule viennent se joindre aux narcisses tazette blancs et aux branches de saule pour embellir le rebord de la fenêtre à Pâques.

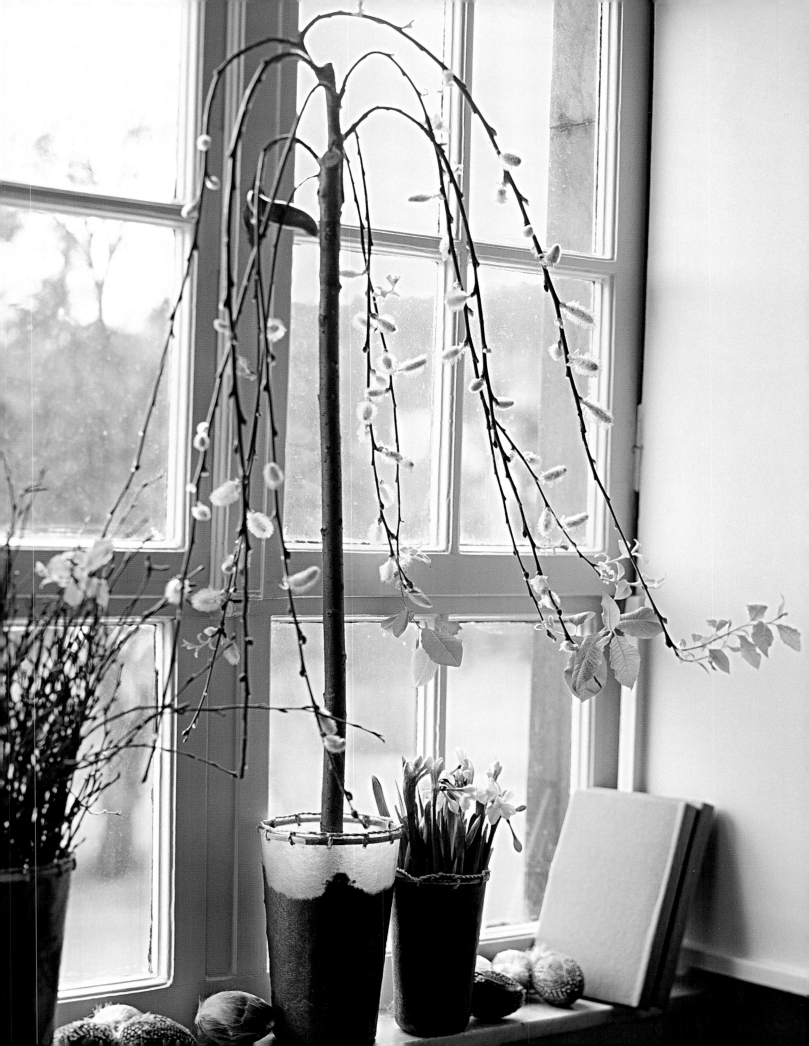

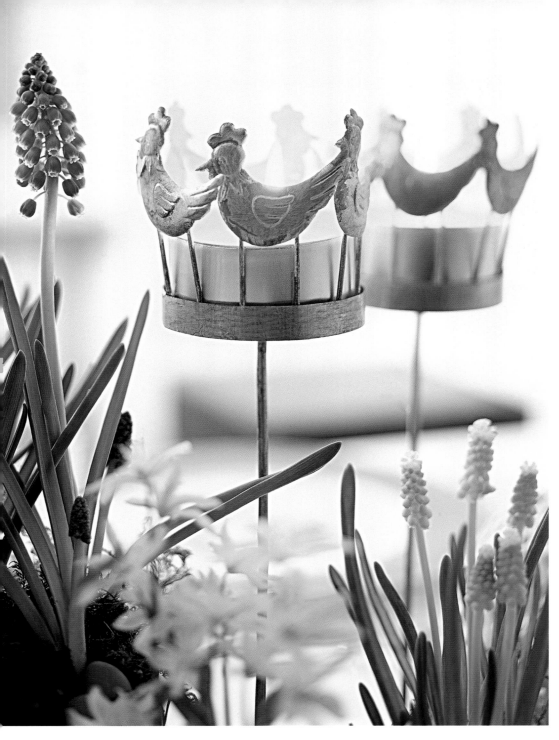

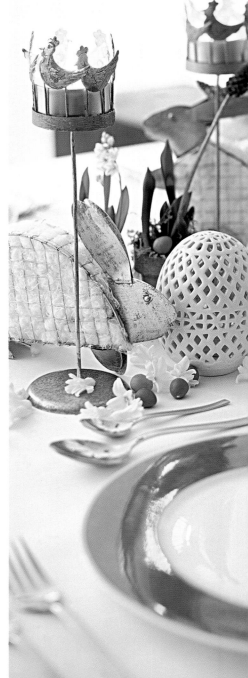

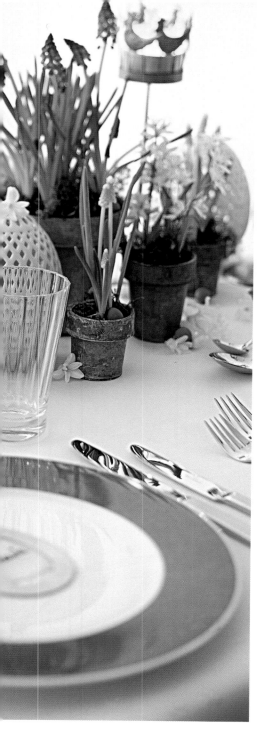
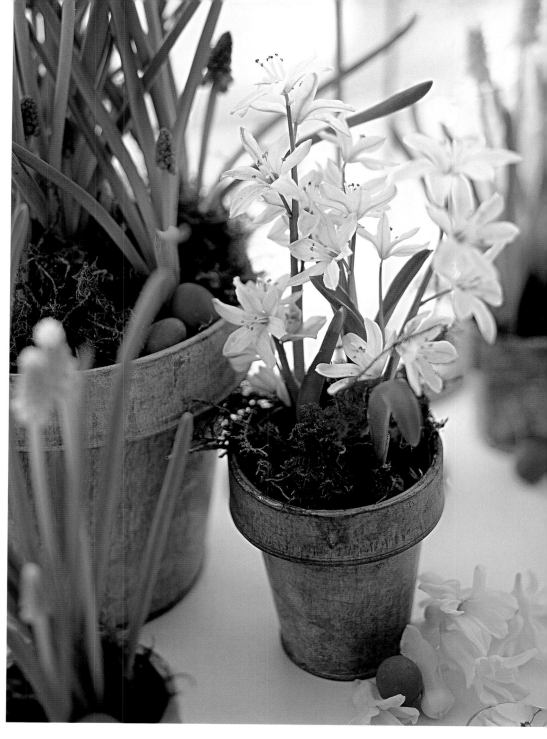

Osterleuchter voller Poesie ergänzen Blausternchen und Traubennarzissen mit ihren frischen Frühlingsfarben. Wertvolles Porzellan und Silberbesteck treffen auf schlichtes Zink.

Easter lanterns full of poetry complement the fresh spring colours of ageratum and grape daffodils. Valuable porcelain and sterling cutlery meet simple zinc.

Ces bougeoirs de Pâques poétiques correspondent à merveille aux couleurs fraîches printanières des scillas et des narcisses. Porcelaine précieuse et argenterie côtoient la simplicité du zinc.

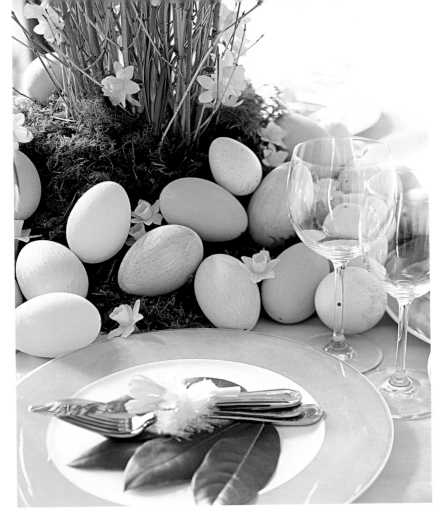

Buntes Eierpotpourri, weich auf Moos gebettet: Die Blätter des Rhododendrons zieren gemeinsam mit Narzissenblüten die Platzteller. Die Zweige des Hartriegelstrauchs, Osterglocken und Eier in Pastelltönen runden die Tischinszenierung ab.

Colourful egg medley, softly arranged on moss: rhododendron leaves and daffodil blossoms adorn the dinner plates. Branches of a dogwood bush, daffodils and pastel coloured eggs complete the composition.

Pot-pourri coloré couché sur un lit doux en mousse : les feuilles des rhododendrons embellissent les assiettes de présentation avec des fleurs de narcisses. Les branches de cornouiller, les jonquilles et les œufs dans les tons pastel viennent parfaire la décoration de la table.

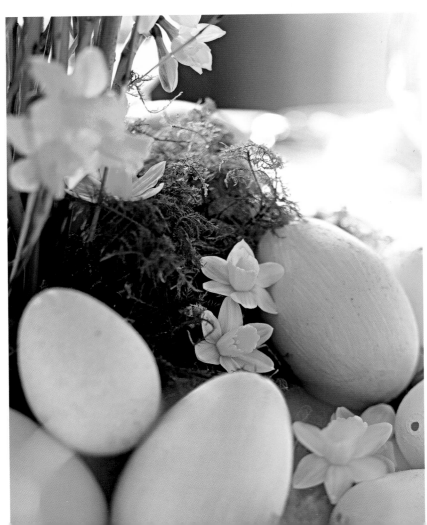

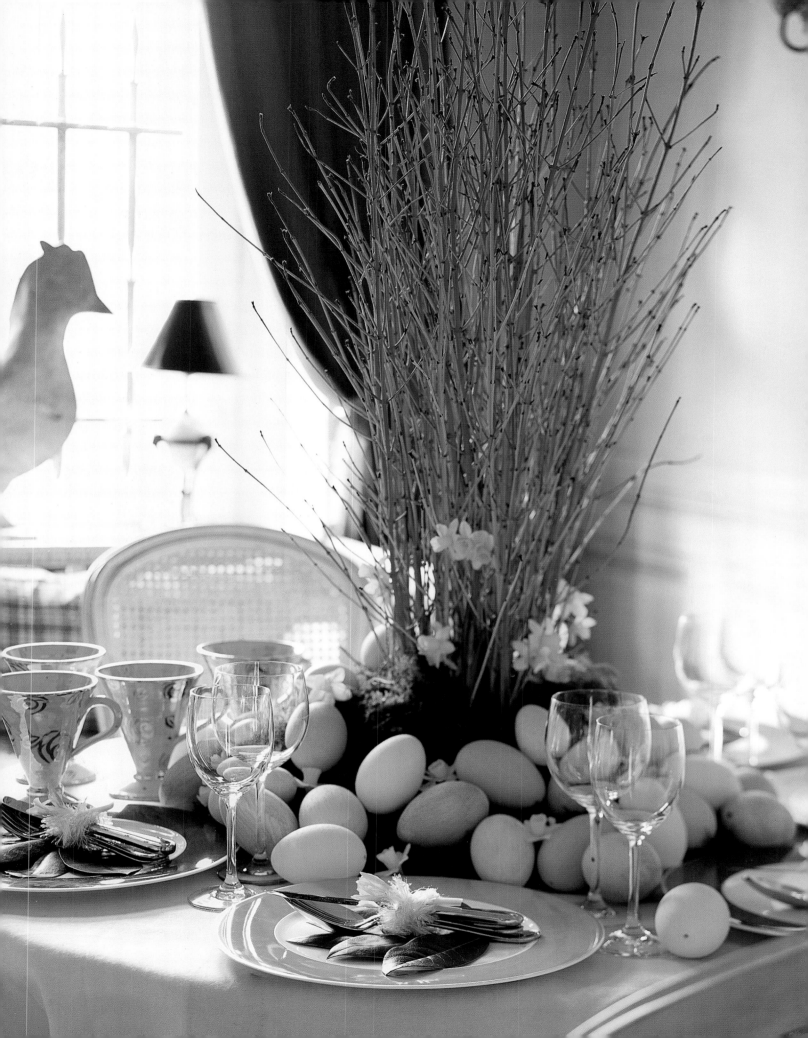

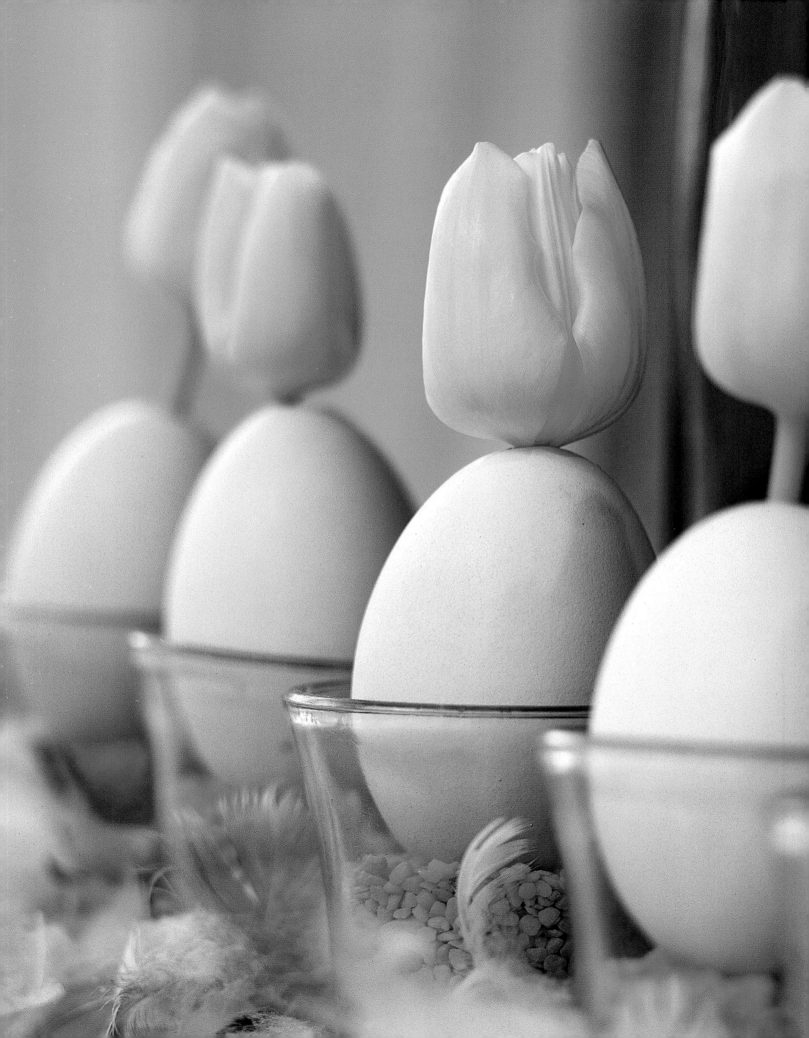

Streben nach Höherem: Diese französischen Tulpen nehmen das Spiel mit dem cremigen Weiß der Gänseeierschalen auf. Allein die kräftiggrünen Steinchen, mit denen die einfachen Gläser gefüllt sind, bilden einen schönen Kontrast.

Aspiring for higher grounds: These French tulips playfully compete with the goose eggshells' creamy white. Only the intense green pebbles, placed in simple glasses, provide a pleasing contrast.

À la recherche de l'exceptionnel : ces tulipes françaises s'harmonisent avec le blanc cassé des œufs d'oies tandis que le vert soutenu des cailloux qui remplissent de simples verres crée un heureux contraste.

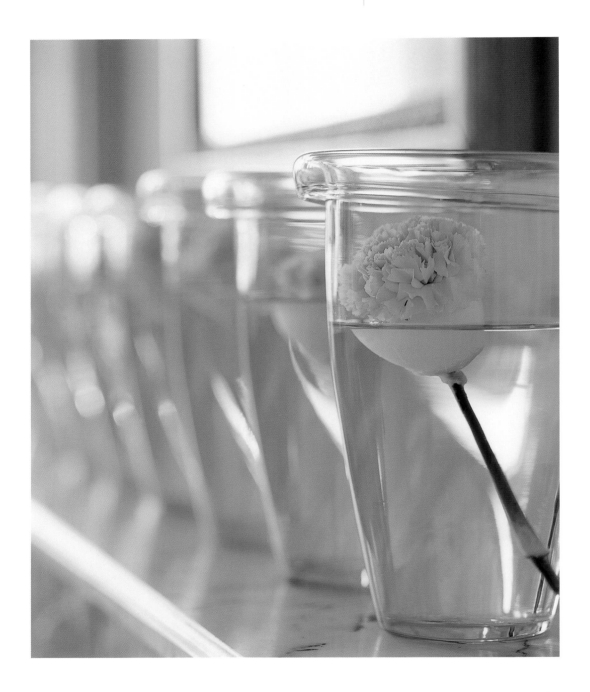

Sensation in Grünweiß: In halbierten Eierschalen, die mit Wachs gefüllt wurden, schwimmen grüne Nelken und werden rhythmisch auf dem Kaminsims platziert.

A green-white sensation: Eggshells are cut in half, filled with wax, and garnished with green carnations. The composition is rhythmically placed on the mantelpiece.

Sensation en vert et blanc : des œillets verts flottent dans des demi-coquilles d'œufs remplies de cire et forment une rangée rythmique sur le manteau de la cheminée.

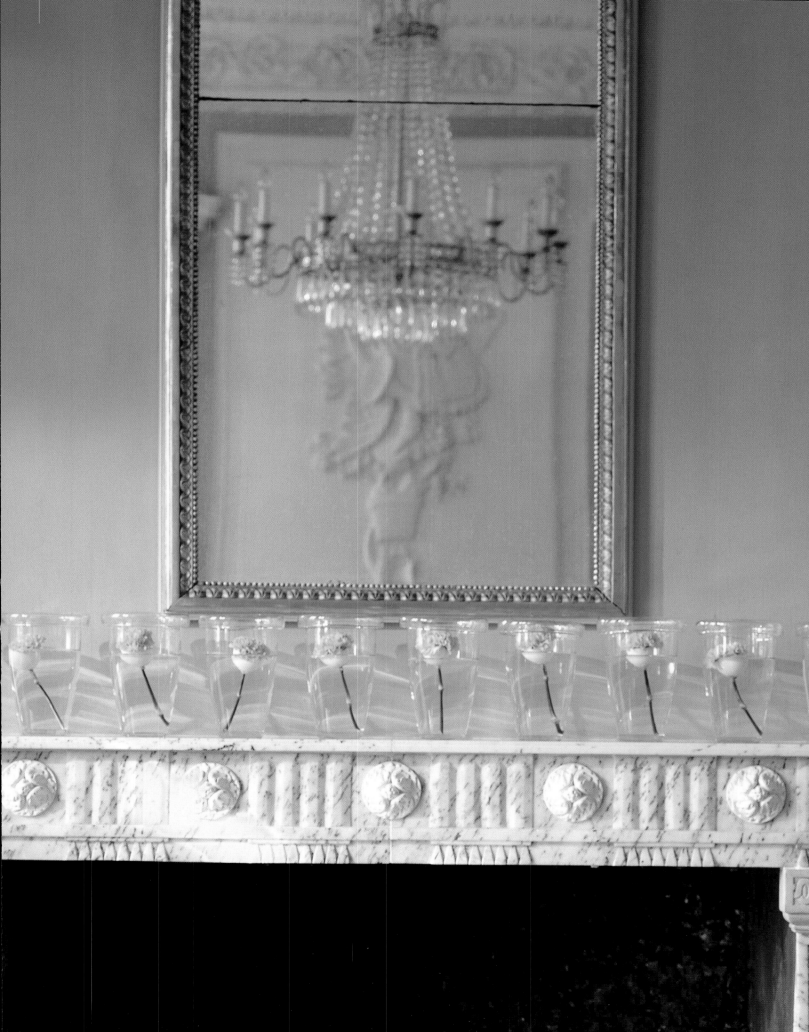

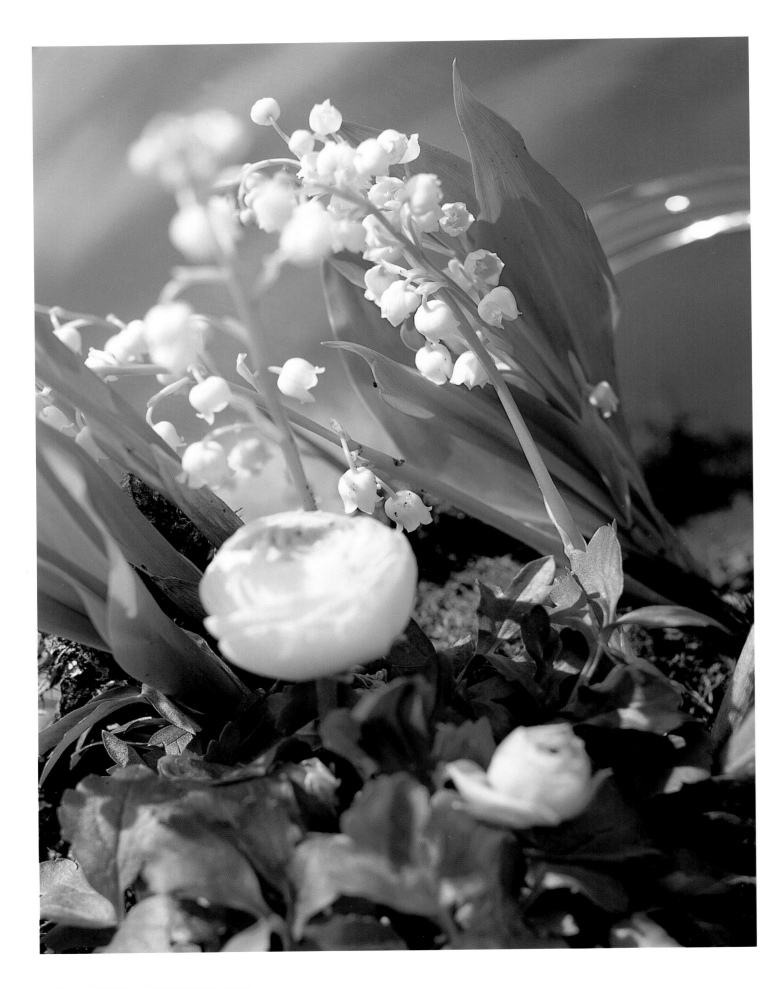

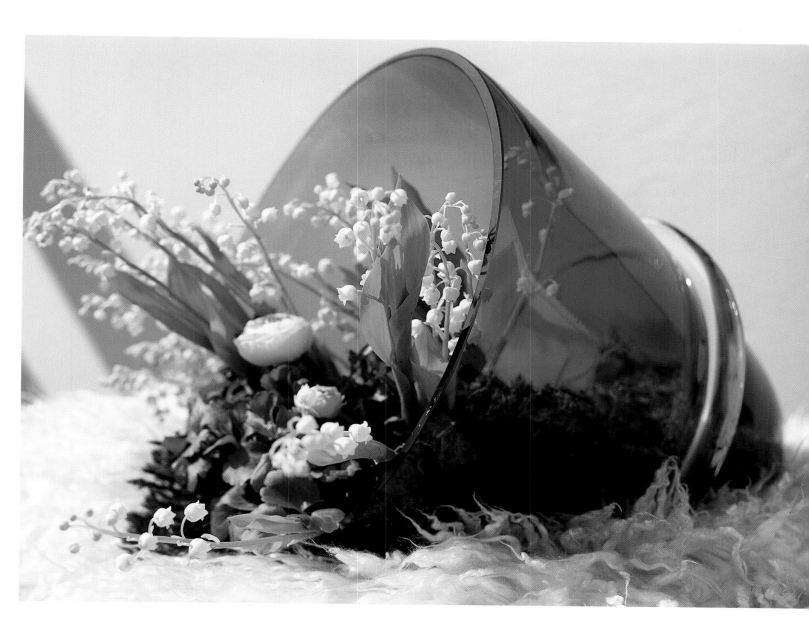

Die besondere Form dieser belgischen Vase regt zu einem ungewöhnlichen Arrangement an: Maiglöckchen, weiße Ranunkeln und Moos finden sich in dem gläsernen Füllhorn in Flaschengrün.

The unique form of this Belgian vase encourages exceptional arrangements: lilies of the valley, white buttercups, and moss are to be found in this bottle-green glass cornucopia.

La forme particulière d'un vase belge a inspiré un arrangement original : muguets, renoncules blanches et mousse reposent dans une corne d'abondance en verre vert.

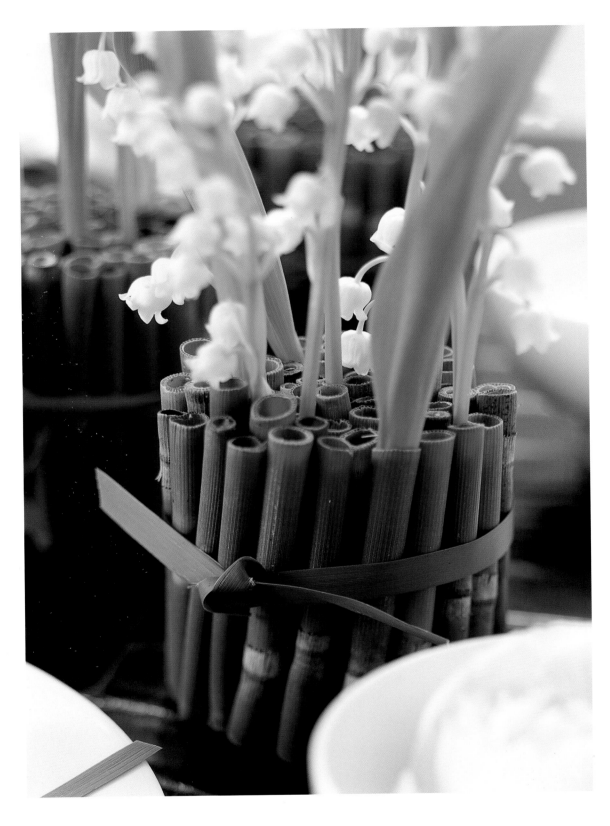

Tischinszenierung mit asiatischem Flair: Grazile Maiglöckchen wachsen aus diesen Schachtelhalmvasen, die von Palmblättern zusammengehalten werden.

Table decoration with an Asian touch: delicate lilies of the valley grow out of this horsetail vase, held together by palm leaves.

Mise en scène asiatique : des brins de muguet graciles semblent pousser dans ces vases de prêle maintenus par des feuilles de palmier.

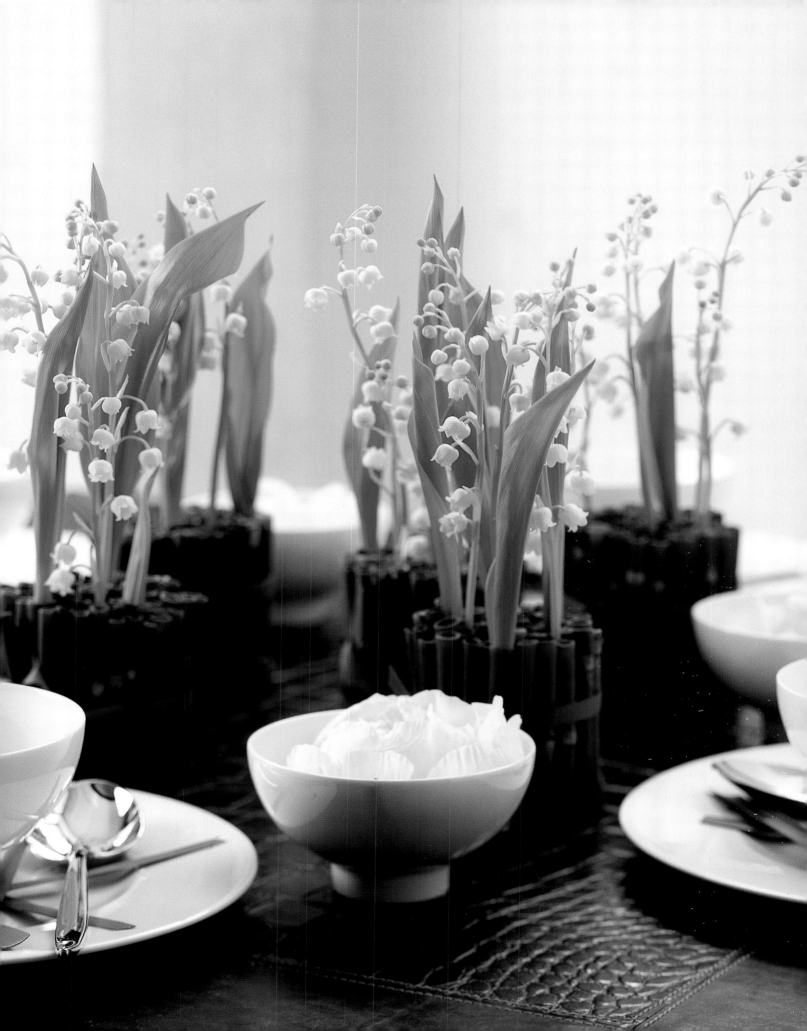

Ein großes geflochtenes Herz aus Rosen ziert dieses Muttertagskissen aus Amerika. Von dort kommt die Tradition, am zweiten Maisonntag die Mütter zu ehren.

A heart-shaped wreath made of roses graces this Mother's Day cushion from America. This is where the tradition to honour mothers on the second Sunday of May originates.

Un grand cœur tressé de roses orne ce coussin de Fête des Mères qui vient d'Amérique. Car c'est aux États-Unis que l'on doit la coutume d'honorer les mères.

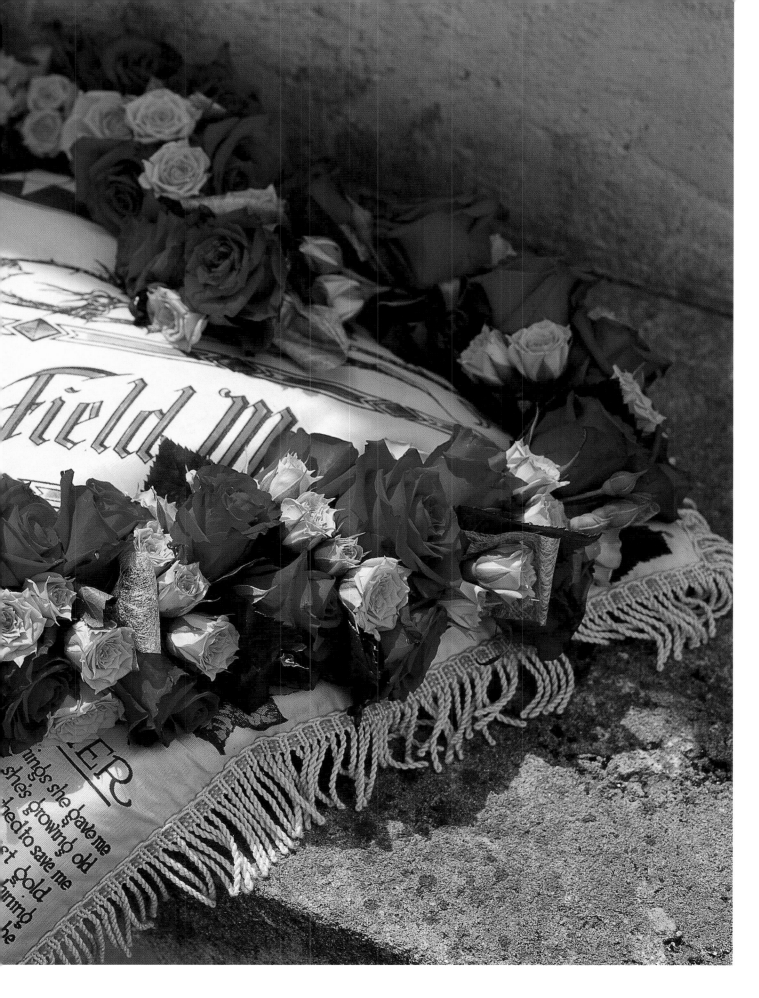

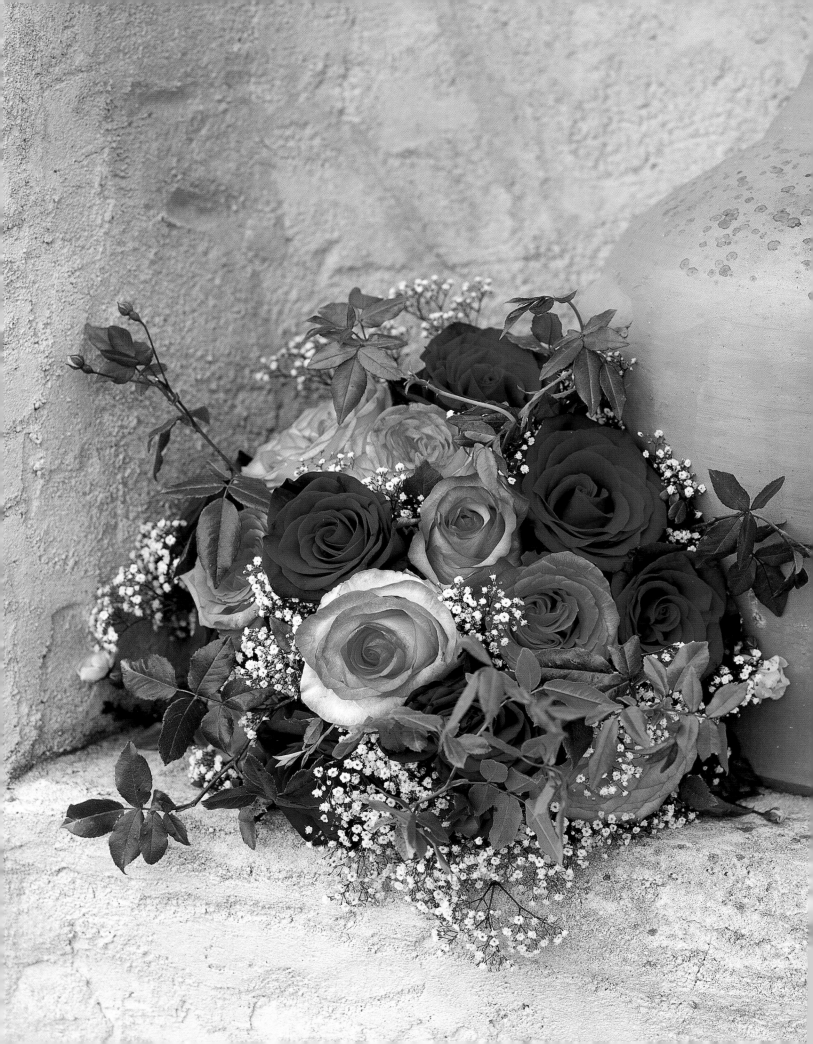

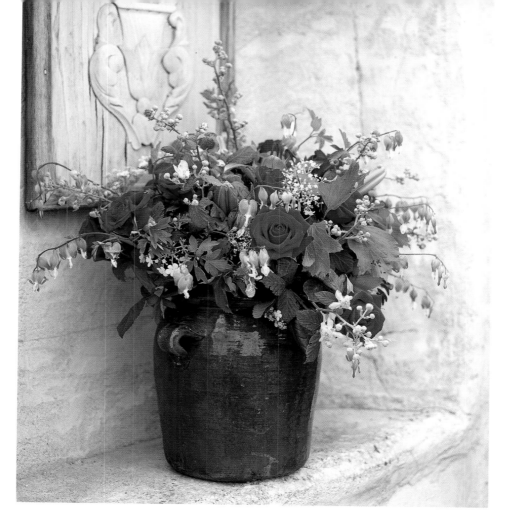

Rosen – die Blumen des Herzens: Luftiges Schleierkraut, Tränende Herzen auch in der weißen Variante, Lilien, wilde Karottendolden, Brombeerranken, Vergissmeinnicht oder Hostiablätter – viele Botschaften sprechen aus den prächtigen Sträußen.

Roses—flowers of the hearts: airy baby's breath, white bleeding hearts, lilies, wild carrot greens, blackberry tendrils, forget-me-nots or hosta leaves—the magnificent bouquets communicate numerous messages.

Roses – fleurs du cœur : gypsophile tendre, cœurs de Marie, également en blanc, lys, ombelles de carottes sauvages, ronces, myosotis et feuilles d'hosta – ces magnifiques bouquets ont beaucoup de messages à délivrer.

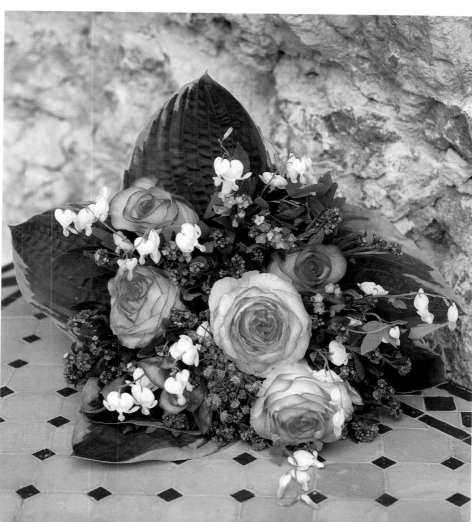

Sommer
Summer
L'été

Den Sommer kann man mit geschlossenen Augen erkennen. Die Natur ist jetzt besonders nah, denn wunderbar laue Luft weht ihre olfaktorischen Verführungen ins Haus. Sie schenkt uns eine weitere Dimension des Blumenglücks, betört einen weiteren unserer Sinne.

Im Mittelpunkt steht die Rose. „Eine Rose ist eine Rose, ist eine Rose", wusste Gertrude Stein die Frage nach dem Wesen der Dinge zu beantworten. Und doch ist jede anders. Die gleichen ergeben niemals denselben Strauß. Und keine Blume altert so schön wie die Rose. Sie ist damit Ausdruck des Lebens und des Vergänglichen zugleich, steht für Stärke und Zerbrechlichkeit. Kann allein stehen, sich aber auch zum ganz großen Auftritt verbünden.

Der Duft der Rose krönt den optischen Genuss, den sie bereitet, und macht den Sommer zur Aromatherapie. Manchmal brauchen wir eben mehr als nur die Augen, um zu erkennen.

Summer can be recognised with closed eyes. Nature is especially close at this time of the year, because the delightfully mild air blows its olfactory temptations into the house. It bestows us with a further dimension of flowerage and charms an additional sense.

Roses takes centre stage. "A rose is a rose is a rose," was Gertrude Stein's characterisation of the essence of things. Yet each is different. The same kinds never result in an identical bouquet. And no flower ages as beautifully as the rose. It therefore represents both, life and transience, strength and fragility. A rose can stand alone, but also be combined for a grand entrance.

The scent of a rose complements the optic pleasure and turns the summer into an aromatherapy. Sometimes we need more than just our eyes to comprehend.

On peut reconnaître l'été – même les yeux fermés. La nature nous semble particulièrement proche, car l'air du dehors s'introduit dans la maison avec son extrême douceur et nous offre ses séductions odorantes. La nature nous fait ainsi le cadeau d'un nouveau bonheur floral et charme un autre de nos sens.

La rose occupe une place centrale. « Une rose est une rose est une rose » disait Gertrude Stein pour expliquer le caractère des choses. Et pourtant chaque rose est différente. Les mêmes roses ne composent jamais deux fois le même bouquet. Et cette fleur porte son âge mieux que toute autre fleur. Elle est à la fois l'expression de la vie et l'expression de la vanité de toutes choses, symbole de force et de fragilité. Elle se suffit à elle-même, mais elle peut aussi s'associer à d'autres variétés pour une entrée triomphale.

Le parfum de la rose vient compléter le plaisir des yeux et fait de l'été une véritable aromathérapie. Parfois, nous avons tout simplement besoin d'autres sens que les yeux pour voir.

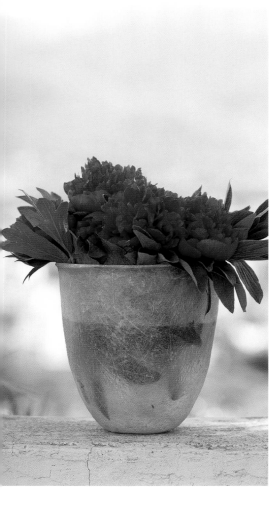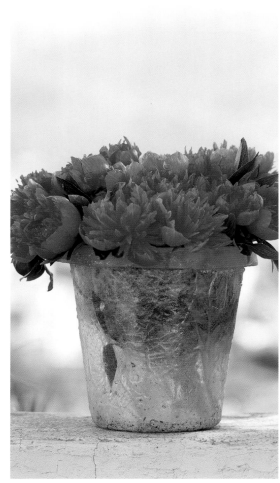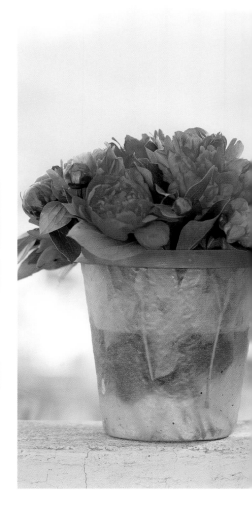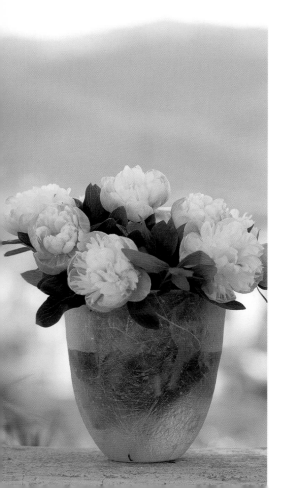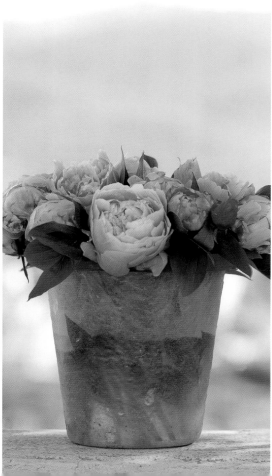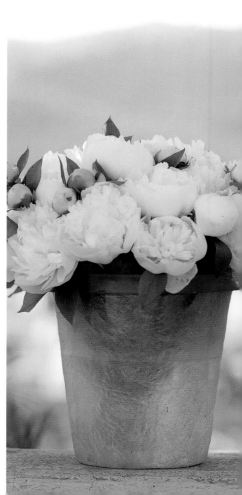

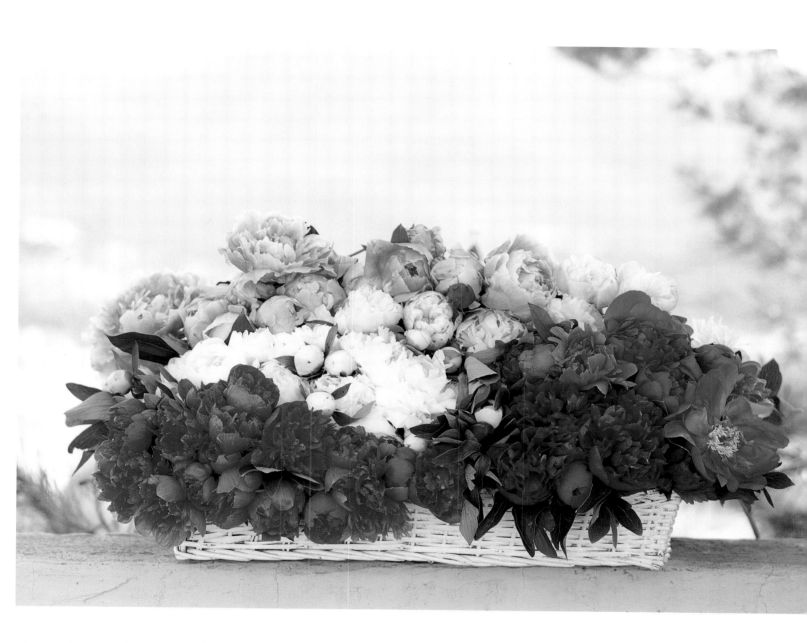

Pfingstrosen übertreffen sich gegenseitig an Farbkraft und Blütenfülle. Den Sommer läuten ein: die Klassiker „Sarah Bernhardt", „Madame Jules Dessert", „Monsieur Jules Elie", „Adolphe Rousseau" und „Alexander Steffen".

Peonies outperform each other concerning colour intensity and bloomage. The classics "Sarah Bernhardt", "Madame Jules Dessert", "Monsieur Jules Elie", "Adolphe Rousseau" and "Alexander Steffen" herald the summer.

Des pivoines rivalisent de beauté : c'est à qui l'emportera par l'éclat des couleurs et l'abondance des fleurs. Les grands classiques annoncent l'été : « Sarah Bernhardt », « Madame Jules Dessert », « Monsieur Jules Elie », « Adolphe Rousseau » et « Alexander Steffen ».

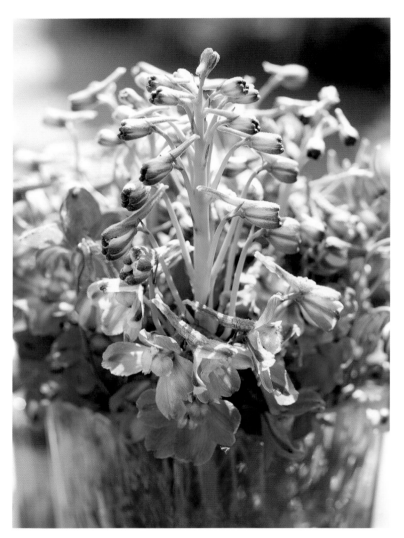

Jetzt wachsen sie wieder in die Höhe, die Blütenkerzen des sonnenverliebten Rittersporns: Neben Phlox und Pfingstrosen gehört die Gattung „Delphinium" zu den bekanntesten Darstellern in jedem Bauerngarten.

Now it's time for the sun loving larkspur blossoms to grow: besides phlox and peonies, the genus "delphinium" is one of the best known elements in every rural garden.

C'est maintenant que les fleurs du pied-d'alouette si friandes de soleil se mettent à pousser en hauteur : avec les phlox et pivoines, le genre « Delphinium » fait partie des variétés les plus répandues dans les jardins de campagne.

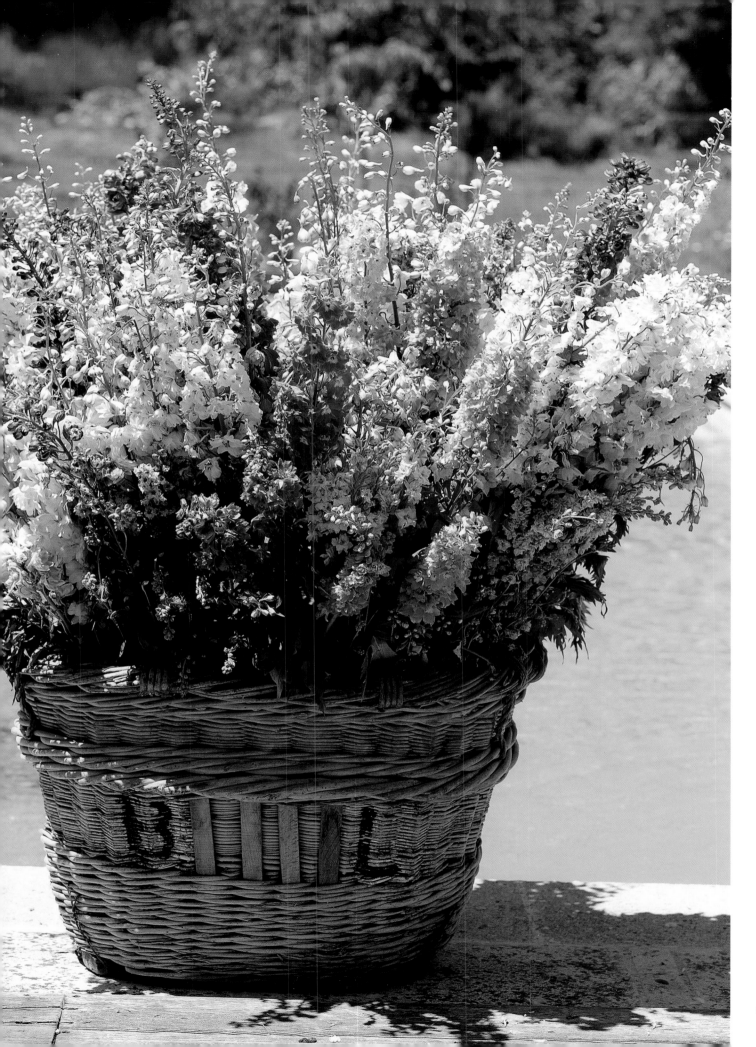

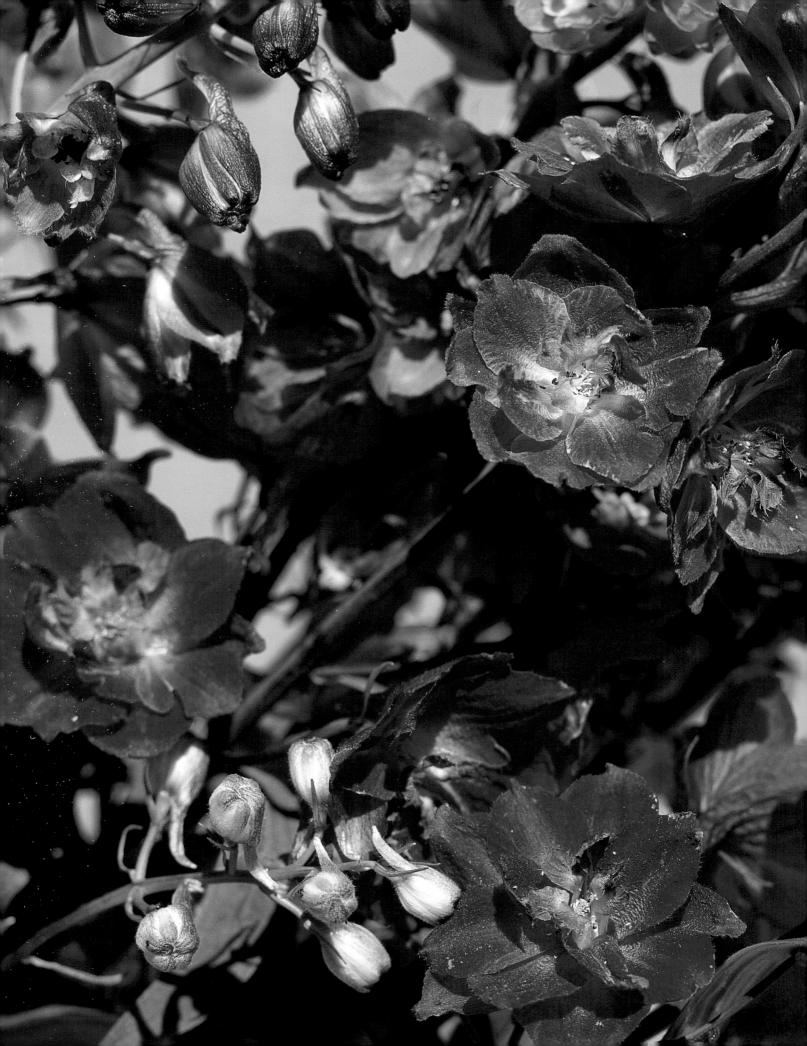

Magische Blautöne bieten die Ritterspornarten „Clack's Choice" und „Yvonne".

The larkspur genera "Clack's Choice" and "Yvonne" offer magical hues of blue.

Les variétés des pieds-d'alouette « Clack's Choice » et « Yvonne » offrent des tons de bleu vraiment magiques.

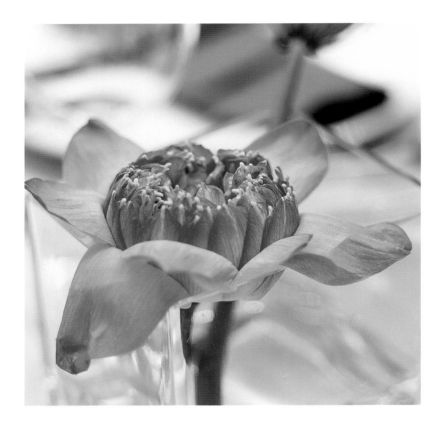

Asiatische Schönheiten: Die pinkfarbenen Blüten des Lotus und seine bizarren Fruchtstände wachsen bei dieser Tischinszenierung aus dem dunklen Grün des Schachtelhalms.

Asian beauty: The lotus' shocking pink-colored blossoms and its bizarre infructescences rise from the horsetail's dark green.

Beautés asiatiques : dans cette décoration de table, les fleurs fuchsia et les infrutescences étranges du lotus poussent au milieu du prêle vert foncé.

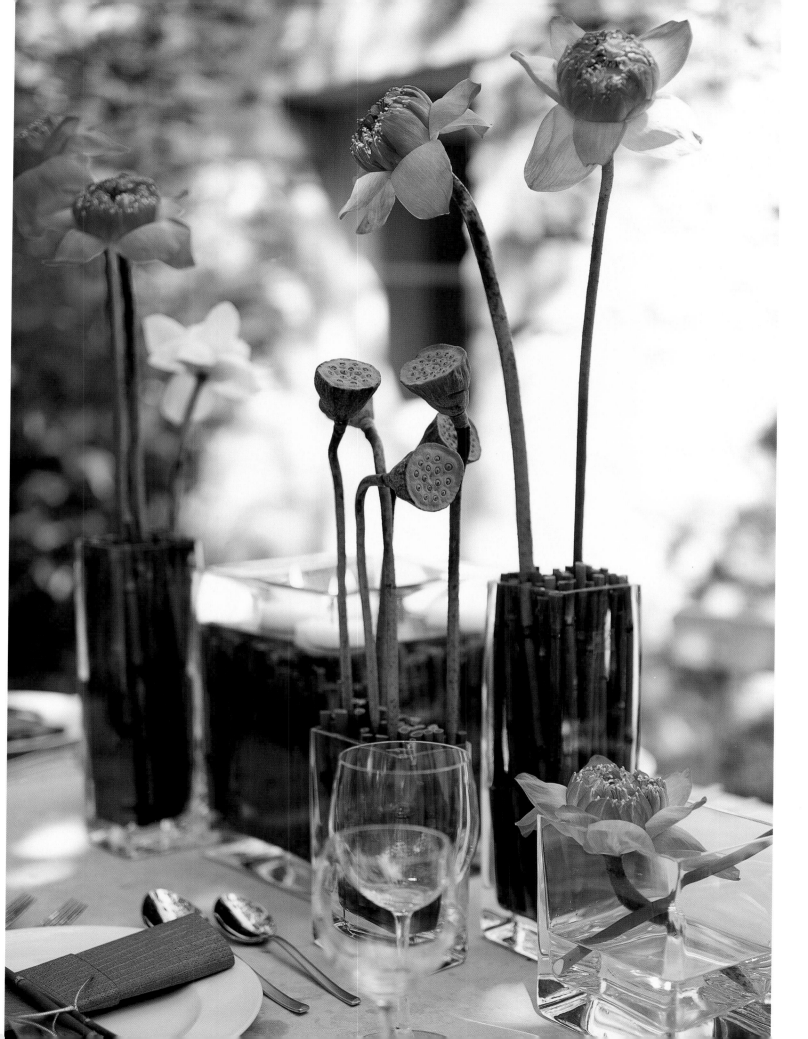

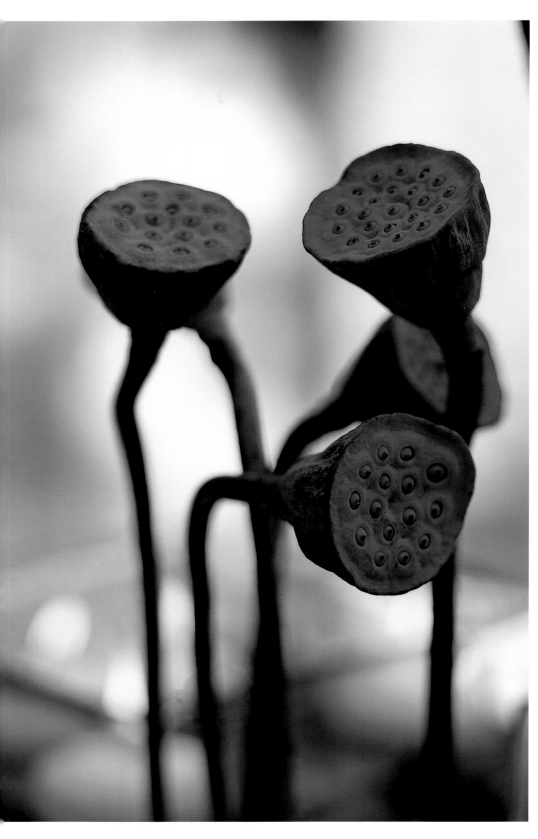
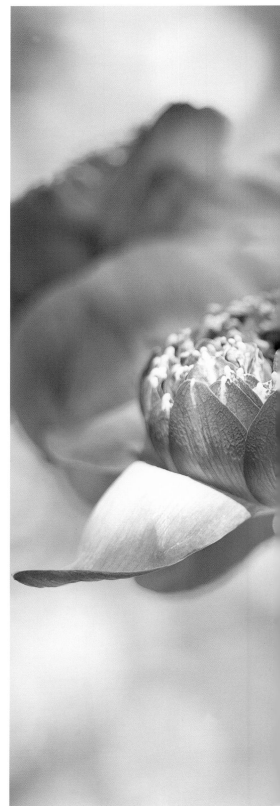

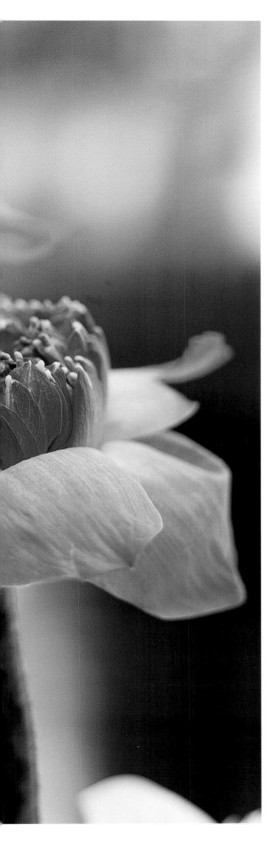

Die Lotusblüte ist nicht nur der Inbegriff von Reinheit, Weisheit und Schönheit, im Buddhismus steht sie zudem für Erleuchtung.

The lotus blossom not only epitomises purity, wisdom, and beauty. According to Buddhism it also stands for enlightenment.

La fleur de lotus n'est pas seulement le symbole de la pureté, de la sagesse et de la beauté, mais elle signifie dans le bouddhisme inspiration et illumination.

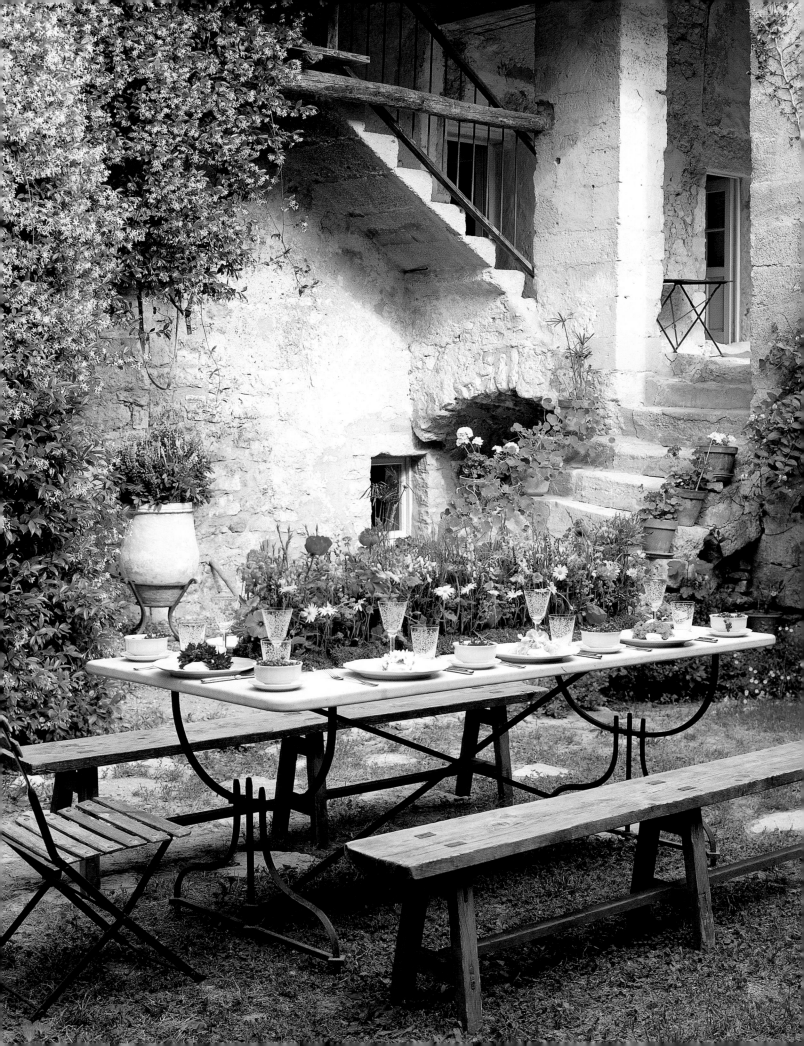

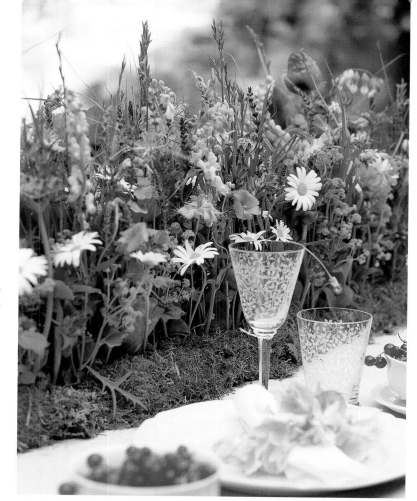

Eine ländliche Tafel auf grünem Gras: Zarte Wicken, leuchtender Mohn, Tränendes Herz, Glockenblumen, Malven, Margeriten und Frauenmantel verwandeln den Tisch in eine Blumenwiese.

A rural table on green grass: delicate sweet peas, bright poppies, bleeding hearts, bellflowers, mallows, marguerites, and lady's mantle turn the table into a meadow of flowers.

Table rustique sur pelouse verte : pois de senteurs délicates, coquelicot éclatant, cœurs de Marie, campanules, mauves, marguerites et alchémilles transforment la table en prairie couverte de fleurs.

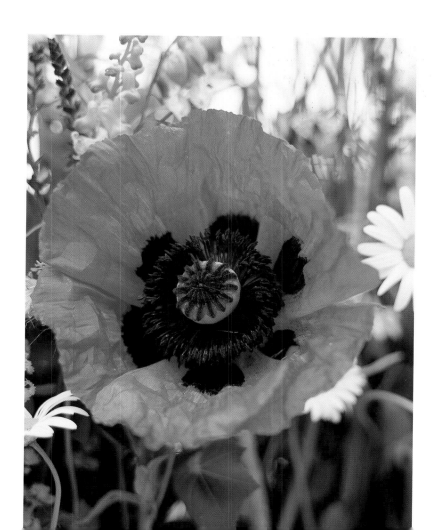

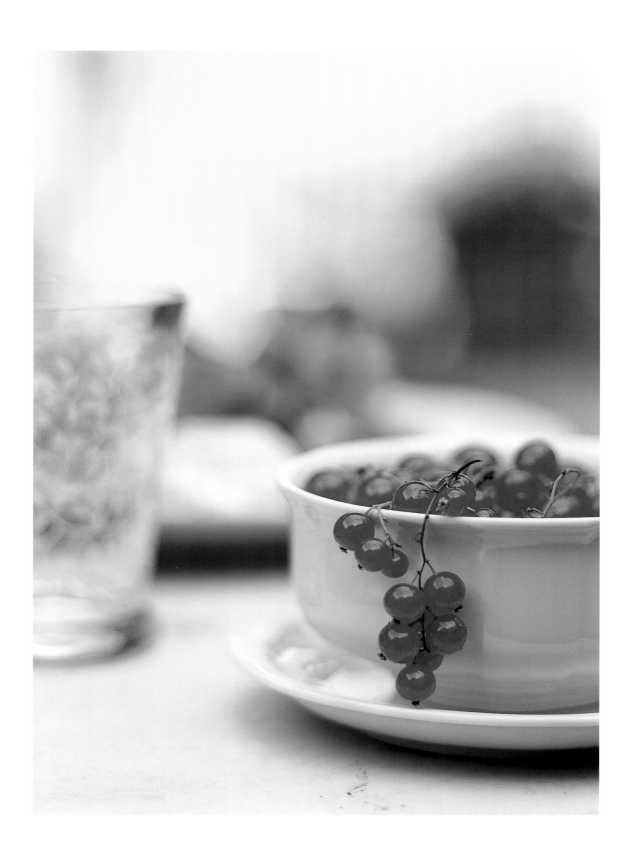

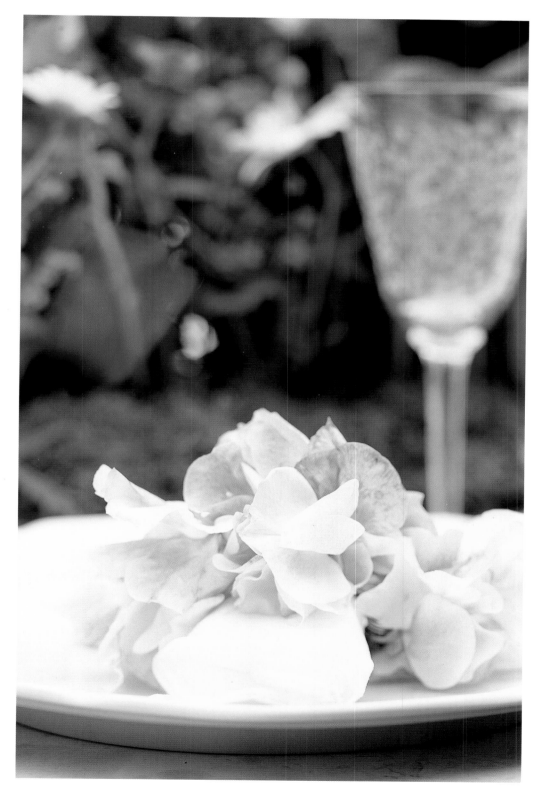

Sommerliche Farbpalette: Rote Johannisbeeren und die zartrosa Blütenblätter der Wicke veredeln jede gedeckte Tafel und versprühen gute Laune und jede Menge Esprit.

Summer's kaleidoscope of colours: red currant and vetch's soft pink petals refine every table decoration, and ensure cheerfulness as well as plenty of esprit.

Palette estivale : groseilles et pétales tendres des pois de senteur roses anoblissent chaque table et répandent bonne humeur et esprit.

Unschuld und Einfachheit, gepaart mit Magie und versteckter Erotik: Die cremefarbenen Callablüten nehmen zwischen dem klassisch modernen Service die Hauptrolle ein.

Innocence and simplicity, combined with magic and hidden eroticism: The cream-coloured calla blossoms play the leading role, amongst the classic modern tableware.

Pureté et simplicité se marient harmonieusement avec la magie et l'érotisme subtil : avec leur ton crème, les callas sont les stars des services de table qui allient classicisme et modernité.

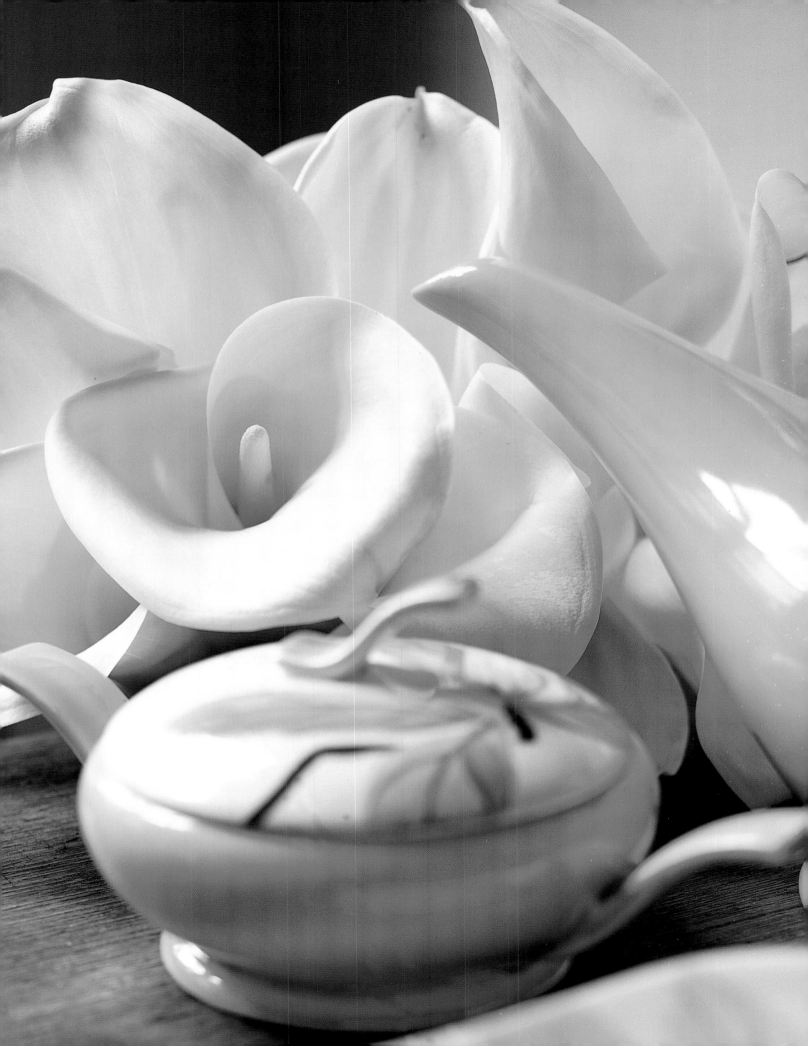

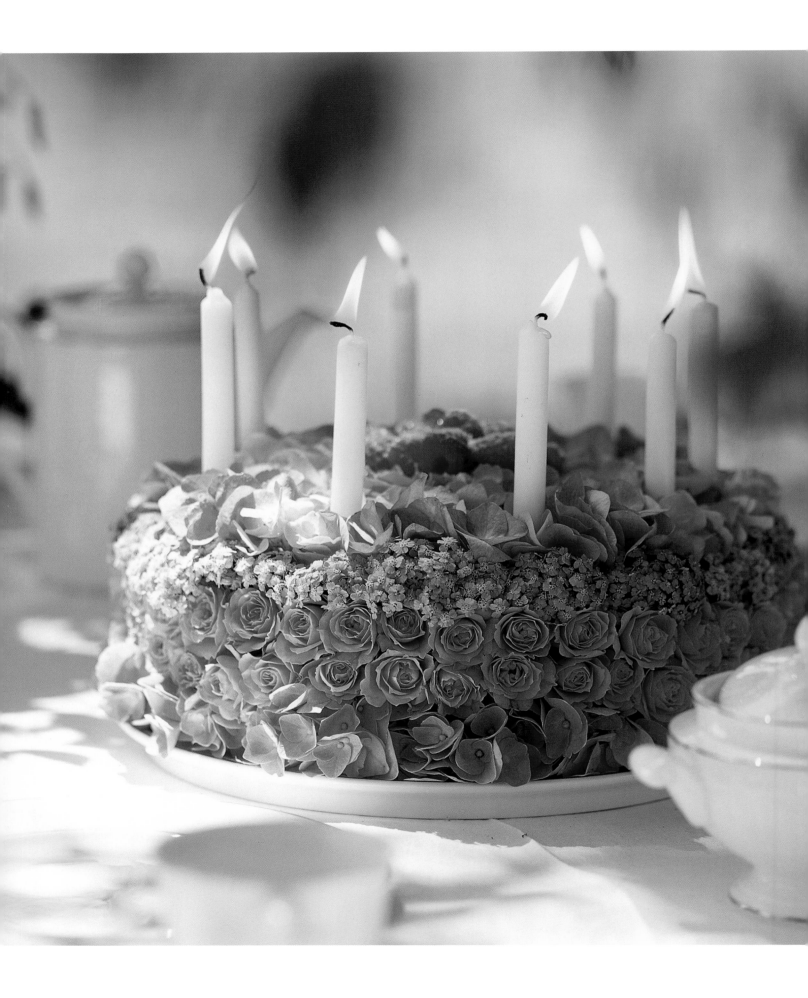

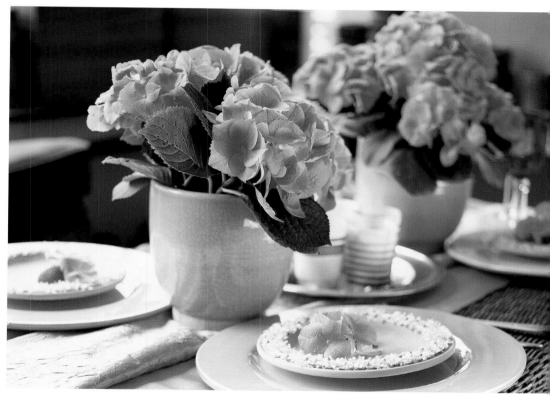

Geburtstag im Sommer: Lebendiges Orange, Rot und Gelb kombiniert mit rot glänzenden Johannisbeeren oder eine Blütentorte aus rosafarbenen Hortensien, kleinknospigen Rosen und rosafarbener Schafsgarbe, gekrönt von gezuckerten Himbeeren, machen den Ehrentag zum Fest.

Birthday in summer: vivid orange, red, and yellow combined with glossy red currants or a blossom cake made of pink hydrangeas, small budded roses and pink coloured yarrow, crowned with sugared raspberries, perfect every celebration.

Anniversaire en été : orange vif, rouge et jaune en combinaison avec des groseilles étincelantes – ou un gâteau de fleurs composé de petites roses, d'hortensias et d'achillées roses et surmonté de framboises sucrées font de ce grand jour une fête.

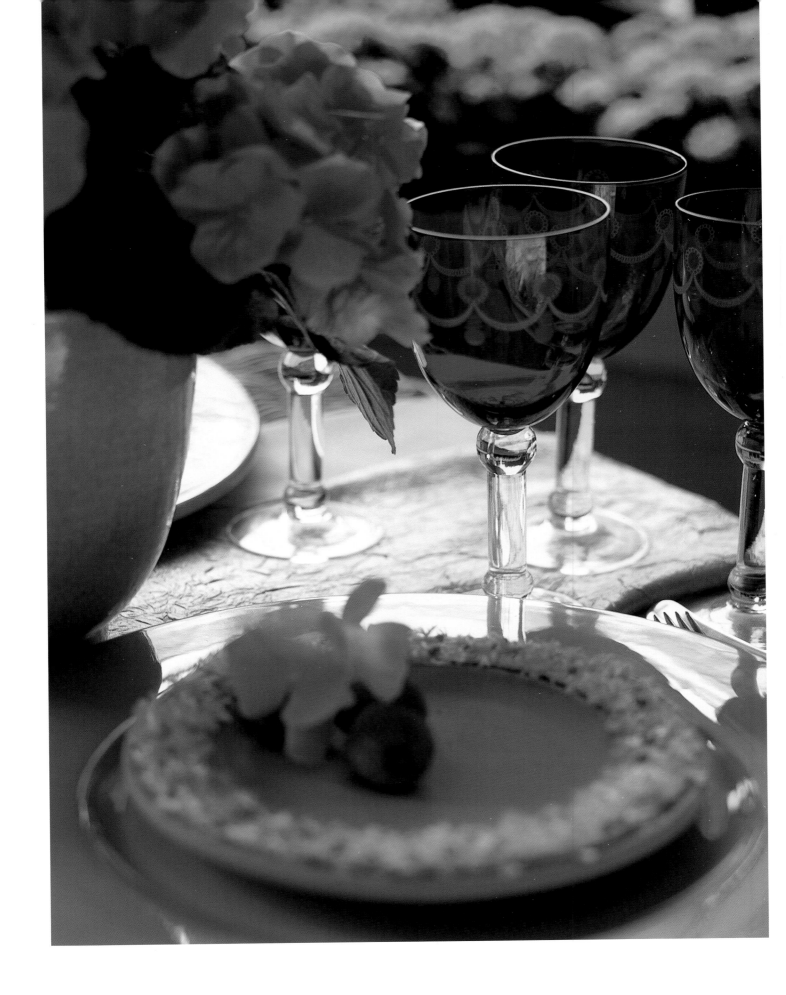

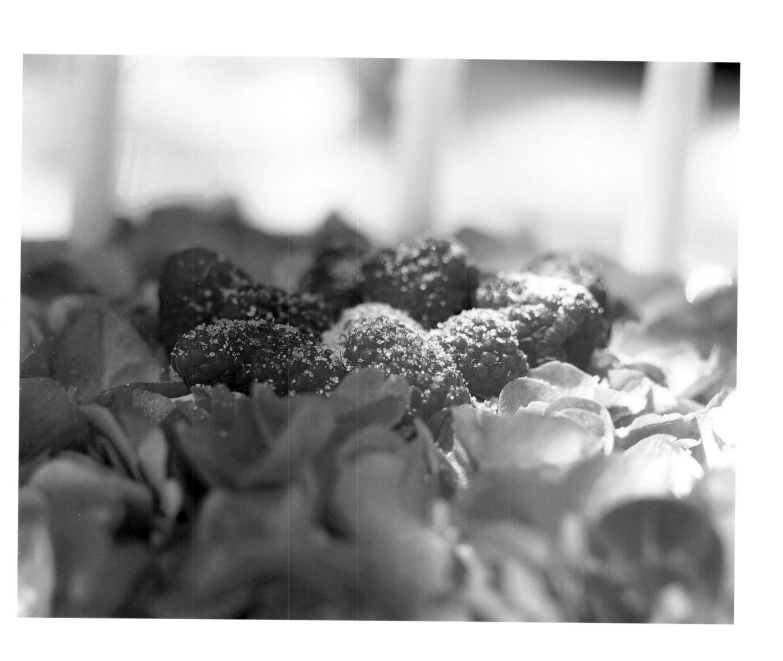

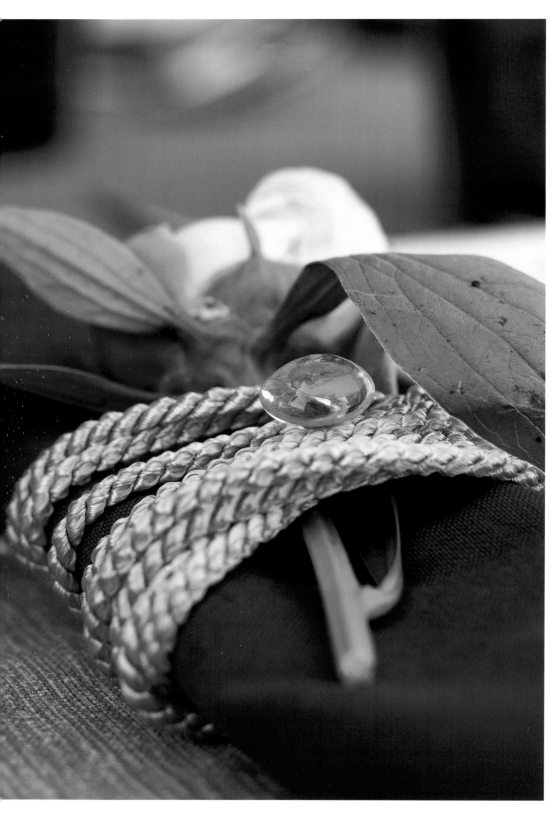

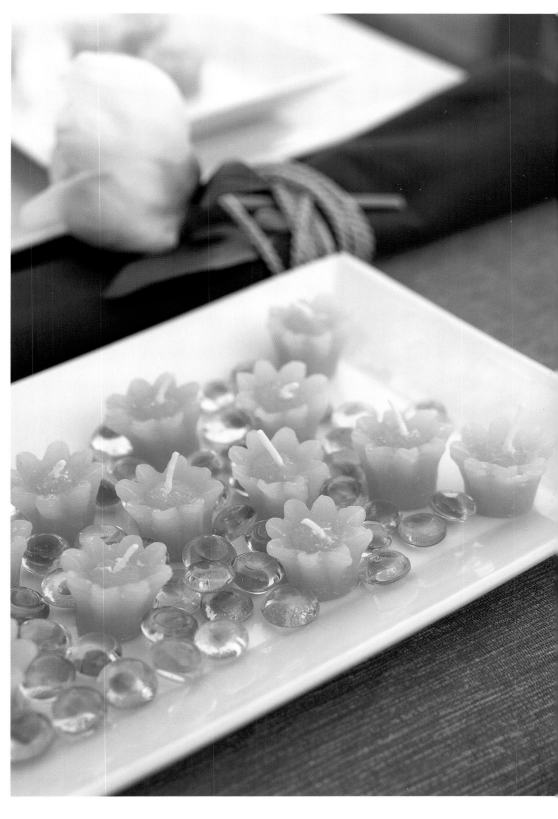

Traum in Blau: Zur maritimen Inszenierung tragen kleine Schwimmkerzen, Kristallperlen und die glänzende Serviettenringkordel bei, während die weiße Pfingstrose ihr eine klassische und sinnliche Note verleiht.

A dream in blue: The maritime decoration is composed of floating candles, crystal beads and a shiny napkin ring cord, while the white peony adds a classic and sensual touch.

Rêve en bleu : bougies flottantes, perles en cristal et un rond de serviette en corde brillant pour la mise en scène ; la pivoine blanche ajoute une note classique et sensuelle.

Mit ihren schwimmenden Blüten zeigt die grazile Seerose, dass der Sommer seinen Höhepunkt erreicht hat.

With its floating blossoms the delicate water lily indicates that the summer has reached its climax.

La nymphéa montre avec ses fleurs flottantes que l'été est arrivé à son zénith.

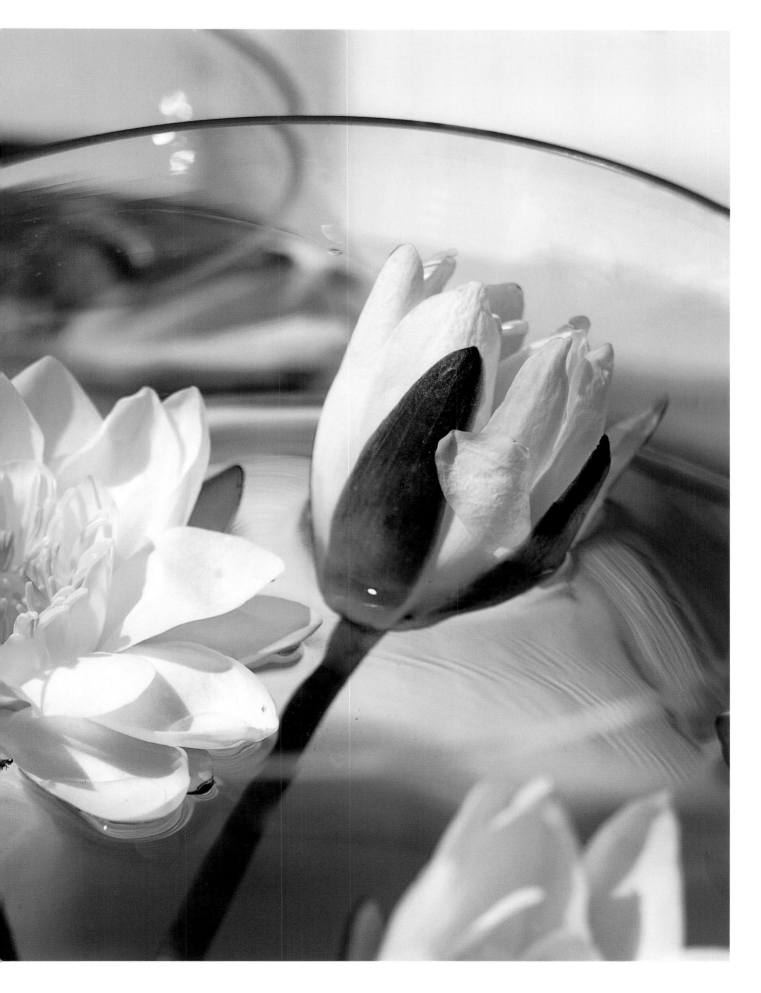

Glasgefäße, in denen grüne Schlingpflanzen treiben, spenden Kühle und verleihen dem Arrangement asiatisch reduzierte Anmut.

The glass vessels, filled with floating twiners, radiate coolness and add minimalist Asian grace to the arrangement.

Les récipients en verre où se déploient des plantes grimpantes semblent rafraîchir l'atmosphère et confèrent à cet arrangement une grâce asiatique épurée.

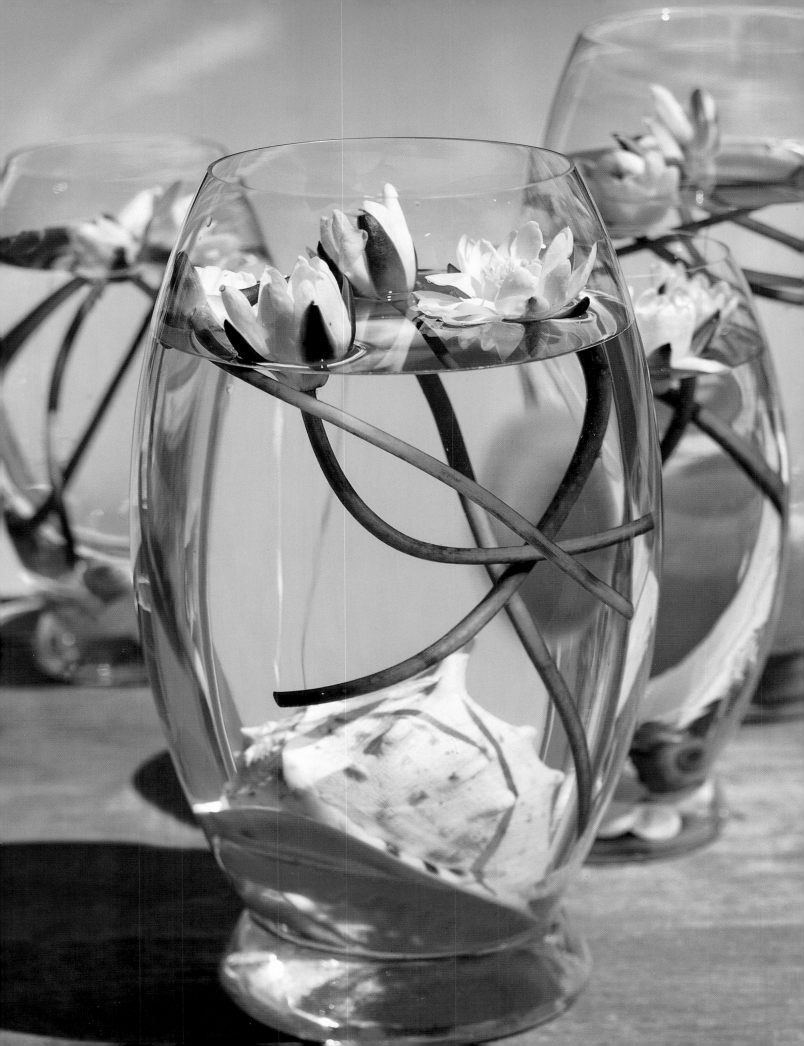

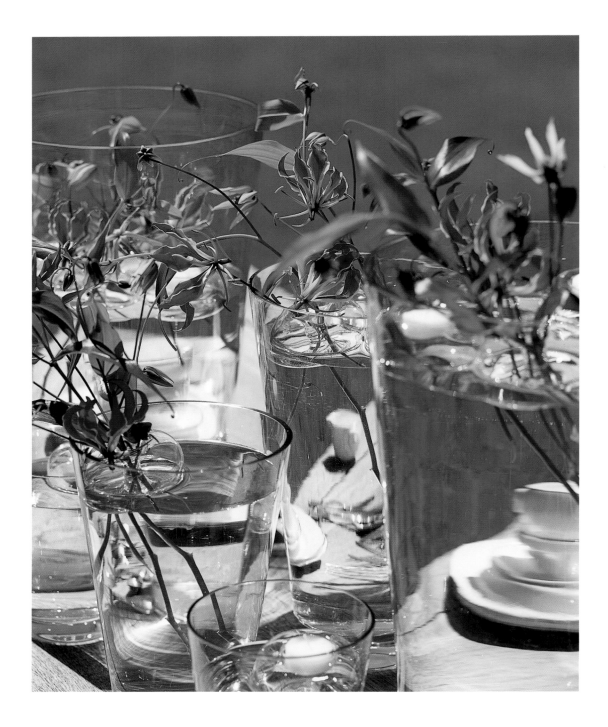

Ein grandioser Auftritt auf beiden Seiten: die exotisch wirkende Ruhmeskrone, deren Blüten an züngelnde Flammen erinnern, und das überschwängliche Rankenarrangement aus Ruhmeskrone, Wicken, Verbenen und Zierspargel im antiken italienischen Eisenpokal.

A grand entrance on both sides: seemingly exotic climbing lily, with blossoms resembling flickering flames, and the exuberant tendril arrangement made of climbing lilies, vetches, verbenas, and asparagus ferns in an antique Italian iron goblet.

Entrée en scène grandiose à double déploiement : d'un côté, le lis de Malabar exotique dont les pétales ressemblent à des flammes jaillissantes ; de l'autre, l'arrangement exubérant de sarments de lis de Malabar, de pois de senteur, de verveine et d'asparagoïdes dans un vase italien antique en fer.

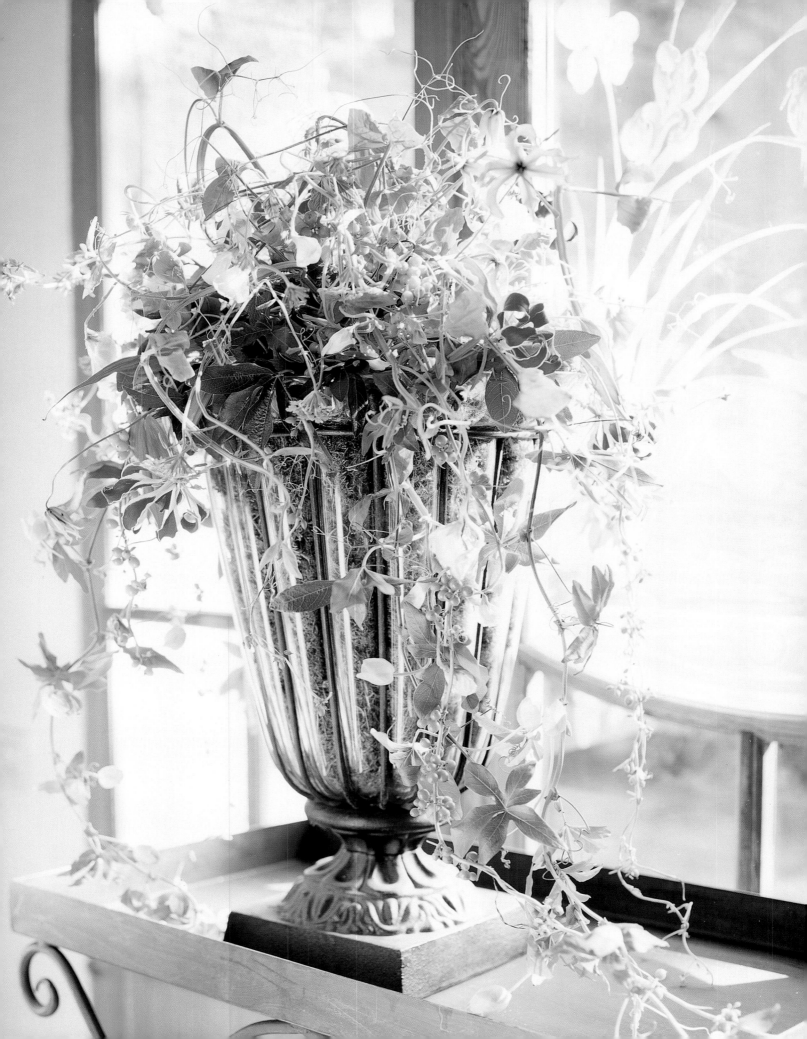

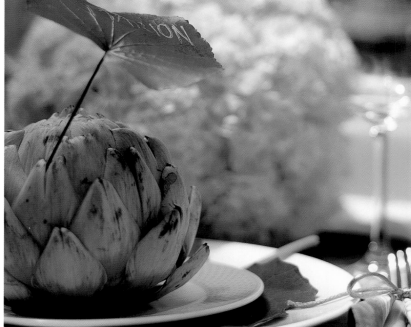

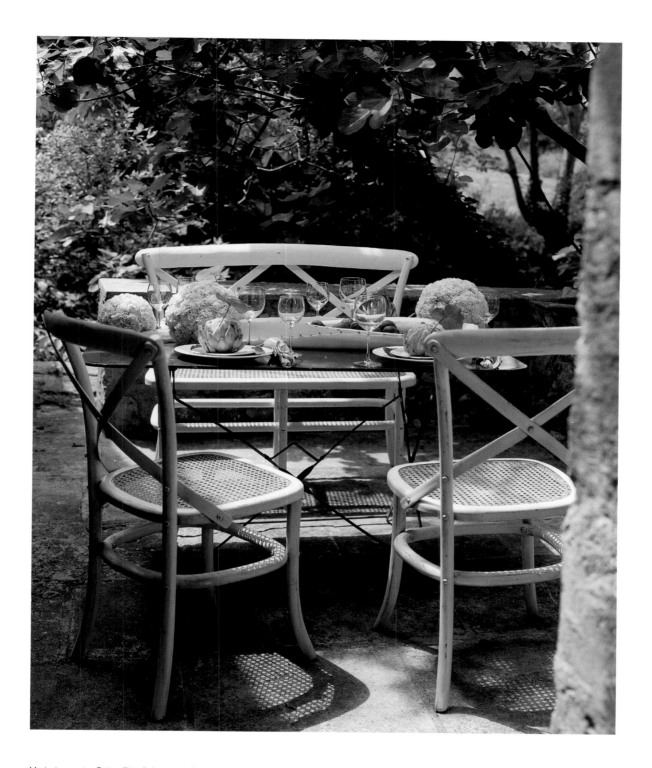

Variationen in Grün: Die Palette reicht vom gelben Grün der aufgesteckten Nelkenbälle über die satten Bronzeblätter und die noch bleiche Tönung eines Agaveblatts bis zu dunkleren Farben der Feigenblätter.

Variations in green: the spectrum reaches from carnation leaves' yellowish green, via luscious galax leaves and agave's pale tinge, to the fig leaves' darker colours.

Variations en vert : la palette couvre un large spectre, du vert-jaune des œillets, des feuilles de galax profondes, de la nuance encore pâle d'une agave jusqu'aux tons plus foncés des feuilles de figuier.

Frühstück bei Sonnenschein: Grüne Blätter und Halme mit einem Strauß aus gefülltem Rittersporn in Lila sorgen für einen gut gelaunten Start in den Tag.

Breakfast in the sunshine: green leaves and blades in addition to a purple bouquet of doubled larkspur promise a cheerful launch of the day.

Petit déjeuner au soleil : les feuilles vertes et les brins d'herbe associées à un bouquet de pieds-d'alouette violets donnent le signal de départ pour une journée dans la bonne humeur.

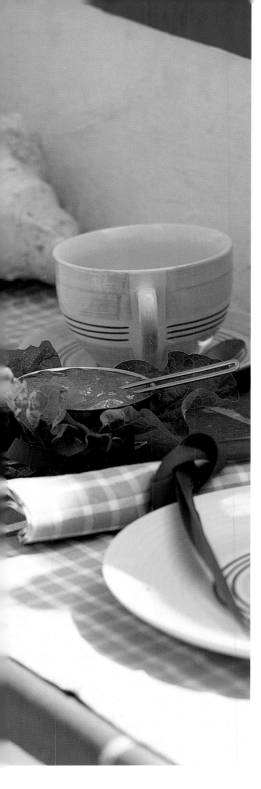
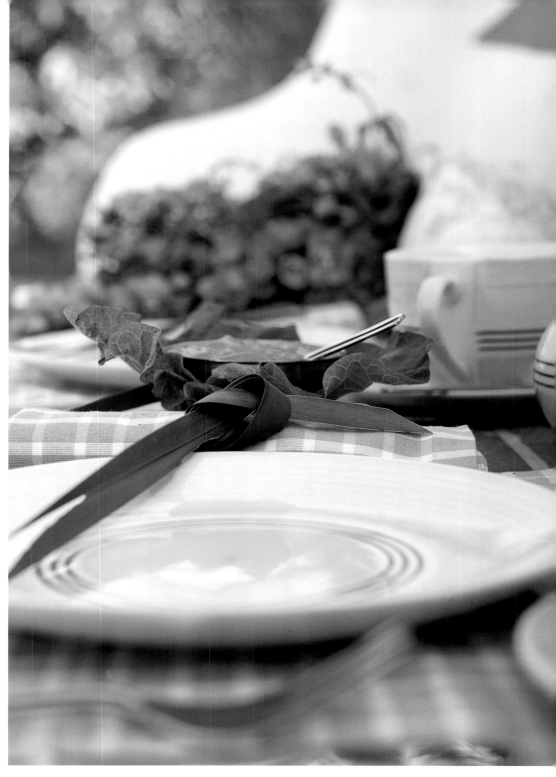

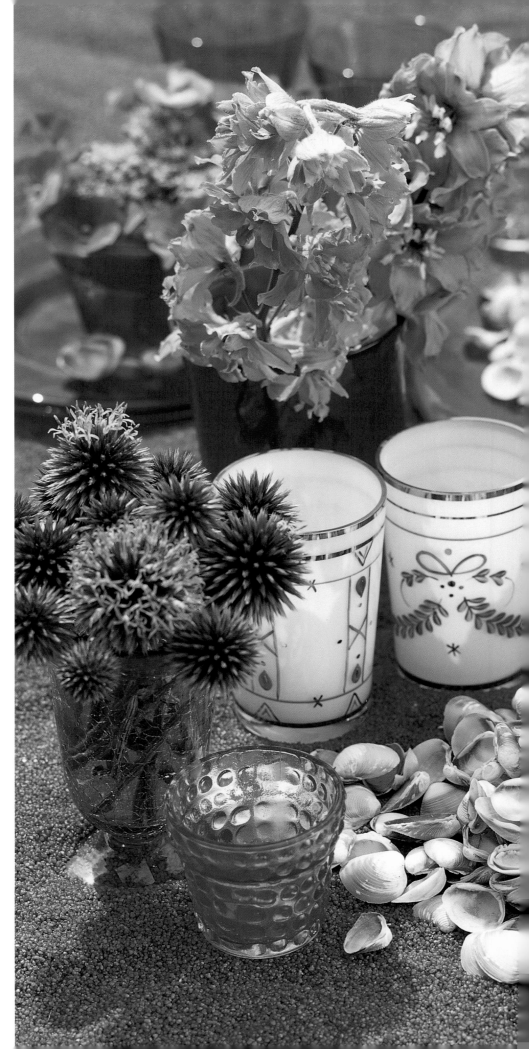

Türkis, Kobaltblau oder Aquamarin: Das Blau von Kugeldistel, Rittersporn, Gartenanemone und Hortensie setzt frische Akzente und sorgt bei 30 Grad im Schatten für optische Kühle.

Turquoise, cobalt blue, or aquamarine: The blue of thistle, larkspur, poppy anemone, and hydrangea sets fresh trends and visually cools the summers heat.

Turquoise, bleu cobalt ou aigue-marine : le bleu du chardon, du pied-d'alouette, de l'anémone des jardins et de l'hortensia donne des accents de fraîcheur et crée une illusion visuelle de rafraîchissement même par 30 degrés à l'ombre.

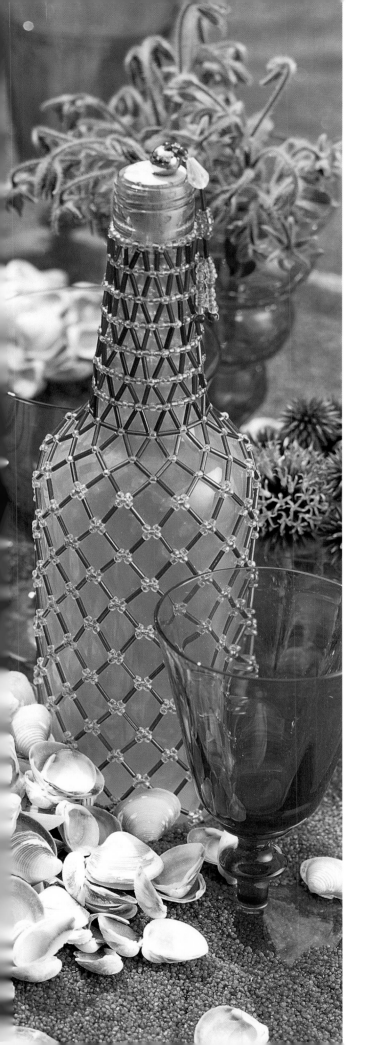

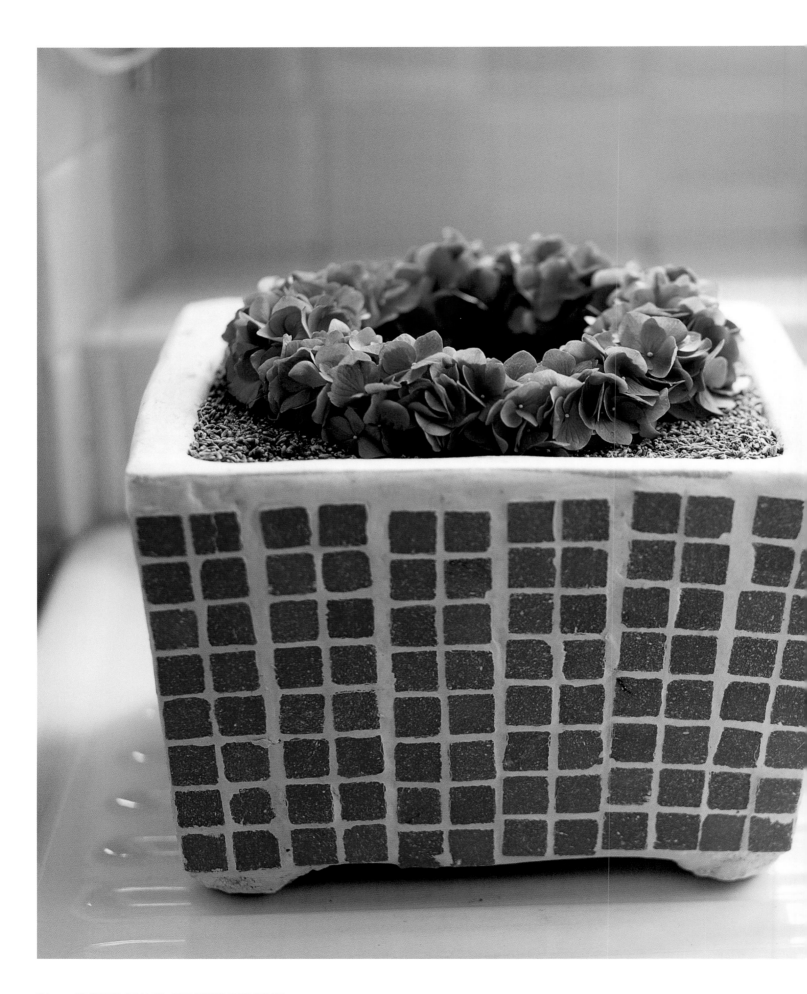

Grafisch schlicht: In einem Gefäß mit himmelblauen Mosaikfliesen ist ein Kranz aus blauvioletten Hortensien-blüten auf Lavendel gebettet.

Graphically simple: A wreath made of bluish-violet hydrangea blossoms is arranged in an azure mosaic pot, filled with lavender.

Simple et graphique : une couronne d'hortensias bleus repose sur de la lavande dans un récipient de mosaïques bleu ciel.

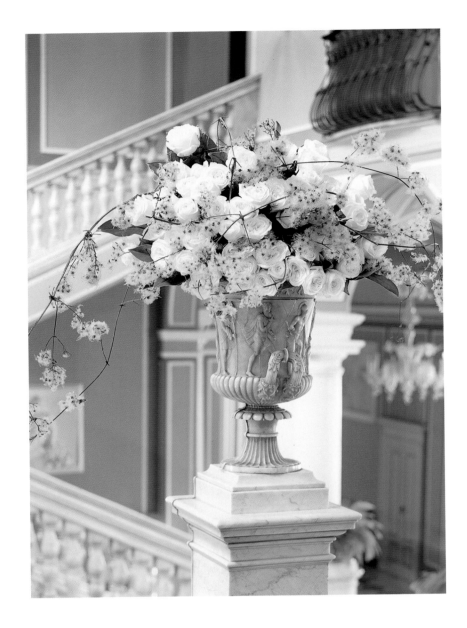

Nostalgie pur: ein Bouquet aus cremefarbenen Freilandrosen und den Fruchtständen der wilden Clematis. Daneben ein Feston aus duftenden Edelrosen und Olivenzweigen auf einem Eisentisch.

Pure nostalgia: a bouquet made of cream-coloured roses and wild clematis' infructescences. Next to it is a composition of fragrant garden roses and olive branches assembled on an iron table.

Nostalgie pure : un bouquet constitué de roses de jardin couleur crème et des infrutescences clématites sauvages. A côté, un feston de branches d'olivier et de roses raffinées très odorantes sur une table en fer forgé.

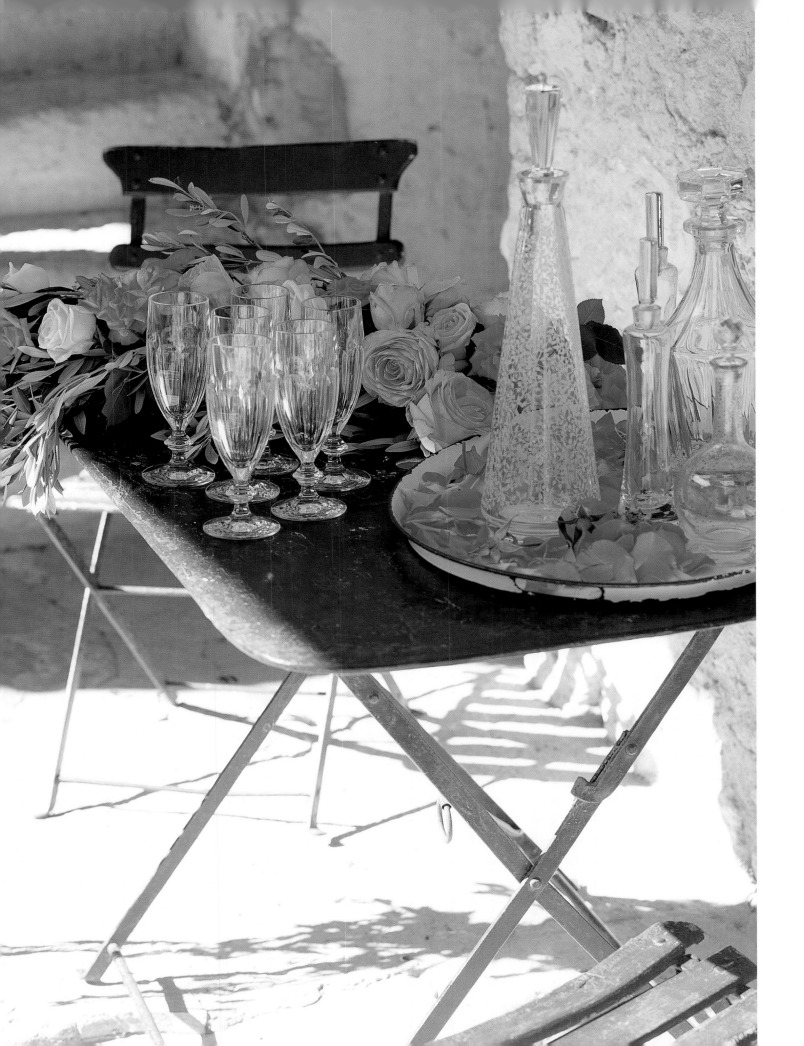

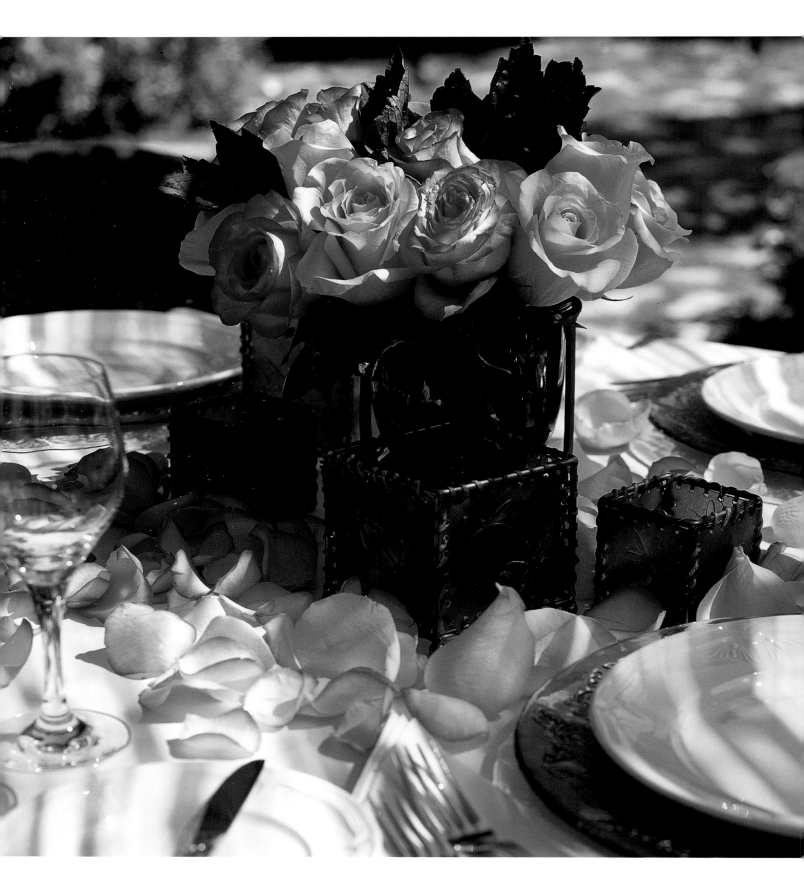

Genuss unter freiem Himmel: Die voll erblühten Edelrosen „Karneval" mit pinkfarbenen Rändern und die rosarote „Susan" passen perfekt zum frischen Grün des Gartens.

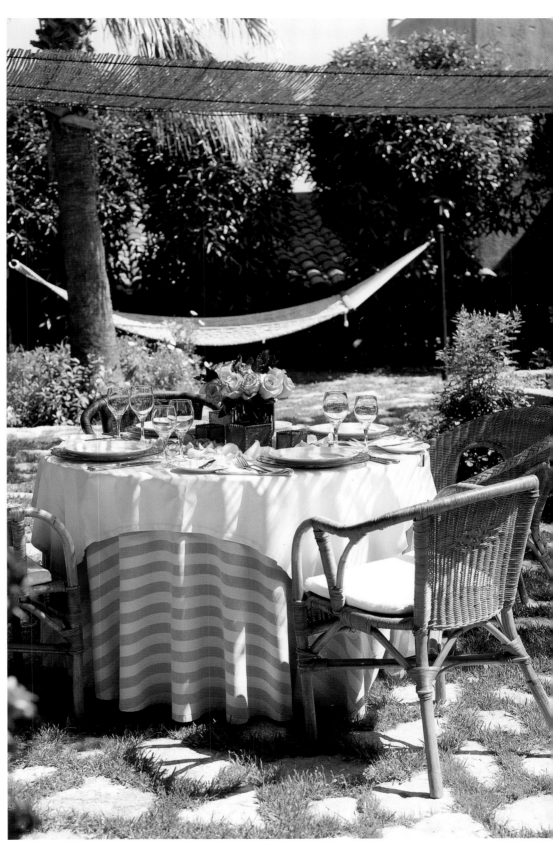

Open-air pleasure: The completely blossomed garden rose "Karneval", with its shocking-pink coloured edges, and the rosy "Susan" perfectly match the garden's bright green.

Plaisir à ciel ouvert : les roses raffinées « Carnaval » épanouies avec leurs bords rose vif et la rose « Susan » s'allient parfaitement au vert frais du jardin.

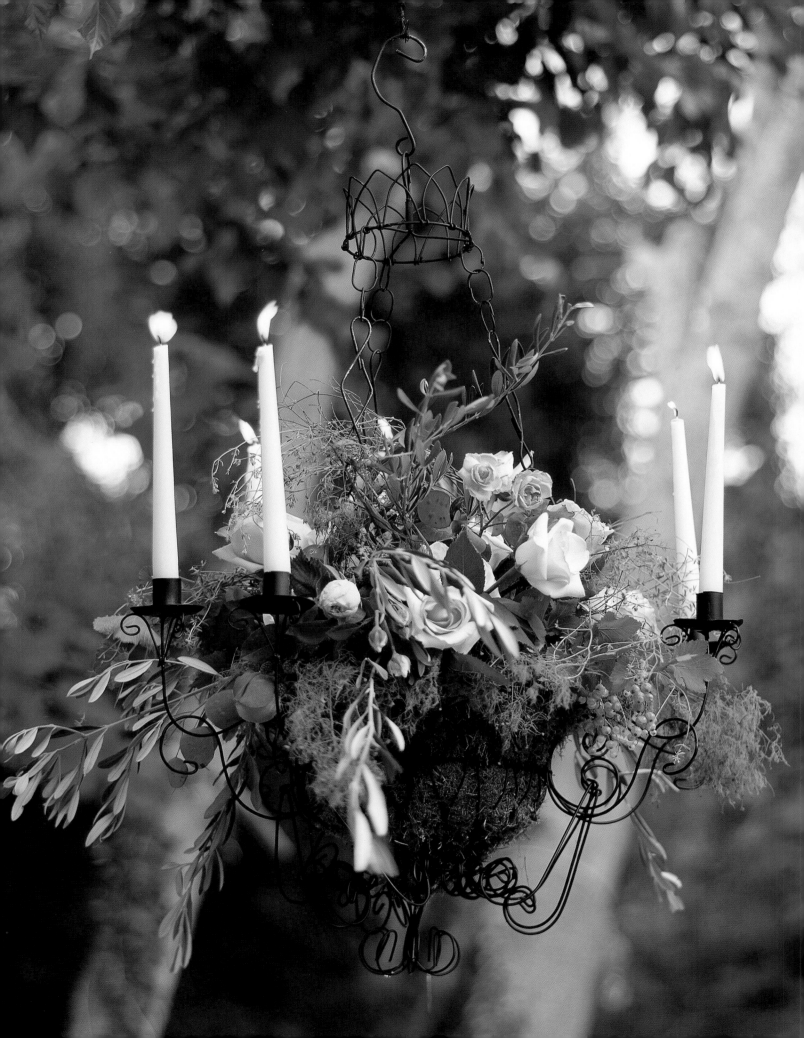

Hoch oben im Baum: Auf weichem Moos präsentiert sich ein lebendiges Bouquet aus Freilandrosen, Olivenzweigen und jungen Fruchtständen von Brombeeren.

Aloft in the trees: Resting on soft moss, a vivid bouquet of roses, olive branches, and early blackberry infructescences presents itself.

Tout en haut dans l'arbre : sur un lit moelleux de mousse, un bouquet vivant de roses sauvages, de branches d'olivier et de jeunes infrutescences de mûres.

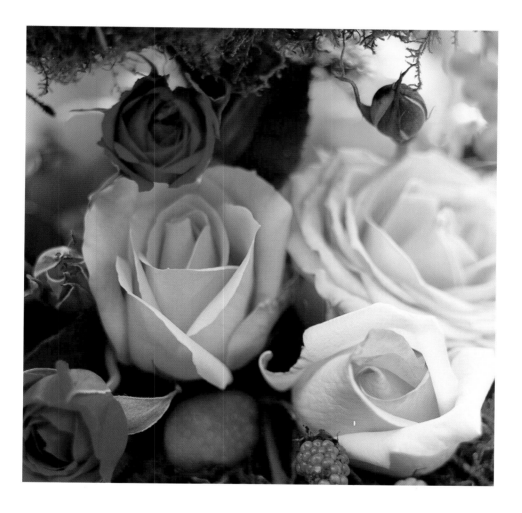

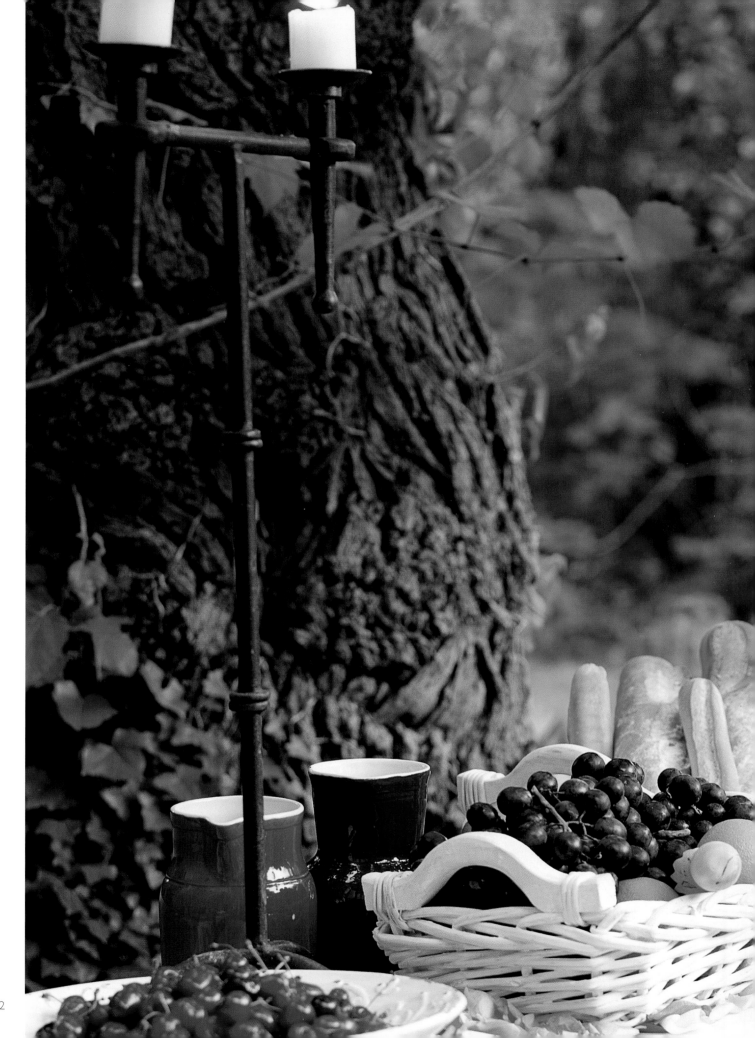

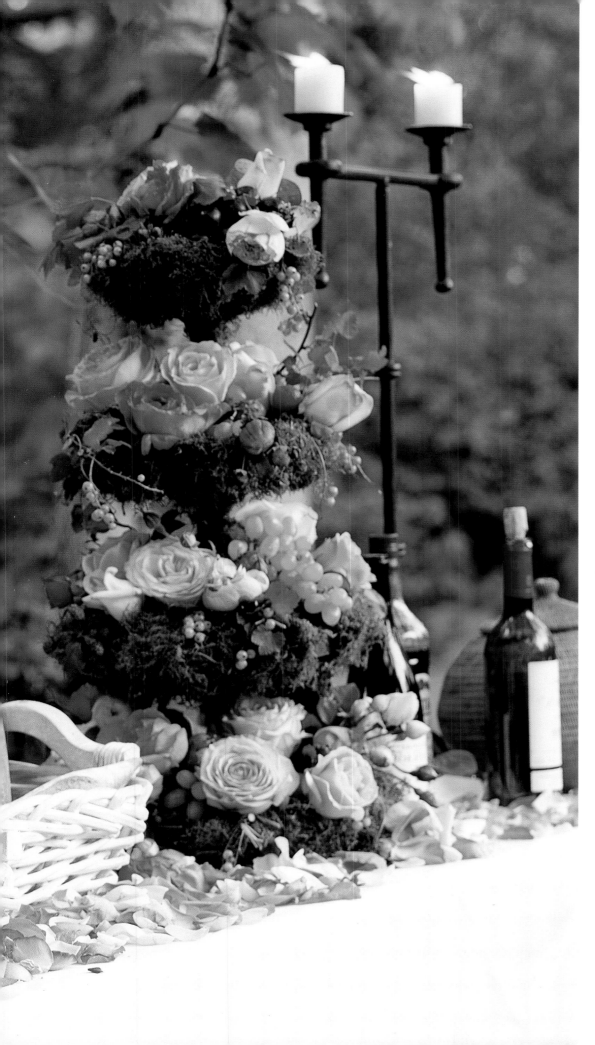

Nichts als Überfluss: Zwischen dem zwanglosen Büfett auf Rosenblättern wächst eine lukullische Etagere in die Höhe — mit Freilandrosen, Weintrauben und grünen Johannis- und Brombeeren.

Absolute opulence: Amongst the informal buffet on rose petals rises an exuberant étagère— brimmed with roses, grapes, green currant and blackberries.

Rien que l'abondance : sur le buffet rustique couvert de pétales de roses s'élève un dressoir qui met l'eau à la bouche, avec l'accumulation des roses de jardin, des grappes de raisin, des groseilles vertes et des mûres.

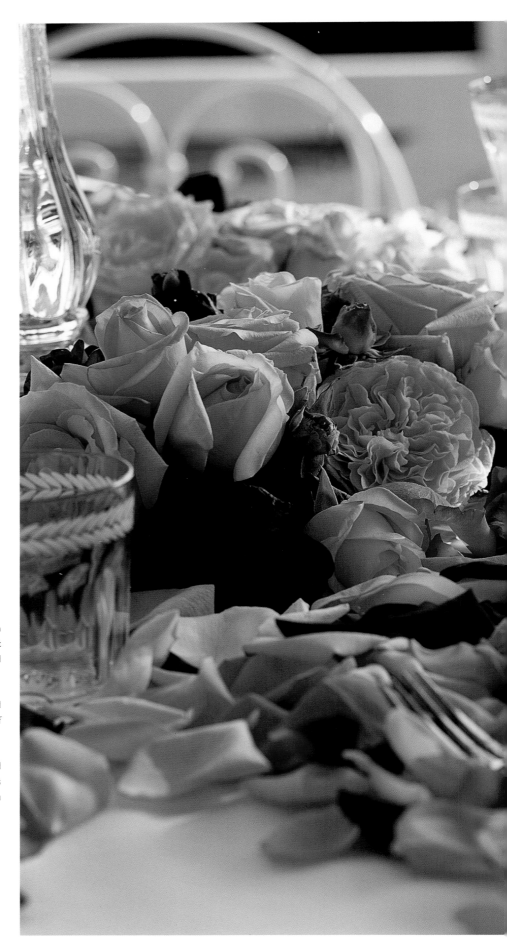

Gebettet auf Rosenblüten: Die Weingläser, deren oberer Rand rosé getönt ist, korrespondieren mit den Farben der englischen Rosen, deren Farbspiel von Gelb bis Violett reicht.

Bed of roses: The wine glasses, with pink coloured edges, harmonise with the English roses, the colours of which range from yellow to violet.

Sur un lit de roses : les verres à vin avec leur bord teinté en rose correspondent aux couleurs des roses anglaises dont le jeu des nuances va du jaune au violet.

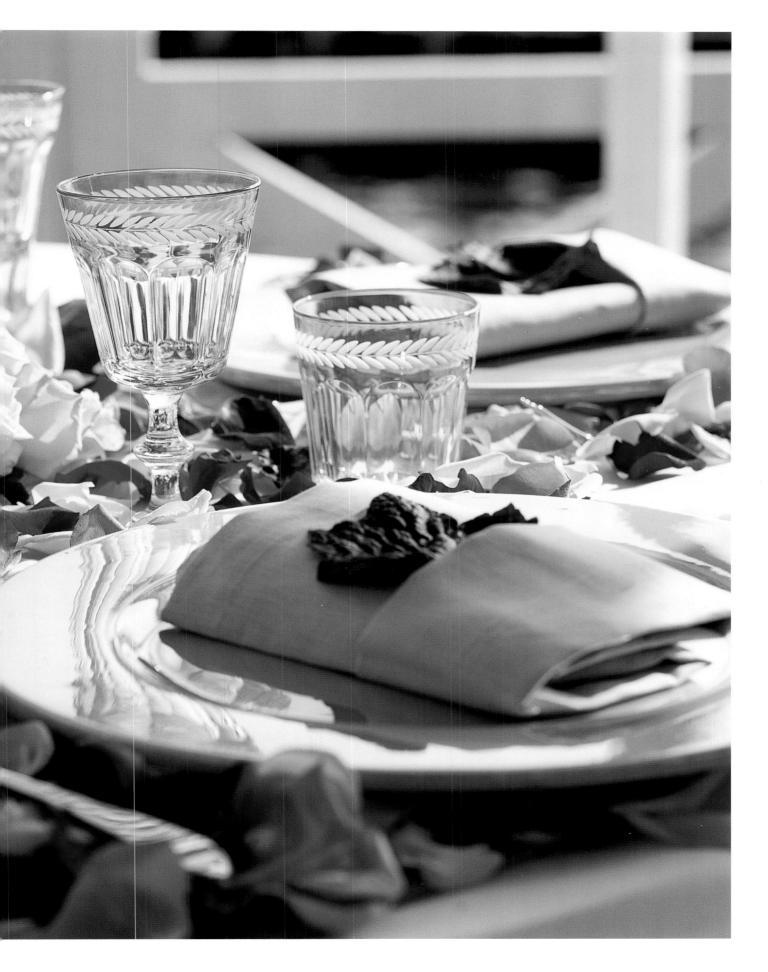

Herbst
Autumn
L'automne

Der Herbst hält Einzug und weiß mit seinen Vorzügen zu glänzen. Jeder Tag breitet eine unglaubliche Farbenvielfalt vor uns aus. Jetzt kommen besonders die Augen auf ihre Kosten und sie werden verwöhnt mit allem, was Gelb, Orange und Rot zu bieten haben.

Buntes Laub und reife Früchte erschaffen stimmungsvolle Bilder. Sie müssen nur aufgehoben und ins Haus getragen werden. Wunderbar leuchtende Kränze lassen sich aus Herbstlaub binden oder prächtige Sträuße, die die Räume dominieren und alle Blicke auf sich ziehen. Tiefrote Astern, bronzefarbene Kaktusdahlien, geflammte Ahornblätter und leuchtende Hagebutten glänzen. Und als Symbol der Wärme ziehen leuchtend gelbe und rotbraune Sonnenblumen ein.

„Verweile doch, du bist so schön", so möchte man dem Augenblick Ewigkeit verleihen. Der Herbst ist einfach göttlich.

Autumn makes its appearance and knows how to show off its advantages. Every day displays an incredible variety of colours. This is a special time for the eyes; they are blessed with everything yellow, orange and red can offer.

Coloured leaves and ripe fruits create impressive images. They only need to be picked up and carried into the house. The autumn leaves can be transformed into wonderful, bright wreaths or sumptuous bouquets, which dominate every room and attract everyone's attention. Deep red asters, bronze cactus dahlias, flame-like maple leaves, and bright rose hips shine. Bright yellow and red-brown sunflowers, are added as a symbol of warmth.

"Please stay, you are so beautiful!" One wants to preserve such moments for all eternity. Autumn is simply divine.

L'automne fait son entrée et sait jouer des ses atouts pour briller. Chaque jour nous fait le cadeau d'une extraordinaire variété de couleurs. Ce sont surtout nos yeux qui sont comblées – tout ce que le jaune, l'orange et le rouge peuvent déployer de charmes vient les flatter.

Feuilles aux couleurs vives et fruits mûrs créent des tableaux pleins de charme. Il ne reste qu'à décrocher ces derniers et les introduire dans la maison. On peut tresser avec ces feuilles de magnifiques couronnes aux couleurs éclatantes ou composer de somptueux bouquets qui s'imposent dans les pièces et attirent tous les regards. Asters rouge foncé, dahlias cactus couleur de bronze, feuilles d'érable en flammes et fruits de l'églantier, ils resplendissent tous. Les tournesols d'un jaune et d'un rouge éclatants s'introduisent dans la maison comme des symboles de chaleur.

« Arrête-toi, tu es si beau ». On voudrait tellement suspendre le cours du temps. L'automne est tout simplement divin.

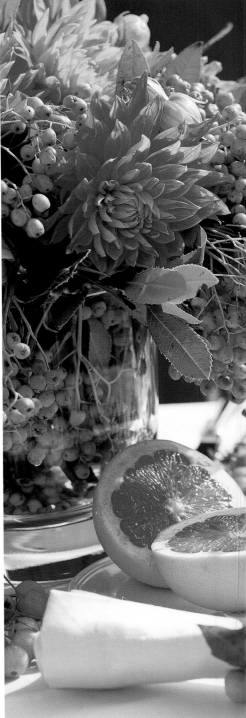

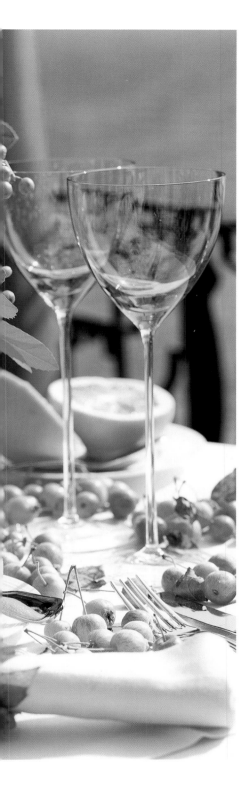

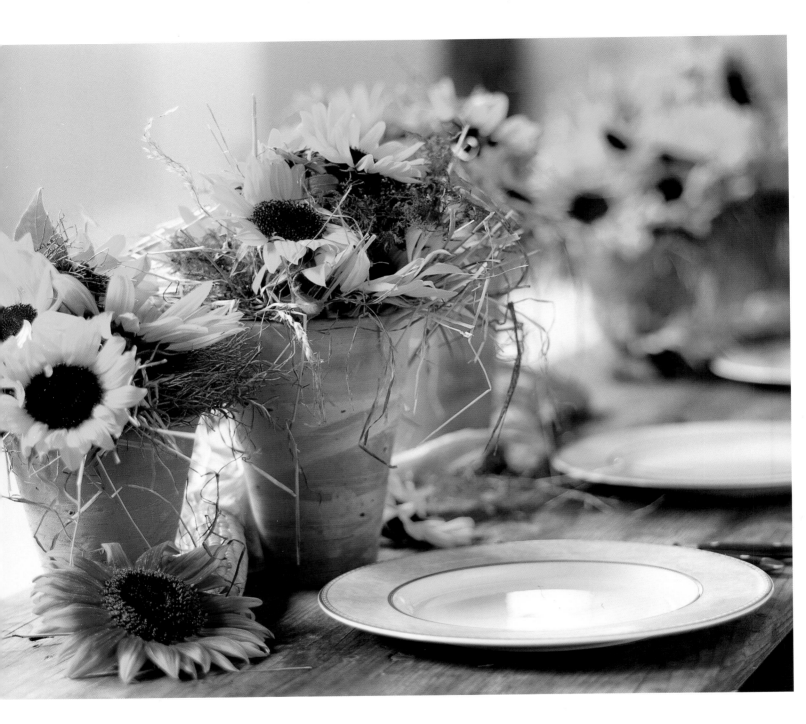

Späte Sonnenblumen lassen die Sommersonne noch einmal aufglühen. Gelbe und rötliche Sorten sind in kleinen Terrakottatöpfen zusammen mit Heu dekoriert.

Late sunflowers let the summer sun rise once more. Yellow and colourfully red kinds, decorated with hay, are arranged in small terracotta pots.

Ces tournesols tardifs sont un dernier rappel du soleil de l'été. Des variétés jaunes et rouges sont décorées avec du foin dans des petits pots en terre cuite.

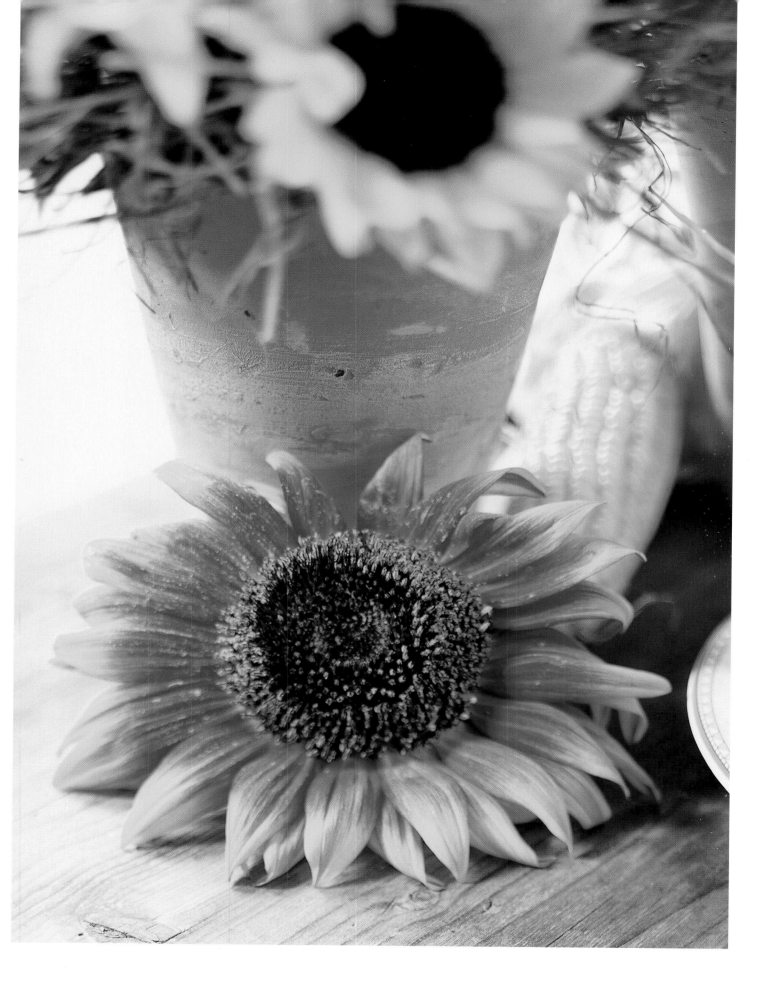

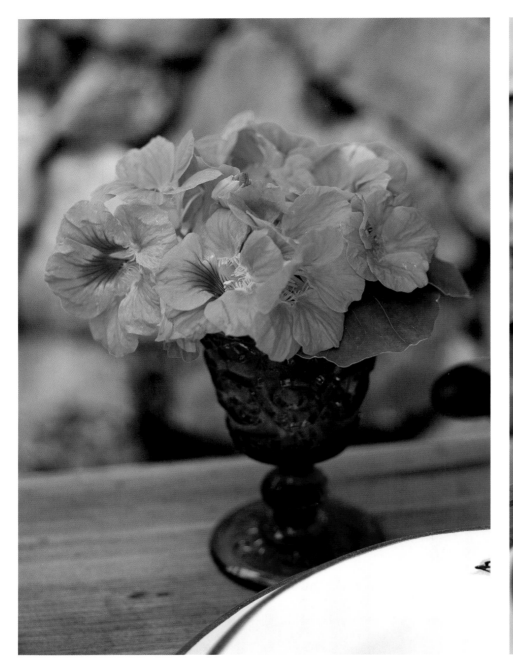

Die Blüten der Ringelblume und Kapuzinerkresse in leuchtendem Gelb und Orange verführen bei Tisch nicht nur mit ihren optischen Reizen, sie sind auch besonders schmackhaft.

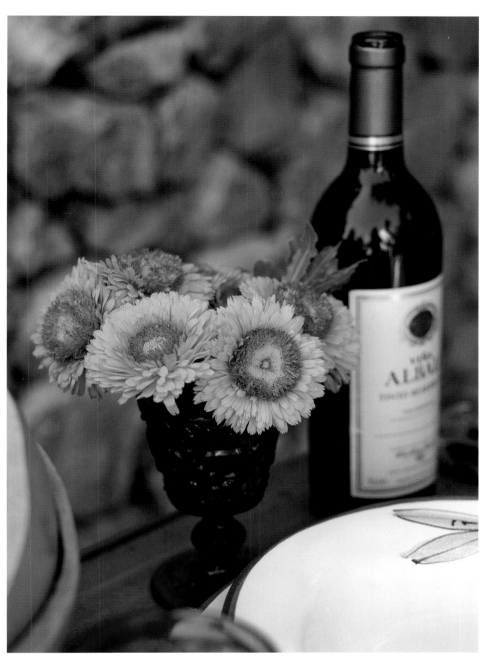

The bright yellow and orange blossoms of marigold and nasturtium, not only seduce with their visual attractiveness, but are also especially tasty.

Les fleurs des soucis et des capucines orange et jaune vif séduisent à table non seulement les yeux mais aussi les papilles.

Mit den warmen Farbtönen des Spätsommers hält der Herbst seinen Einzug: Ganz dicht wurden die Blüten des Sonnenhuts zu einer Pyramide gebunden, umgeben von Stroh und zartvioletten Drachenbaumblättern.

Along with late summer's warm colours the autumn makes its appearance: densely packed the cone flower blossoms are modelled into a pyramid, surrounded by straw and pale violet dragon tree leaves.

L'automne fait son entrée avec les ton chaudes de l'été tardif : les fleurs d'échinacée, étroitement tressées, ont été fixées à une pyramide et sont entourées de paille et de feuilles de dragonnier d'un violet tendre.

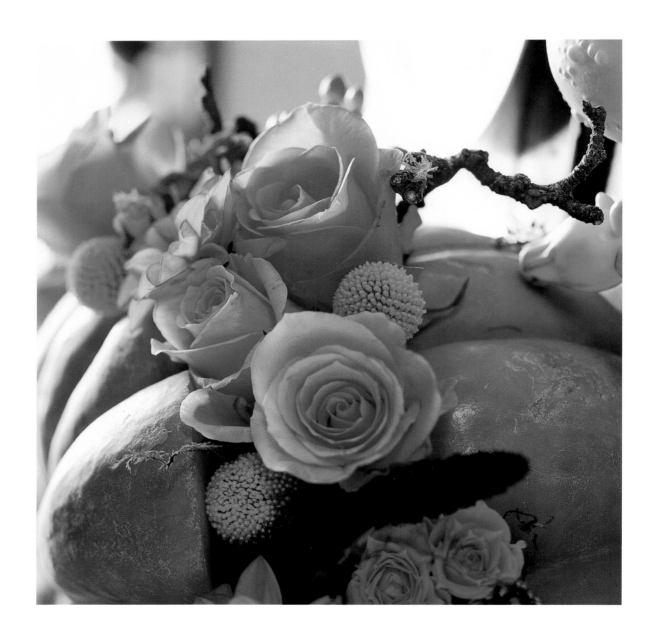

Pralle Freilandrosen: einmal kombiniert mit halbgefüllten Dahlien und den runden Blüten der gelben Kugelschafgarbe im Inneren eines Muskatkürbisses, einmal als Nest für Pfirsiche und Nektarinen.

Turgid roses: first arranged within a butternut squash, together with semidoubled dahlias and yellow yarrow's round blossoms, then serving as a nest for peaches and nectarines.

Roses de jardin bien pommelées : associées à des dahlias et aux fleurs rondes d'achillée jaune dans une courge muscade ou bien en nid pour pêches et nectarines.

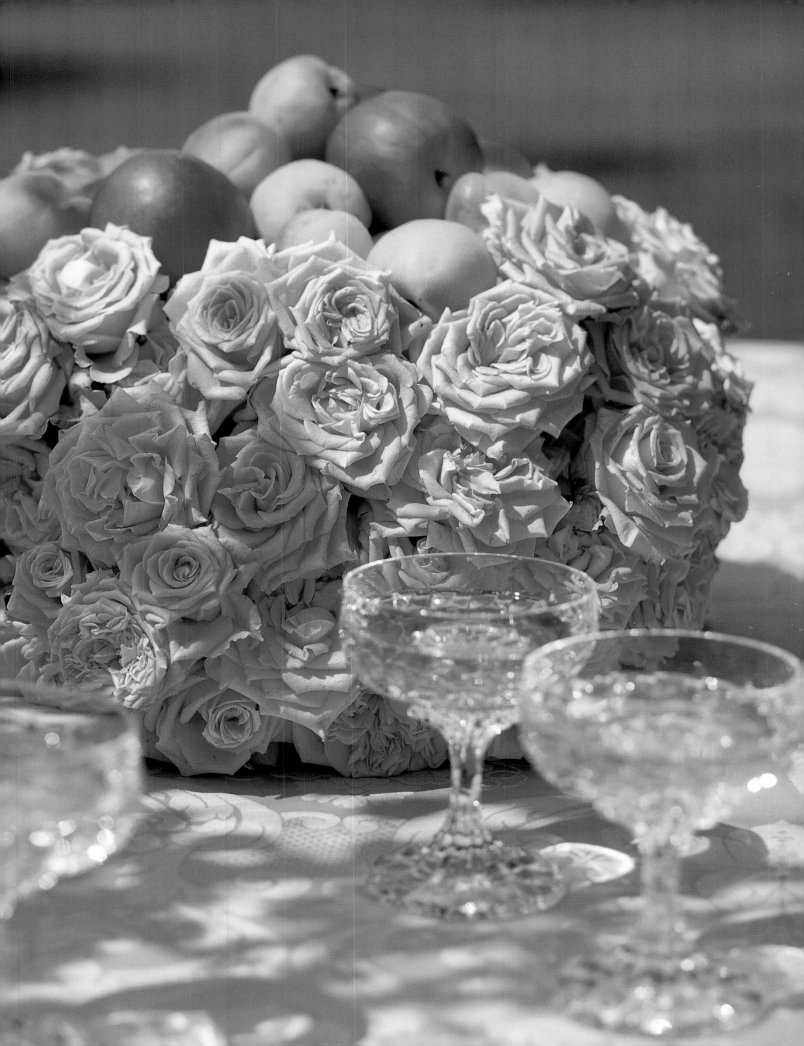

Herbstbouquet von Lila bis Gelb: In Weidenkörbchen stehen Mignondahlien, Gartenhortensien, Fruchtstände der Skimmien, Bronzeblätter und Weintrauben.

Autumnal bouquet ranging from purple to yellow: Mignon dahlias, hydrangeas, Japanese skimmia infructescences, galax leaves, and grapes are placed in wicker baskets.

Bouquet automnal dans une palette allant du lilas au jaune : dans des paniers en osier, dahlias mignons, hortensias de jardin, fruits de skimmias, feuilles de galax et raisins.

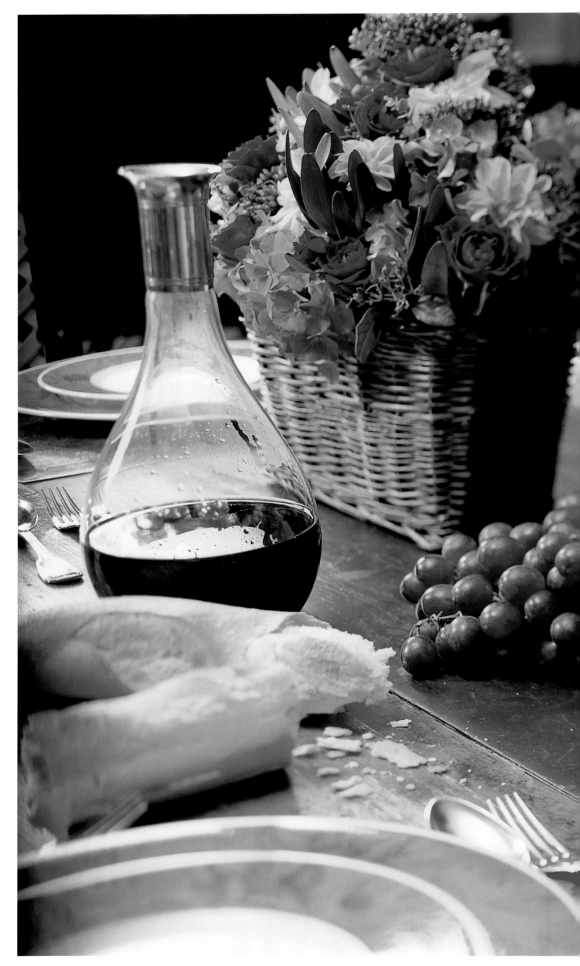

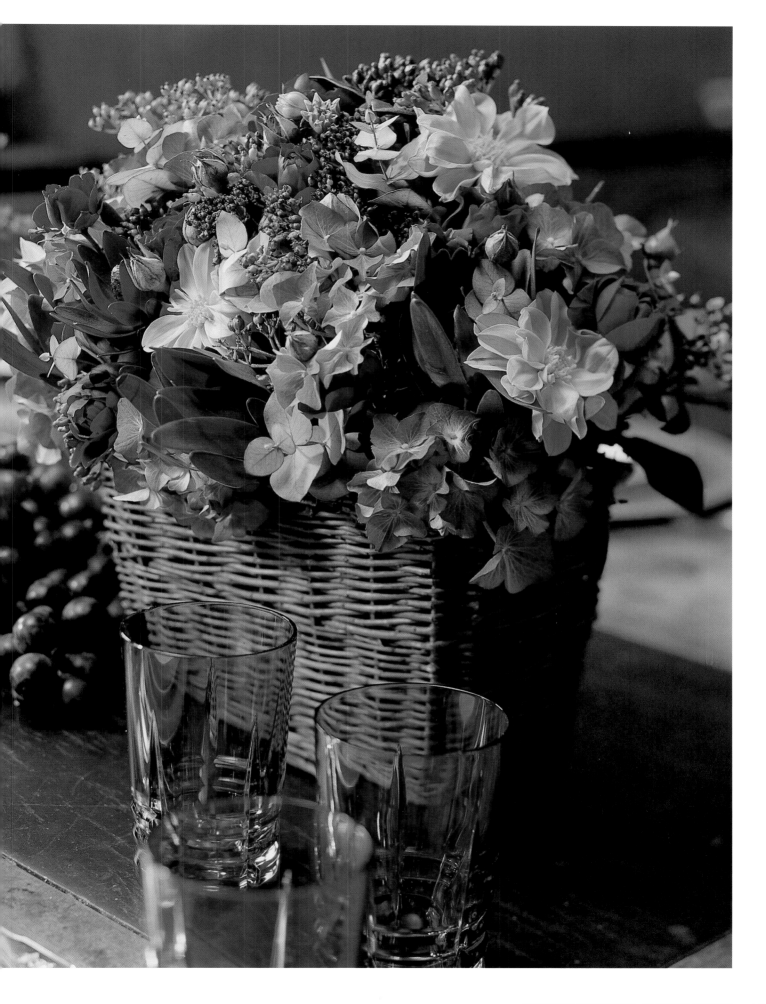

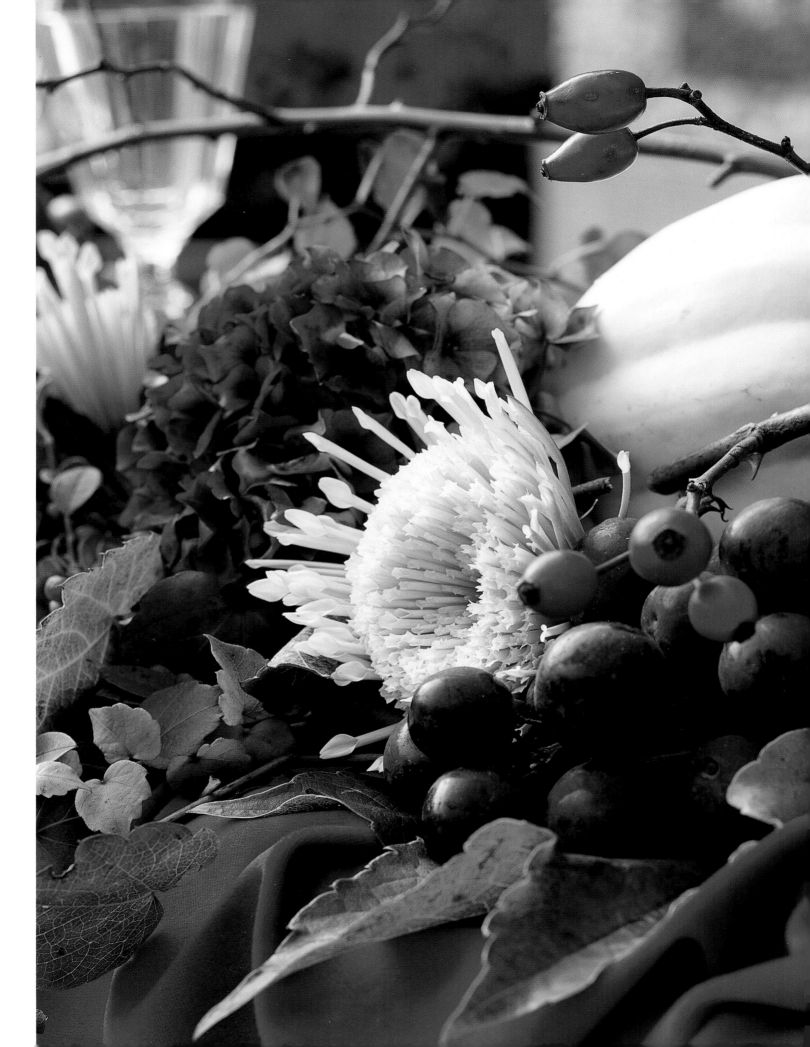

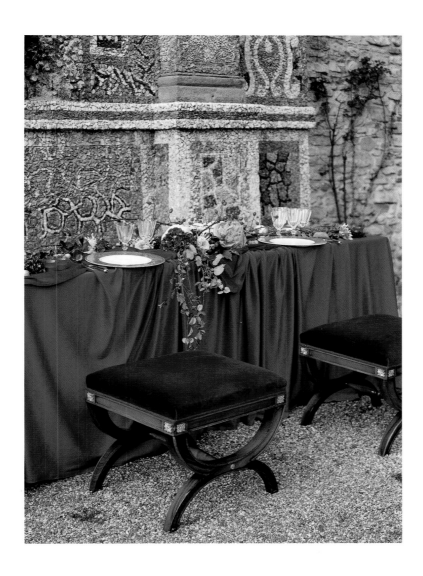

Ein göttliches Bouquet aus Hortensienblüten, Chrysanthemen, Ranken aus wildem Wein, Romanesco, Zierkürbis, blauen Trauben und feurigen Hagebutten.

A divine bouquet of hydrangea blossoms, chrysanthemums, wild wine tendrils, romanesco, ornamental gourd, blue grapes, and fiery rose hips.

Un bouquet divin composé de fleurs d'hortensia, de chrysanthèmes, de sarments de vignes sauvages, de romanesco, d'une citrouille, de raisins noirs et de fruits d'églantier flamboyants.

Gelbe Zieräpfel leuchten über dem Früchtekorb mit getrockneten Maiskolben, Moos und duftenden Eukalyptuszweigen. Draußen fangen gelborange Herbstastern, Kalebassen und Schalottenringe die Sonne ein.

Yellow ornamental apples shine above a fruit basket containing corn cobs, moss, and fragrant eucalyptus twigs. Outside yellow-orange Michaelmas daisies, gourds, and shallot wreaths try to capture the sun.

Des pommes décoratives brillent sur la corbeille de fruits avec le maïs seché, la mousse et les branches d'eucalyptus odorantes. A l'extérieur, des asters d'automne jaunes orange, des calebasses et des échalotes captent les rayons du soleil.

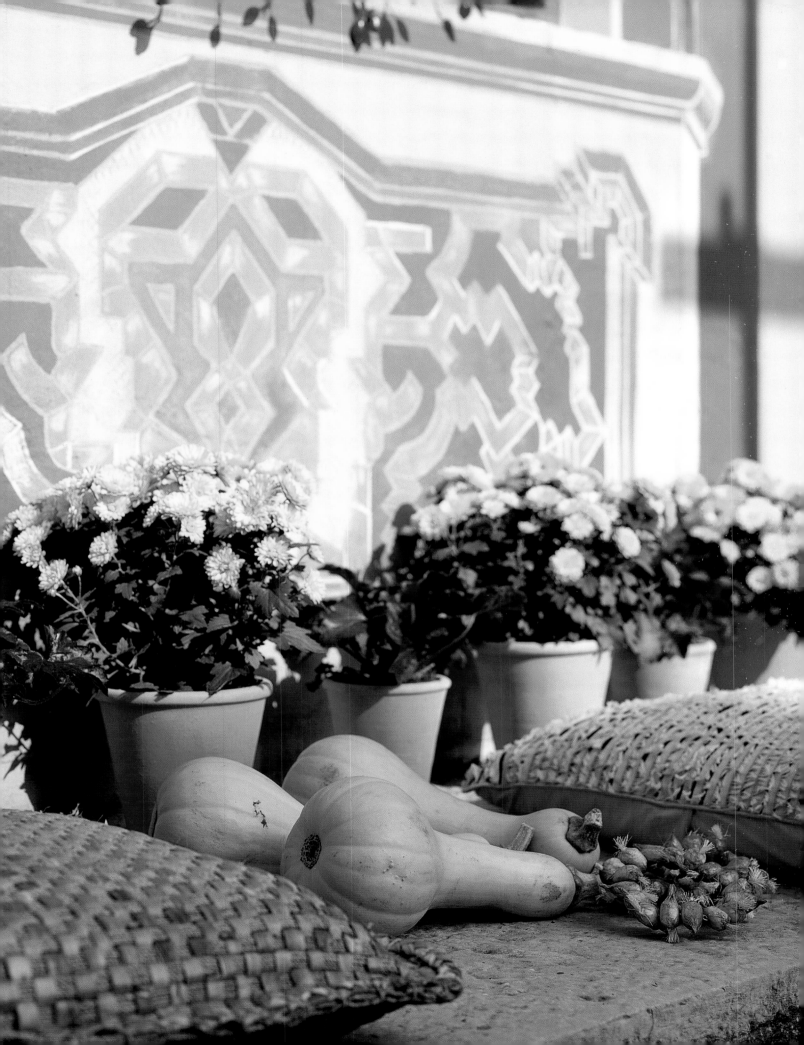

Filigran wirken die kleinen Glockenblüten der Herbstheide nicht nur vor dem weißen Zierkürbis, sondern auch gebunden als großes Rund. Klassisch mutet dagegen ein Kranz aus rotem Herbstlaub an.

Autumn heather's filigree bell-blossoms are accentuated in front of the white ornamental gourd, as well as arranged into a huge wheel. In contrast, the wreath made of red leaves radiates a more classic charm.

Les clochettes de la bruyère d'automne nous donnent à voir leur beauté délicate non seulement devant la citrouille blanche, mais aussi tressées en un large cercle. Bien classique en revanche : la couronne de feuilles d'automne rouges.

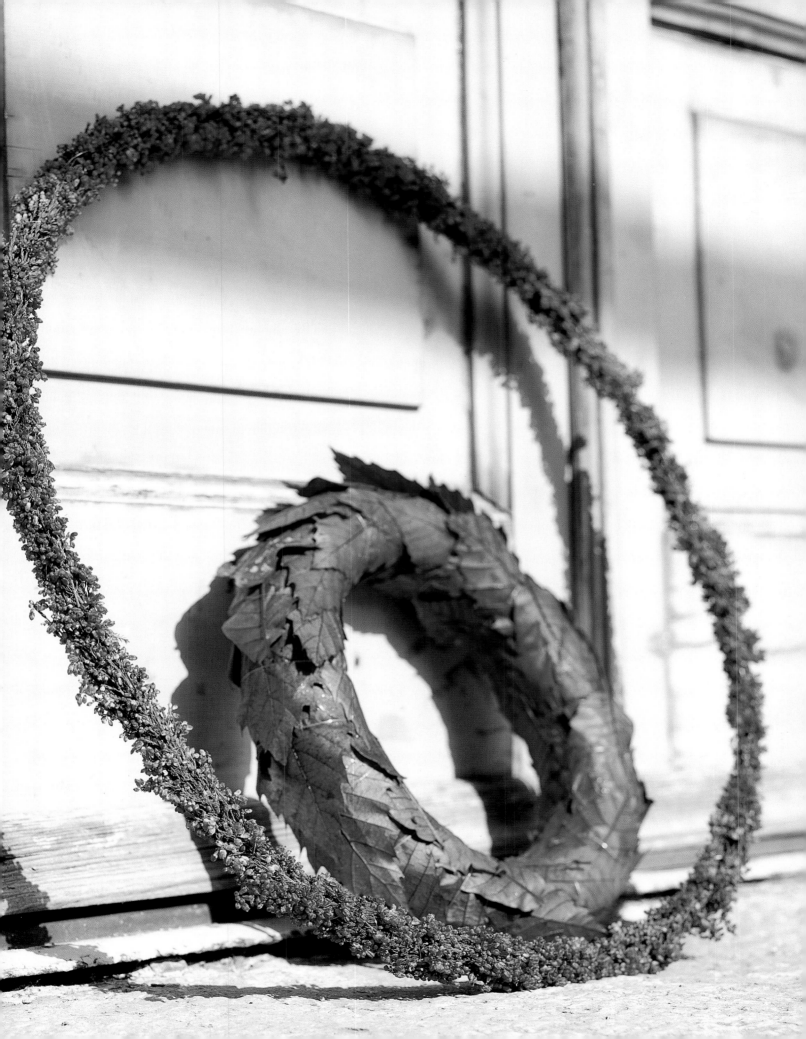

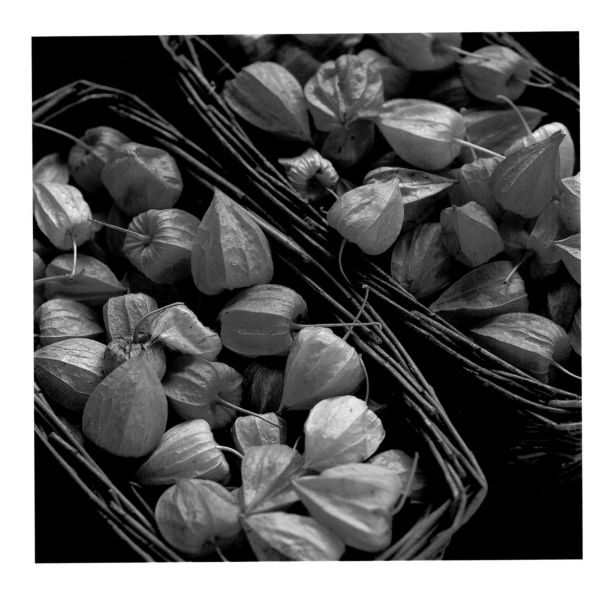

Furioses Flammenmeer: Die unerreichte Intensität an Tönen spiegelt dieser Kranz wider. In dunklem Orange glühen die Fruchtstände der Lampionblumen.

Furious sea of flames: This wreath mirrors the unprecedented intensity of hues. The Chinese lantern plants' infructescences glow in dark orange.

Une mer de flammes impressionnante : cette couronne offre une intensité de couleurs sans égal. Les infrutescences de physalis portent l'orange à l'incandescence.

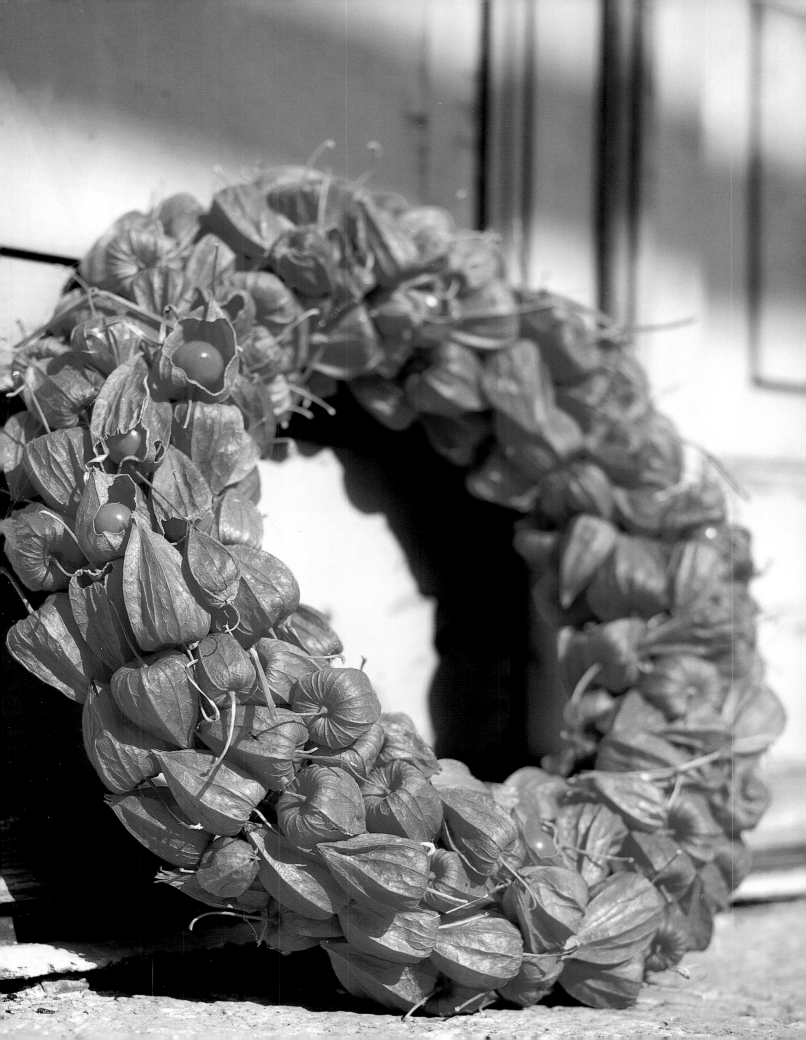

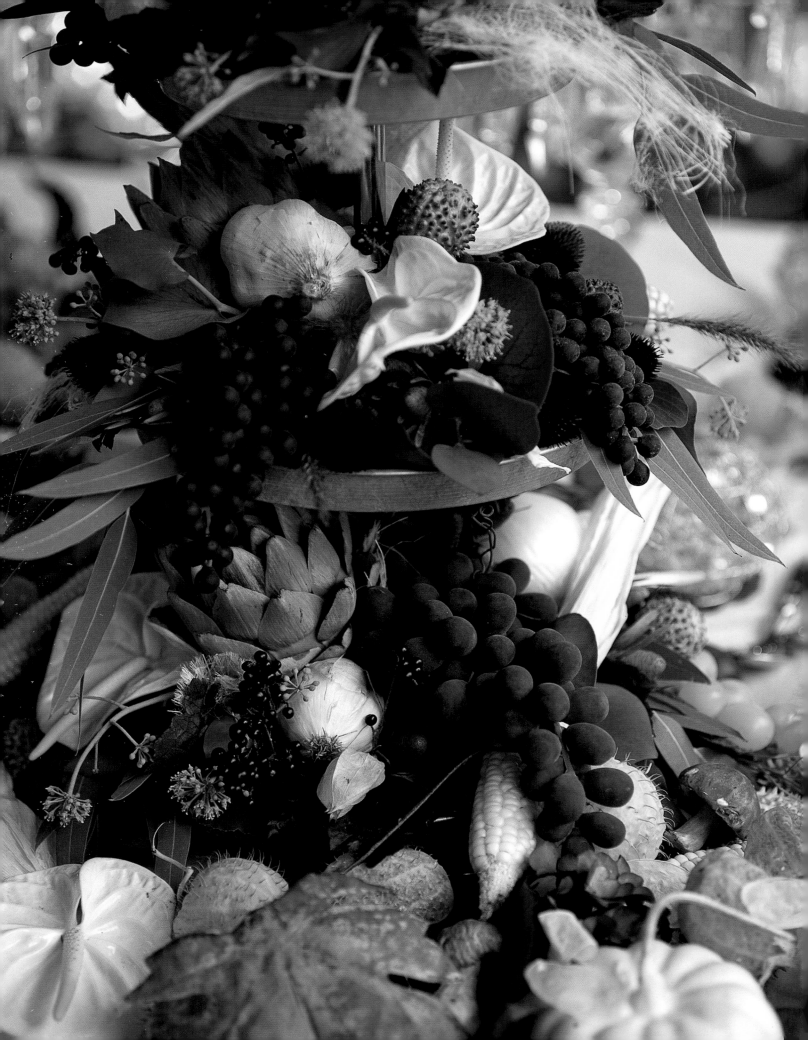

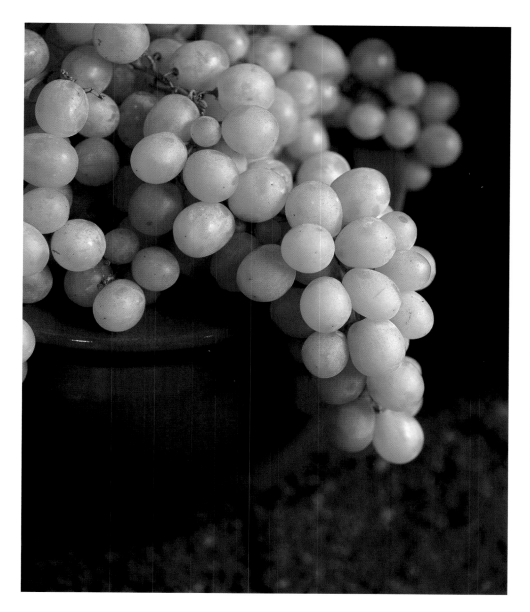

Ein herbstliches Stillleben entfaltet sich auf Etagere und Tisch. Mit dabei: Weiße Anthurien, Herbstlaub, silberblättriges Greiskraut, gelbgrüne Efeublüten und Cosmeenfruchtstände.

An autumnal still life unfolds upon étagère and table. Amongst others: white anthurium, autumn leaves, silver leaved groundsel, yellow-green ivy blossoms, and cosmos infructescences.

Nature morte d'automne sur table et dressoir avec des anthuries blanches, des feuilles d'automne, du séneçon argenté, des fleurs de lierre jaune-vert et des jeunes infrutescences de cosmos.

Die flachen Vasen mit tiefvioletten Vandaorchideen sind ideal als Tischdekoration.

The shallow vases with dark violet Vanda orchids are an ideal table decoration.

Les vases bas avec des orchidées Vanda d'un violet intense sont un centre de table idéal.

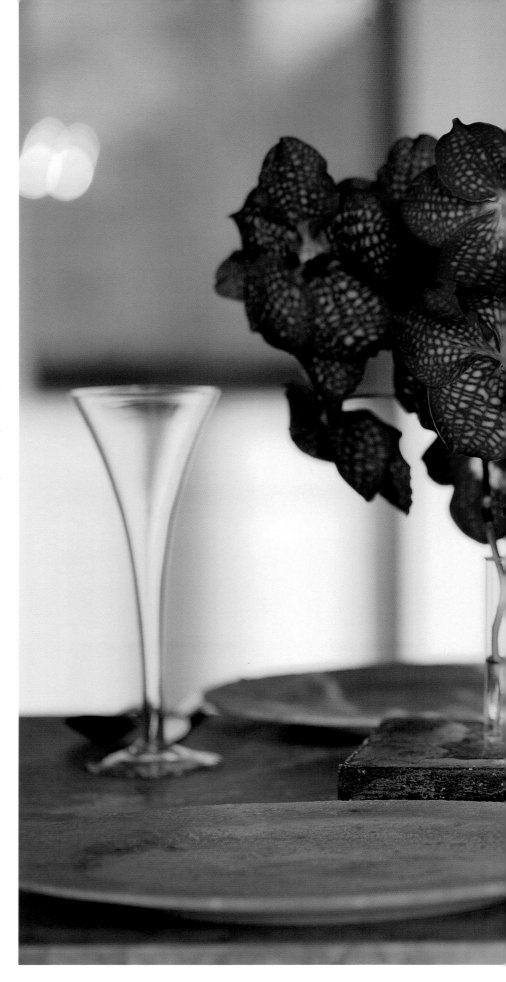

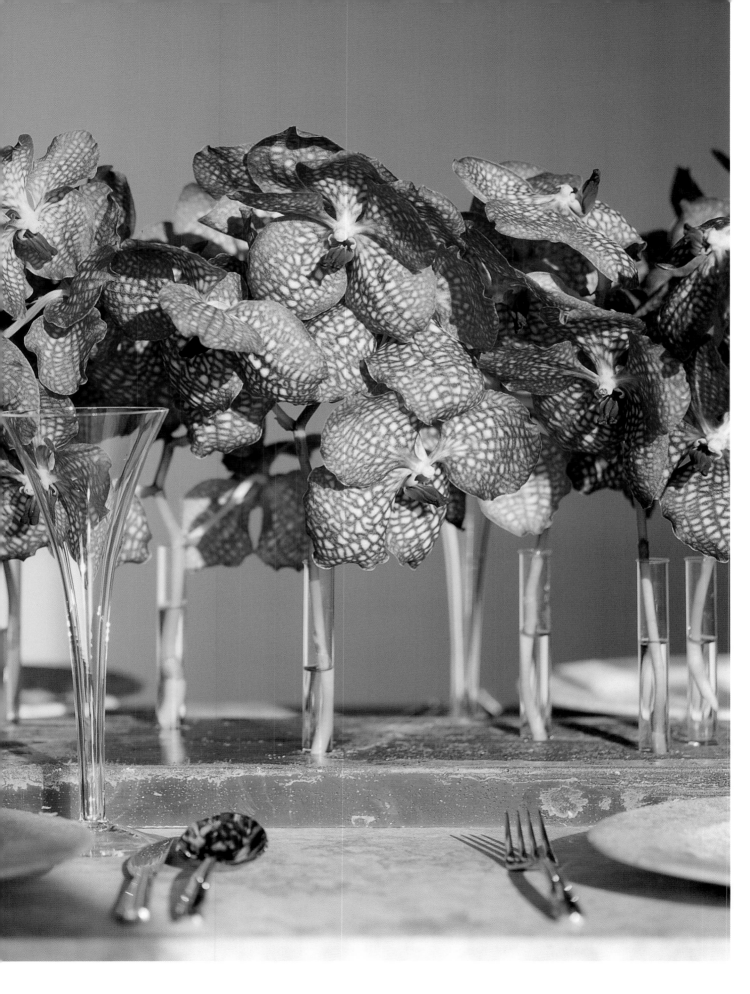

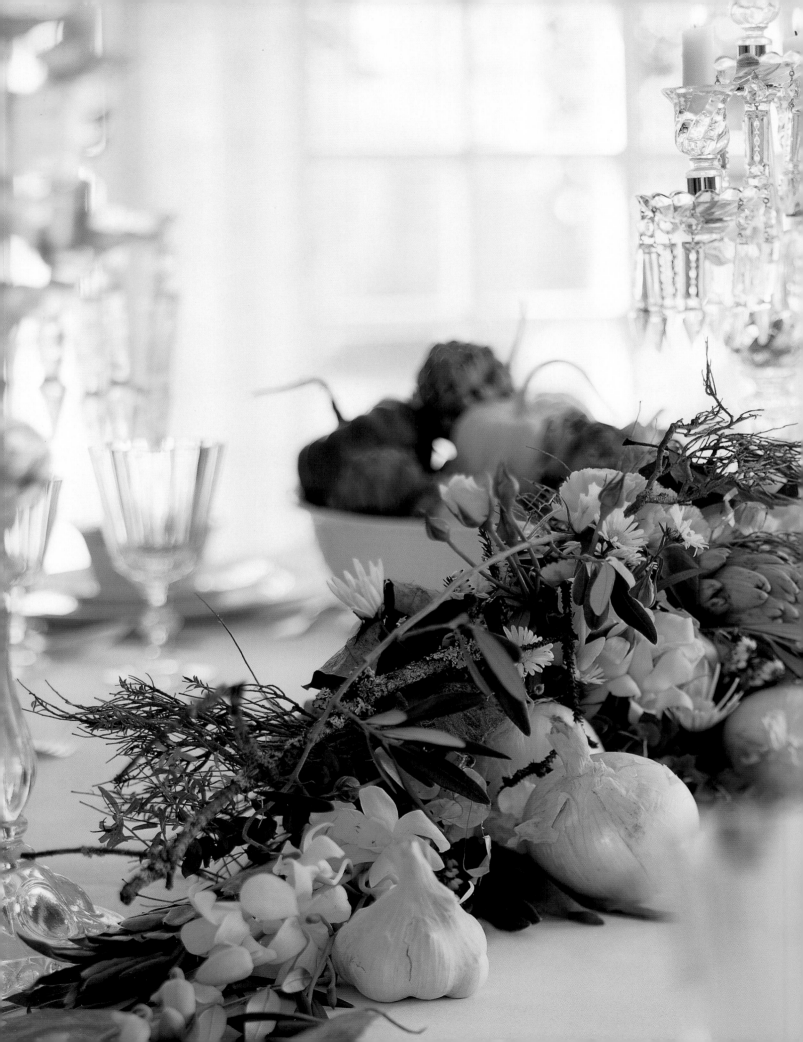

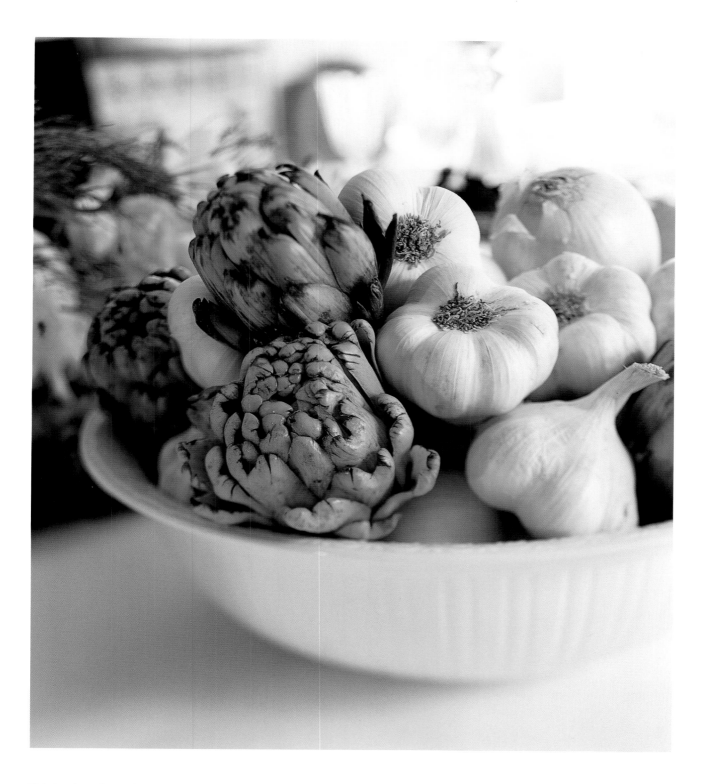

Einfach schön, dieses Gemüse: Artischocken im silbrig grünen Zusammenspiel mit Knoblauch und Olivenzweigen. Dazu gesellen sich weiße Spinnenchrysanthemen, grüne Edelnelken und weiße Polyantharosen.

These vegetables are simply beautiful: A silvery green interplay of artichokes, garlic, and olive branches. They are joined by chrysanthemum, green carnations, and white polyantha roses.

Tout simplement beaux, ces légumes : des artichauts vert argenté jouent avec l'ail et les branches d'olivier. Des chrysanthèmes blancs, de verts œillets précieux et des polyantharoses blancs se sont joints à eux.

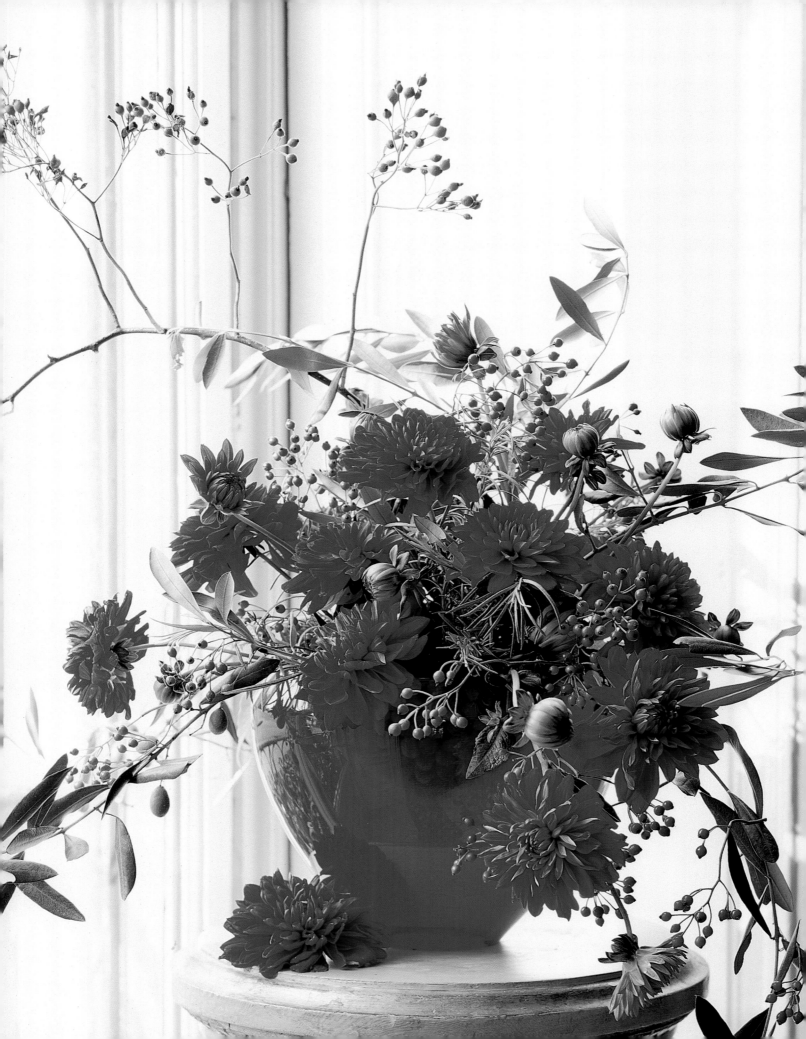

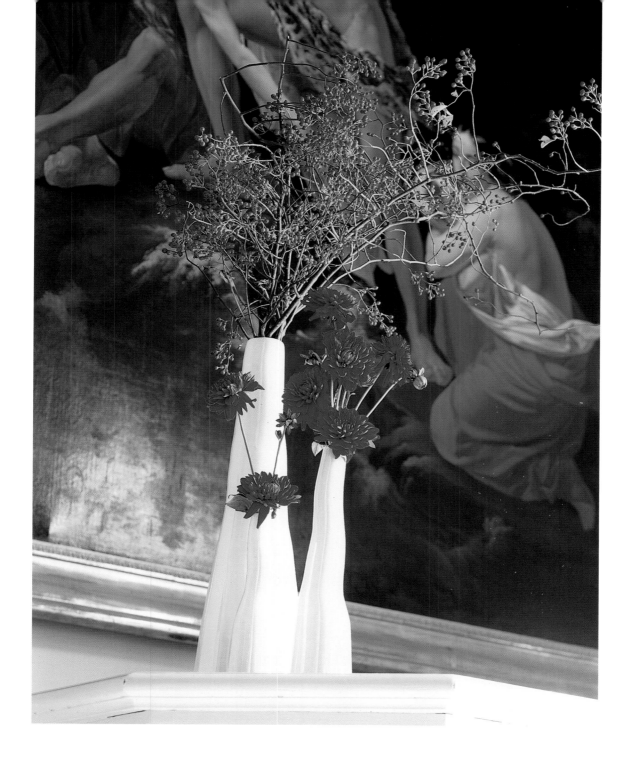

Karmesinrote Pampondahlien und Heckenrosen, die die Farbkraft reifer Hagebutten präsentieren, stehen im Kontrast zu den silbrig grünen Zweigen der Oliven.

Crimson coloured pompon dahlias and dog roses, which have the colour intensity of ripe rose hips, are contrasted with silvery green olive branches.

Des dahlias pompon rouge carmin et des roses des haies font ressortir l'éclat des fruits d'églantier dans leur maturité et contrastent avec les branches vert argenté de l'olivier.

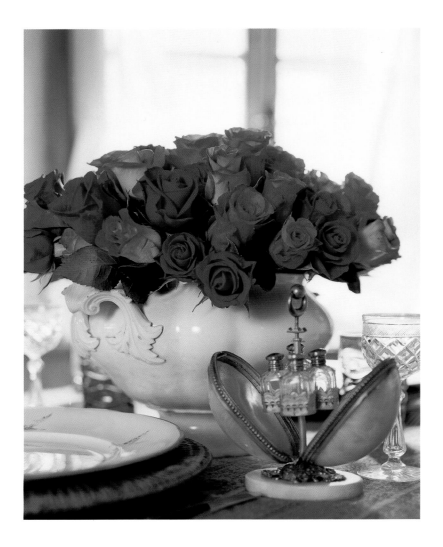

Rote Kontrapunkte: Zwischen Hirschgeweih und Fasanenkleid setzen Anemonen, Nelken und Ranunkeln frische Akzente, zwischen Perlmutt, Kristall und Porzellan bilden klassische Rosen ein Gegengewicht.

Red contrasts: Between the stag antler and pheasant feathers, anemones, carnations, and buttercups set new trends, between mother-of-pearl, crystal and china, classic roses act as a counterbalance.

Contrepoint rouge : entre les bois du cerf et les plumes de faisan, des anémones, des œillets et des renoncules apportent une note de fraîcheur – parmi la nacre, le cristal et la porcelaine, les roses classiques jouent les contrastes.

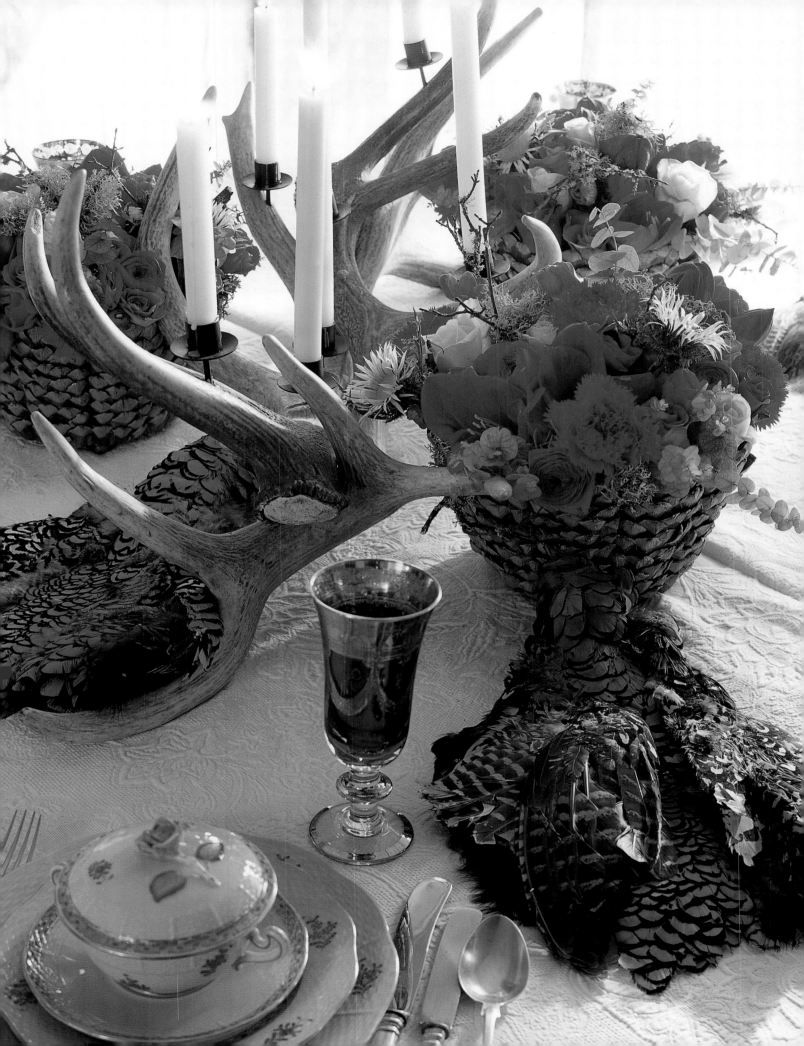

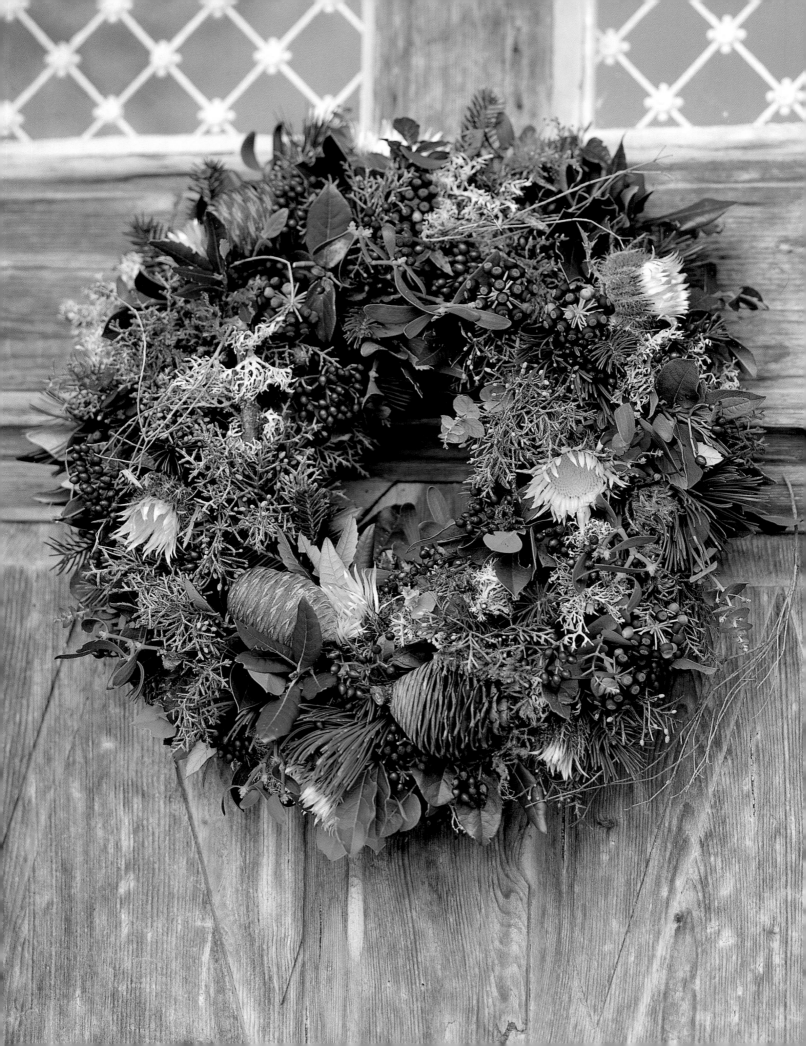

Winter

Winter
L'hiver

Der Herbst ist zum Sehen und der Winter zum Hören da. Die Zeit der Besinnung und Stille steht bevor. Aber die leisen Töne der dunklen Jahreszeit vernimmt nur, wer seine Augen auf das Schöne richtet.

Advent und Weihnachten bestechen durch schlichte und klassische Dekorationen. Orchideen verschiedener Arten und Rosen in all ihrer Vielfalt sind auf den festlich geschmückten Tischen zu entdecken. Umspielt von den Farben des Eises kommen die korallenrot lackierten Zweige des Ginkgobaums besonders gut zur Geltung. Unterstrichen wird die Kühle der Jahreszeit noch durch die rein weiße Farbe der Christrose. Eine sinnliche Atmosphäre dagegen entsteht mit tiefroten Rosen, die um Kerzen drapiert werden. Und dann endlich ist es soweit – der üppig geschmückte Weihnachtsbaum lässt die Augen der Betrachter leuchten.

Advents- und Weihnachtsarrangements, die die Klänge des Winters hören lassen. Sie halten ein Versprechen bereit: Auch der Winter kann blühen!

Autumn is for seeing while winter is for hearing. The time of reflection and silence lies ahead. But only those who focus on beauty can perceive the dark season's gentle sounds.

Advent and Christmas captivate with simple and classic decorations. Various kinds of orchids and a great diversity of roses can be found on the brightly decorated tables. Surrounded by icy colours, the gingko branches, varnished in coral-red, especially show to advantage. The season's coolness is underlined by the Christmas rose's pure white colour. A sensual atmosphere on the other hand calls for deep red roses, arranged around candles. And eventually Christmas is just around the corner—the sumptuously decorated Christmas tree delights every observer.

Advent and Christmas arrangements make winter's sounds audible. They live up to their promise: even winter can blossom!

L'automne est la saison de la vue, l'hiver celle de l'ouïe. Le temps de la réflexion et du silence est devant nous. Mais seulement celui qui dirige ses yeux vers la beauté entendra les bruits étouffés de la saison sombre.

Les décorations classiques et simples sont celles qui conviennent le mieux à l'Avent et à Noël. Sur les tables festives, on découvre les multiples variétés de l'orchidée et de la rose. Les couleurs de la glace magnifient les branches du ginkgo laquées rouge corail. Le blanc pur de la rose de Noël évoque particulièrement bien les températures fraîches de la saison. Mais pour une atmosphère plus sensuelle, on utilisera des roses rouge foncé autour de bougies. Et maintenant nous y sommes ! Le sapin de Noël richement décoré s'offre aux yeux émerveillés de la famille.

Des arrangements floraux pour l'Avent et Noël, qui font entendre les sons de l'hiver. Elles tiennent une promesse : l'hiver aussi peut fleurir !

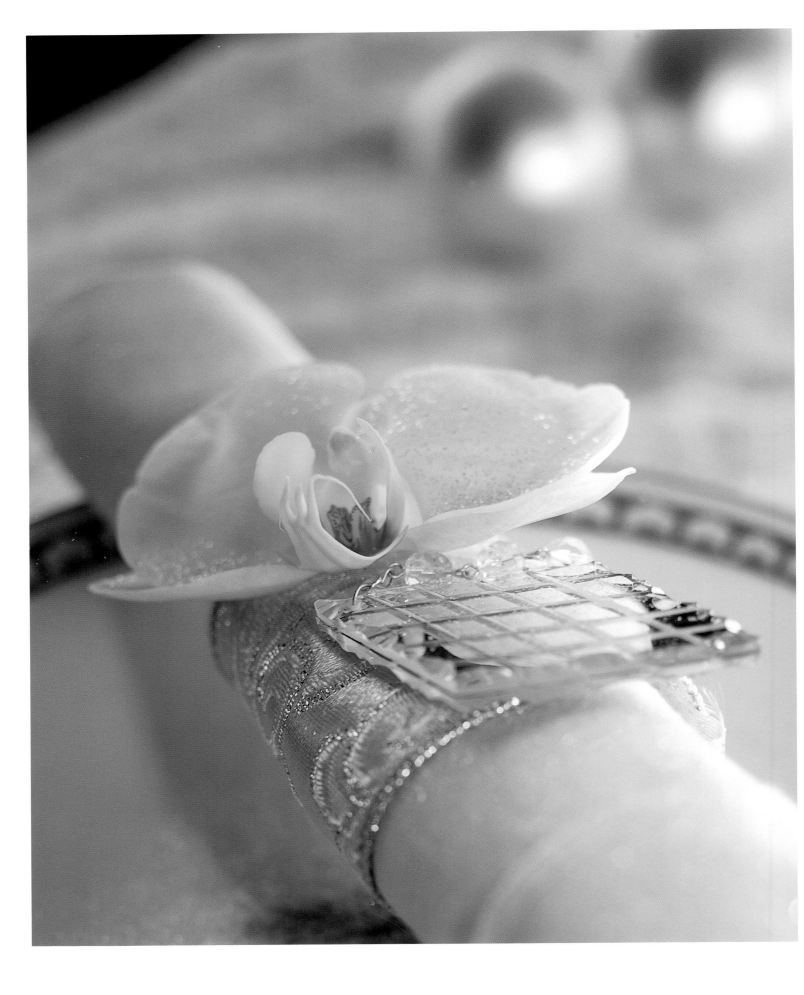

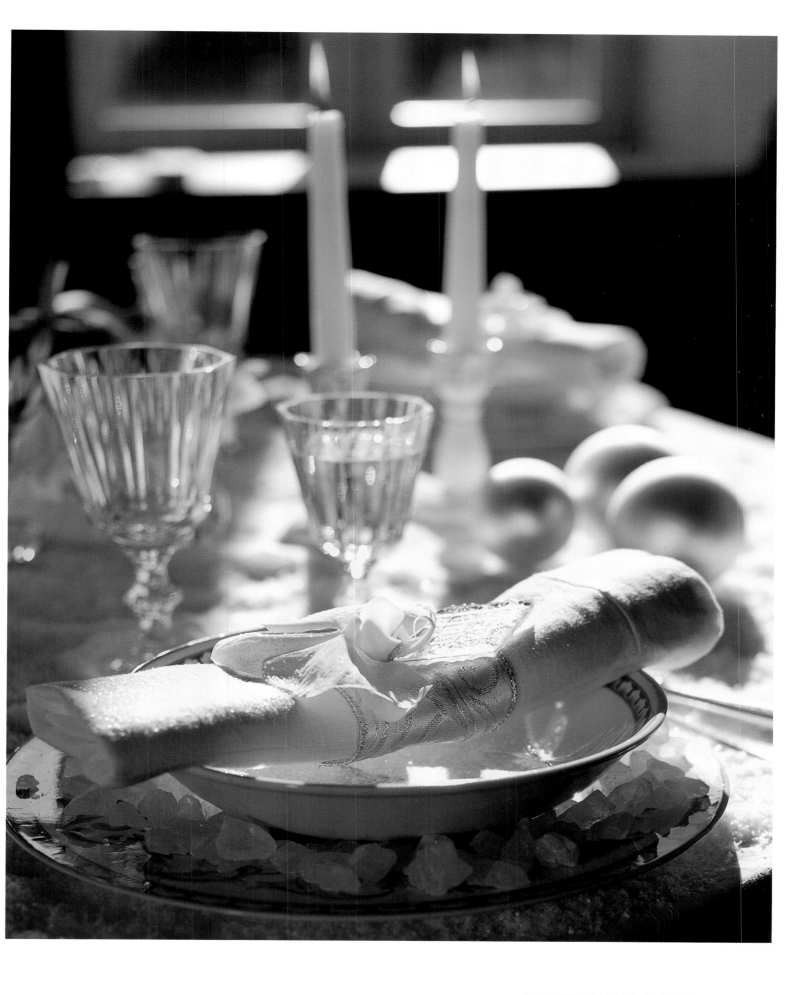

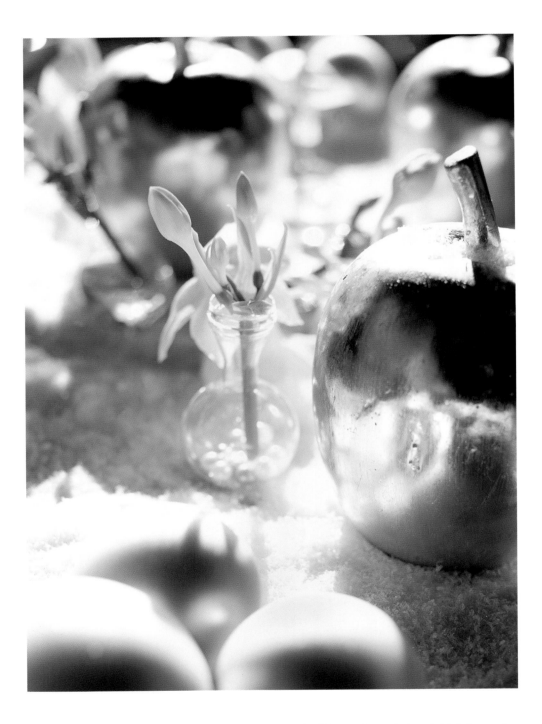

Prachtvolles in kühlem Blau und schlichtem Weiß: Die Blüte der Schmetterlingsorchidee wird bei dieser edlen Tischinszenierung zum vornehmen Serviettenhalter.

Grandeur in cold blue and simple white: For this noble table decoration, the butterfly orchid blossom turns into an elegant napkin ring.

Splendeur en bleu glacé et en blanc : dans la mis en scène de cette table, la fleur de l'orchidée papillon devient un porte-serviette raffiné.

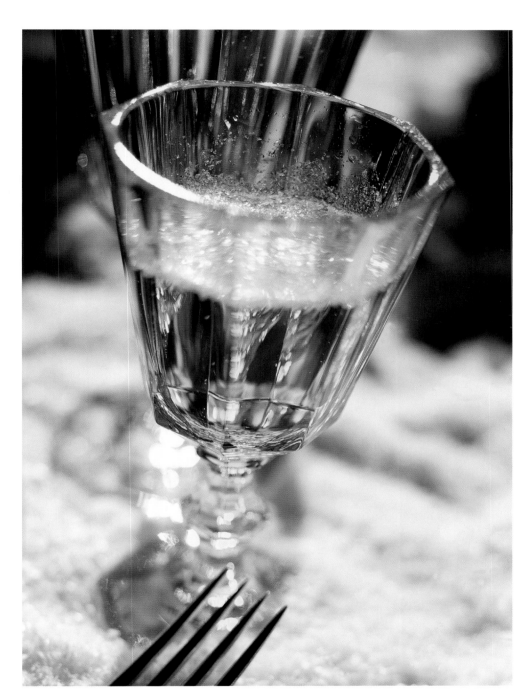

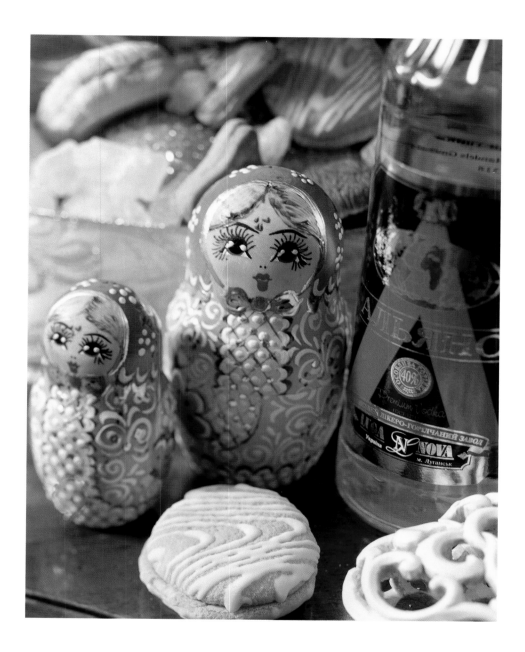

Magie der Kontraste: Schmetterlingsorchideen stehen neben Babuschkapuppen, die einen Schmuck aus kleinen Glasperlen und bernsteinfarbenen Herzen tragen.

The magic of contrasts: Butterfly orchids stand next to babushka dolls, adorned with small glass beads and amber-coloured hearts.

Magie des contrastes : des orchidées papillon sont posées à coté de poupées russes décorées de petites perles en verre et de cœurs d'ambre.

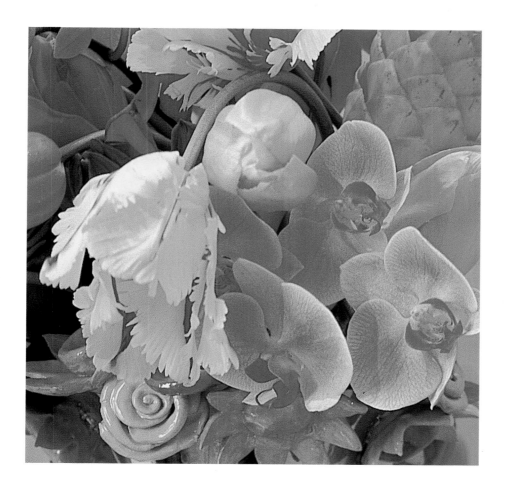

Vertreiben trübe Gedanken in der kalten Jahreszeit: Das kräftige Violett der Schmetterlingsorchidee, das flammende Gelbrot der Papageientulpen und das aufmunternde Orange der Blütenstände des Ingwers machen gute Laune.

Banish dreary thoughts in the cold season: The bright violet colour of butterfly orchids, parrot tulip's blazing yellow-red, and ginger inflorescences' cheerful orange boost the spirits.

Ils chassent des idées tristes durant la saison froide : le violet soutenu de l'orchidée papillon, le rouge-jaune flamboyant des tulipes perroquet et l'orange revigorant des fleurs de gingembre inspirent la bonne humeur.

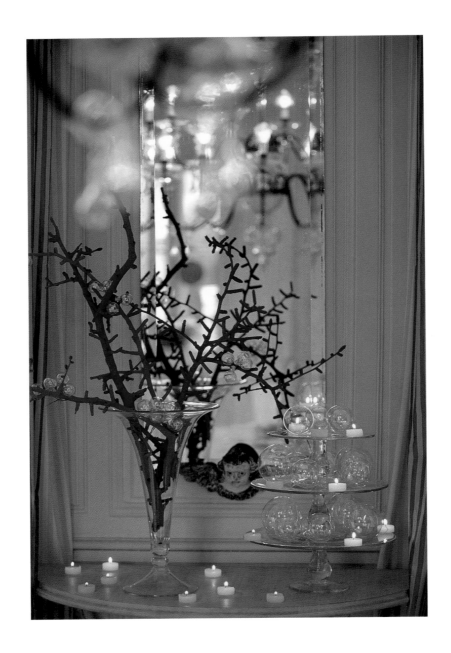

Feierlich gedeckte Tafel im Esszimmer: Die schlichten Kristallkugeln stehen im Kontrast zu den korallenrot lackierten Zweigen des Ginkgobaums.

Ceremoniously set dining room table: The simple crystal balls contrast with the gingko branches, varnished in coral-red.

Une table festive dans la salle à manger : toutes simples, les boules de cristal contrastent avec les branches du ginkgo laquées de rouge corail.

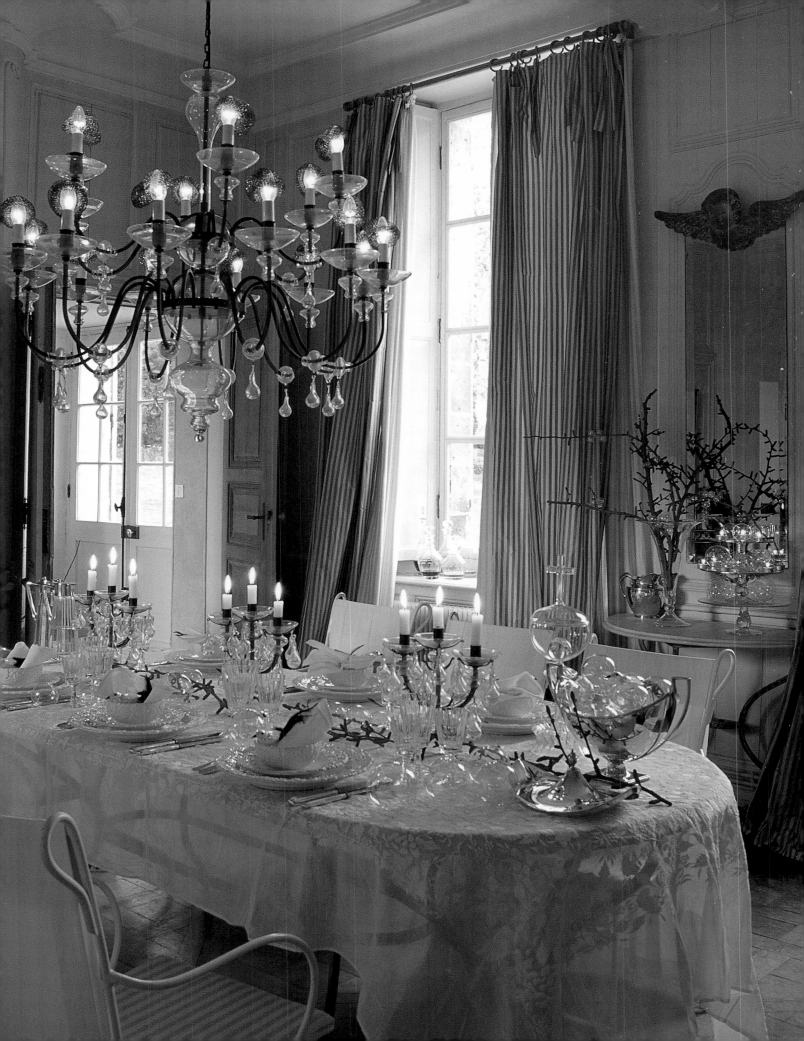

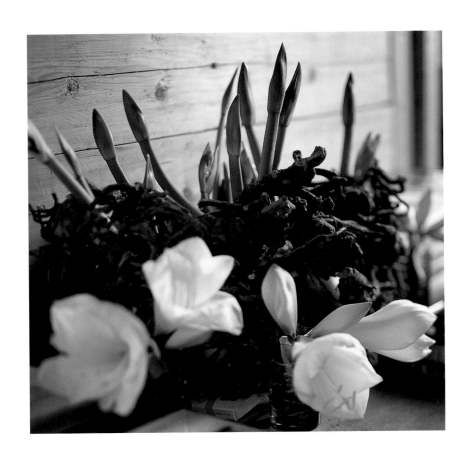

Amaryllis – bereits der Name verspricht Eleganz. In Kombination mit Rosenwurzeln oder inszeniert in einem Bouquet aus japanischen Mispeln und Silberdisteln bekommt sie Bodenhaftung.

Amaryllis—the name already promises elegance. In combination with rose roots or arranged in a bouquet of loquats and mistletoes they are brought down-to-earth.

Amaryllis – ce nom est à lui seul une promesse d'élégance. Associée des racines de roses ou mise en scène dans un bouquet de nèfles du Japon et de gui, elle se fait rustique.

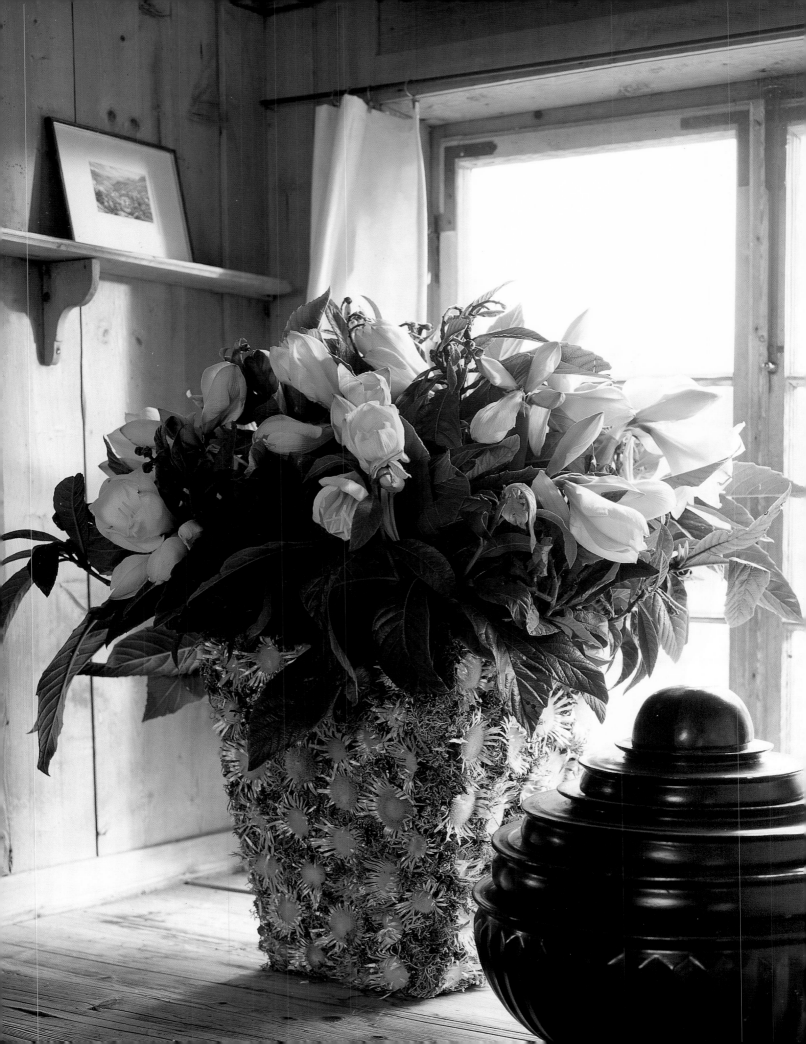

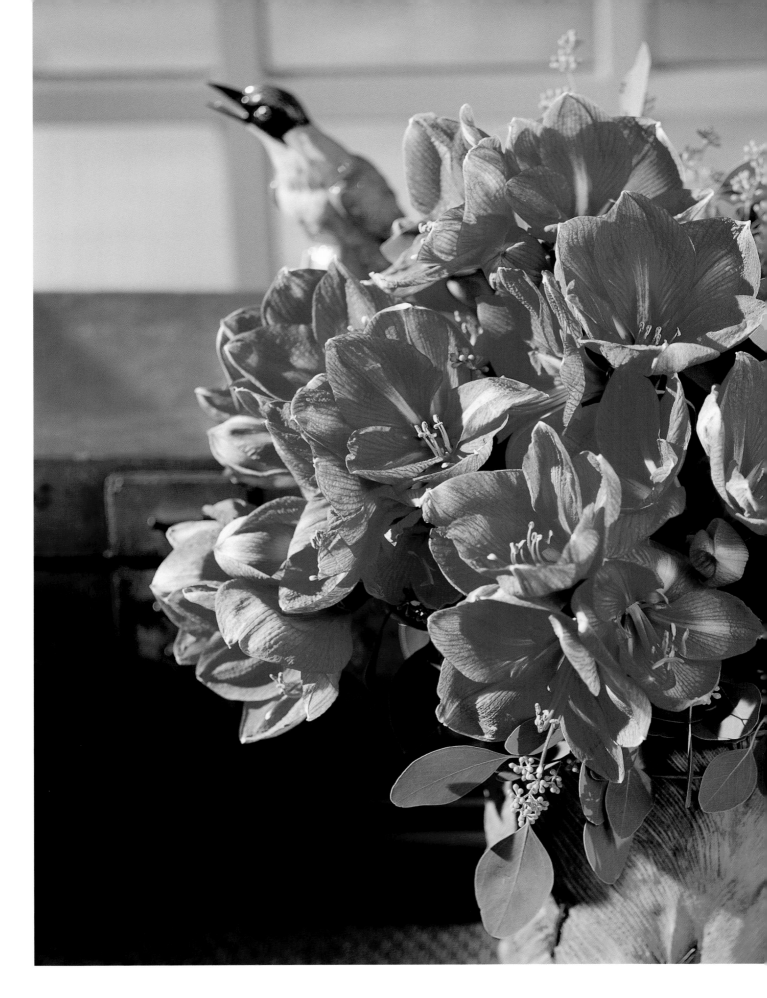

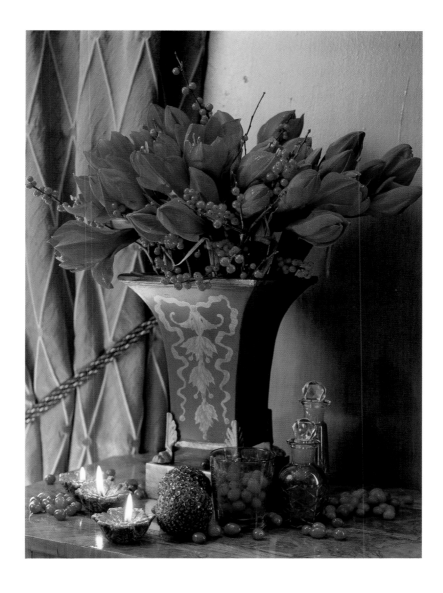

In Violett, kombiniert mit kräftig grünen Eukalyptuszweigen, oder in Rot, gemeinsam mit Ilexzweigen, weiß die exotische Amaryllis mit ihrer Farbenvielfalt zu beeindrucken.

In violet, combined with bright green eucalyptus twigs, or in red, together with ilex twigs, the exotic amaryllis knows how to impress with its colour diversity.

Violette, combinée avec des branches d'eucalyptus vert vif ; rouge, avec des branches d'ilex : l'amaryllis exotique sait nous impressionner par la variété de ses couleurs.

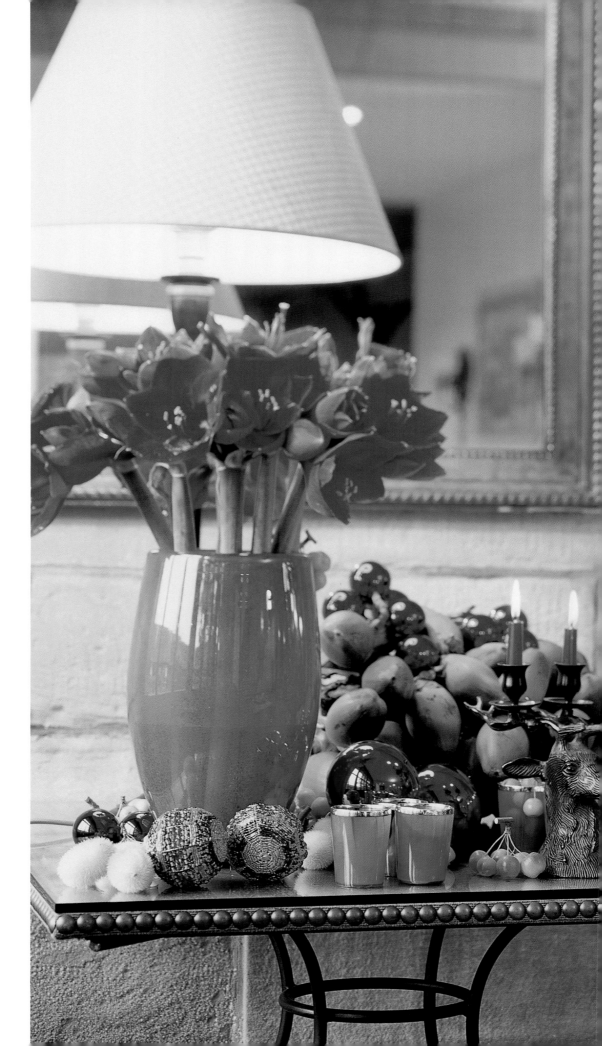

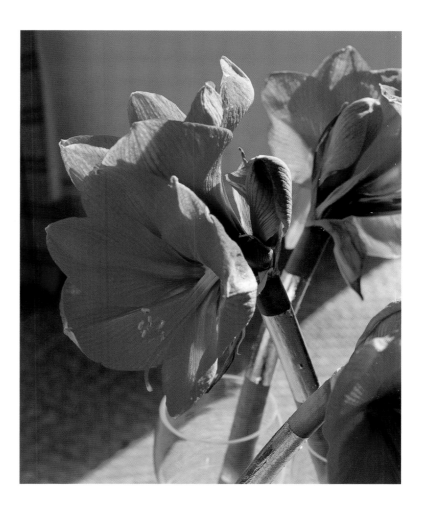

Versilberte Stiele kontrastieren mit der opulenten roten Amaryllisblüte und verleihen ihr eine sehr reine und kühle Erscheinung.

Silver plated stems contrast with the opulent red amaryllis blossom, and result in a very pure and cool appearance.

Des tiges argentées créent un contraste avec la magnifique fleur rouge de l'amaryllis et lui donnent une aura froide et très pure.

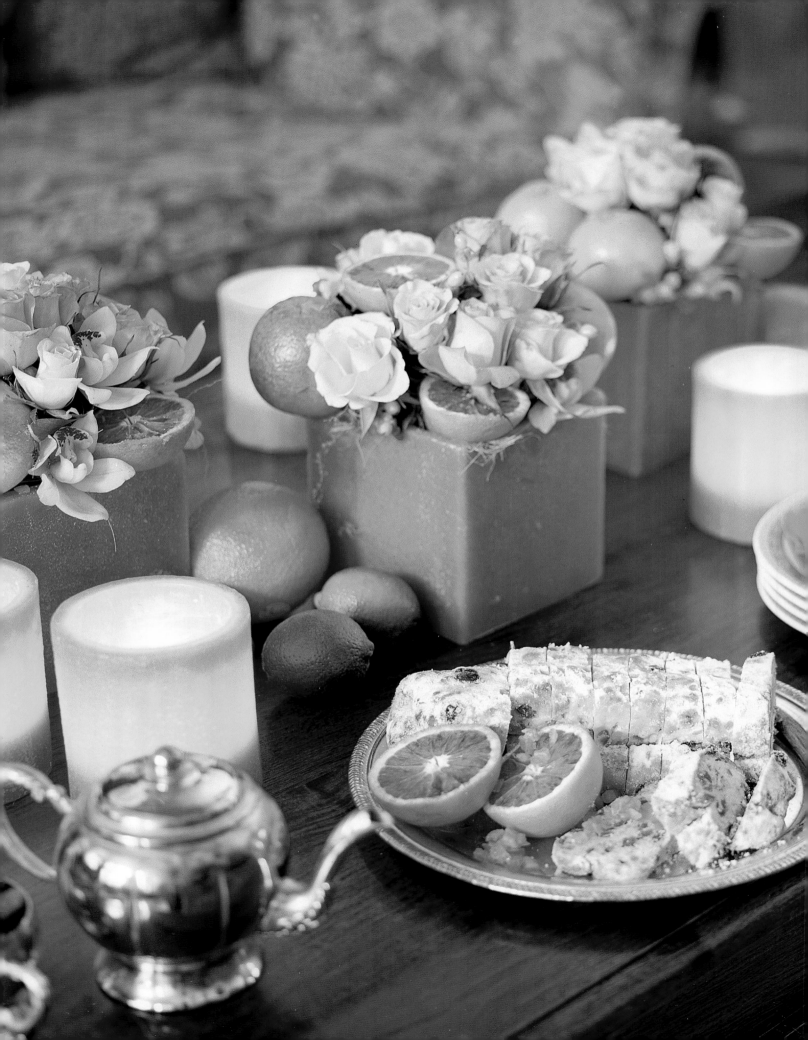

Ode an die Farbe: Kleine Bouquets aus gelben Freilandrosen, Cymbidienorchideenblüten und Blutorangen in Wachswürfeln oder cremefarbene, in Wachs getauchte Rosen unterstreichen die Vielseitigkeit der Königin der Blumen.

Ode to colour: Small bouquets of yellow roses, cymbidium orchid blossoms and blood oranges in wax cubes, or cream-coloured roses, dipped in wax, emphasise the variety of the queen of flowers.

Ode à la couleur : petits bouquets des roses de jardin jaunes, orchidées cymbidien, oranges sanguines dans des cubes de cire et roses crème préalablement plongées dans la cire nous donnent à voir les multiples facettes de la reine des fleurs.

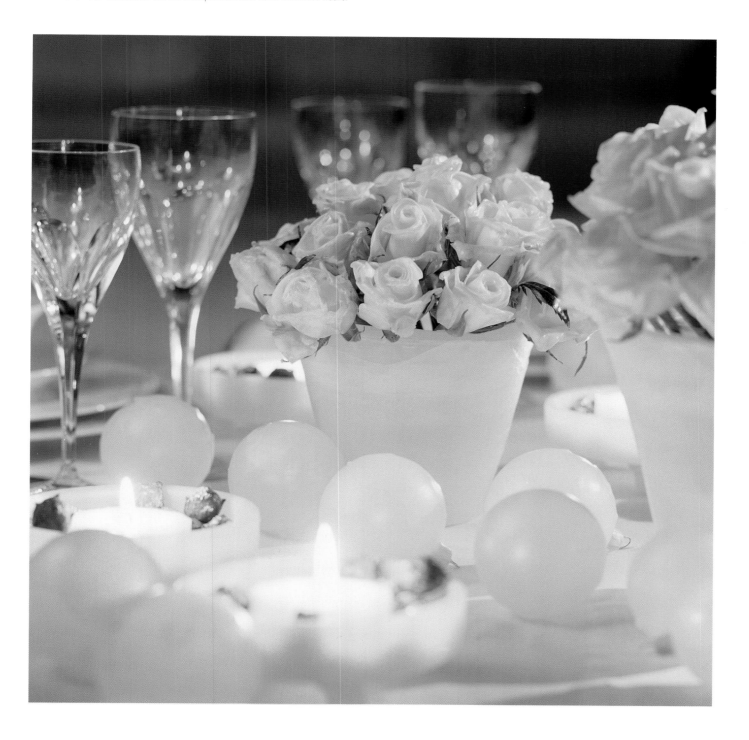

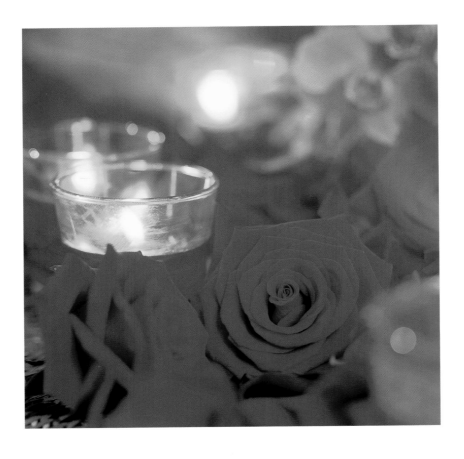

Eine sehr sinnliche Stimmung entsteht durch das Arrangement aus Rosen, Kerzen und exotischen Blüten in Rotorangetönen zwischen weichen Kissen.

A very sensual atmosphere arises from the arrangement of roses, candles, and exotic blossoms in hues of red and orange, amongst soft cushions.

Une atmosphère très sensuelle se dégage de cet arrangement qui associe roses, bougies et fleurs exotiques rouge orangé au milieu de moelleux coussins.

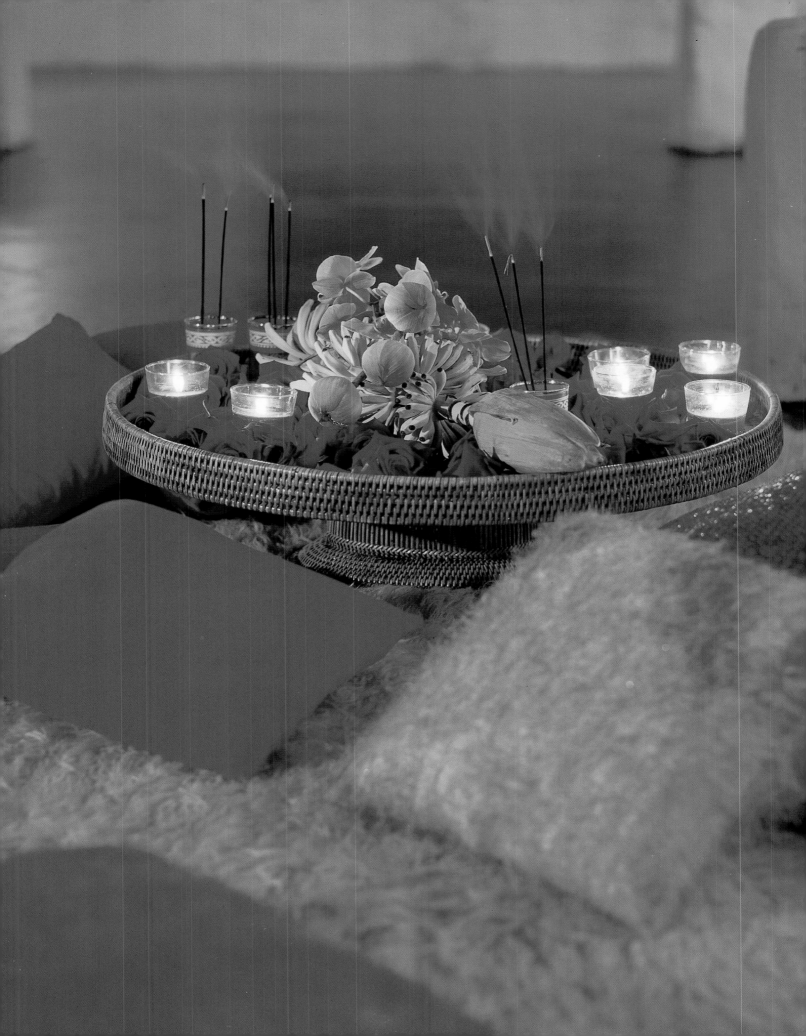

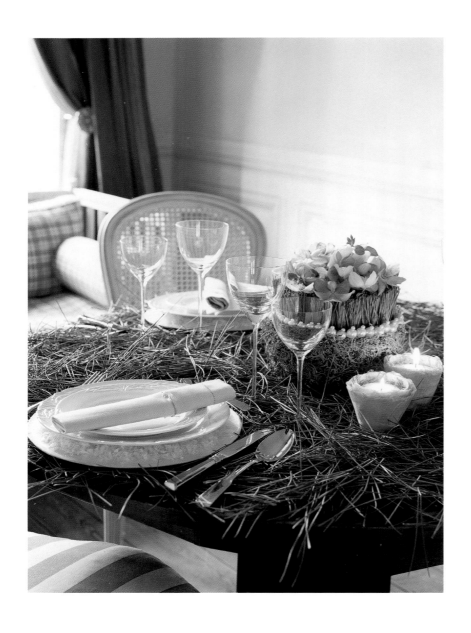

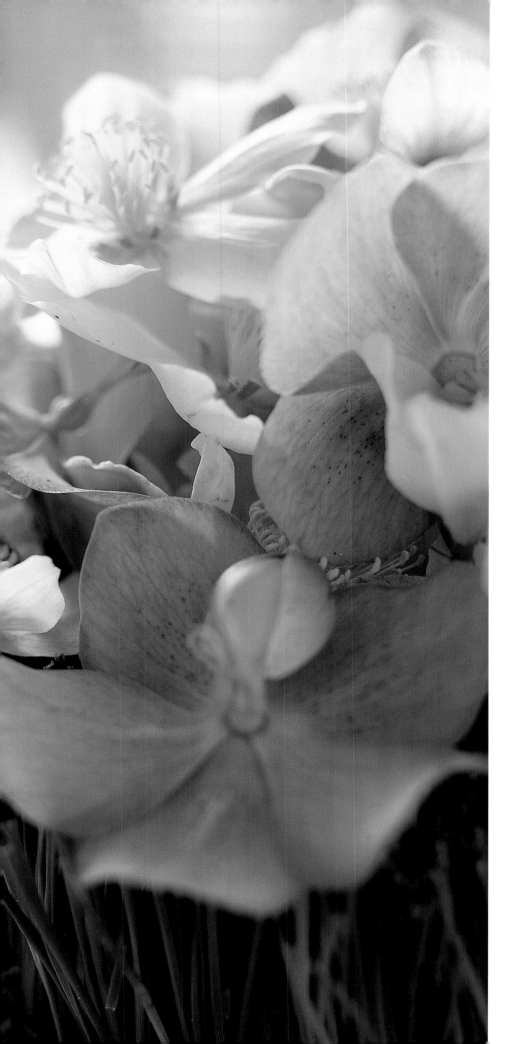

Duftende Kiefernnadeln umrahmen das Arrangement aus getrocknetem Islandmoos und gestutzten Nadeln, das von weißgrünen Christrosen gekrönt wird.

Scented pine-needles frame the composition of dried Iceland moss and trimmed needles, crowned by white-green Christmas roses.

Des épines de pin odorantes entourent l'arrangement de mousse d'Islande séchée et d'épines coupées, couronné par des roses de Noël blanches et vertes.

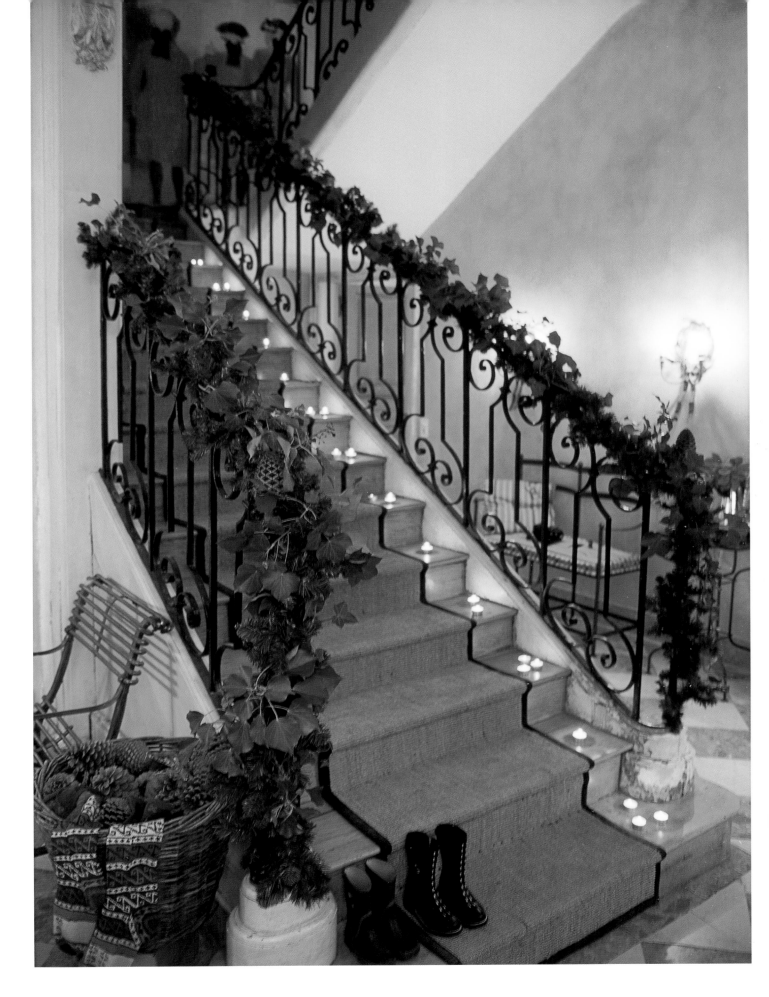

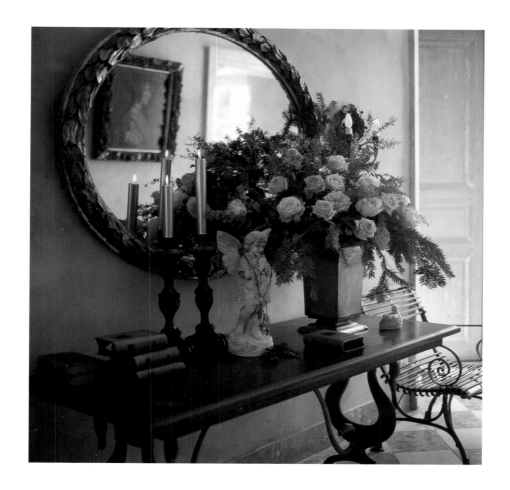

Die Töne der Wand in dunklem Orange bilden die ideale Kulisse für das adventlich geschmückte Treppengeländer. Ein Strauß Edelrosen verdoppelt vor dem Spiegel seine Wirkung.

The wall's dark orange hues constitute the perfect setting for the festively decorated stair-rail. A bouquet of floribunda roses in front of a mirror doubles its impact.

Les nuances de l'orange intense du mur constituent un fond de décor idéal pour l'escalier festif. Un bouquet de roses nobles se reflète dans le miroir et redouble de beauté.

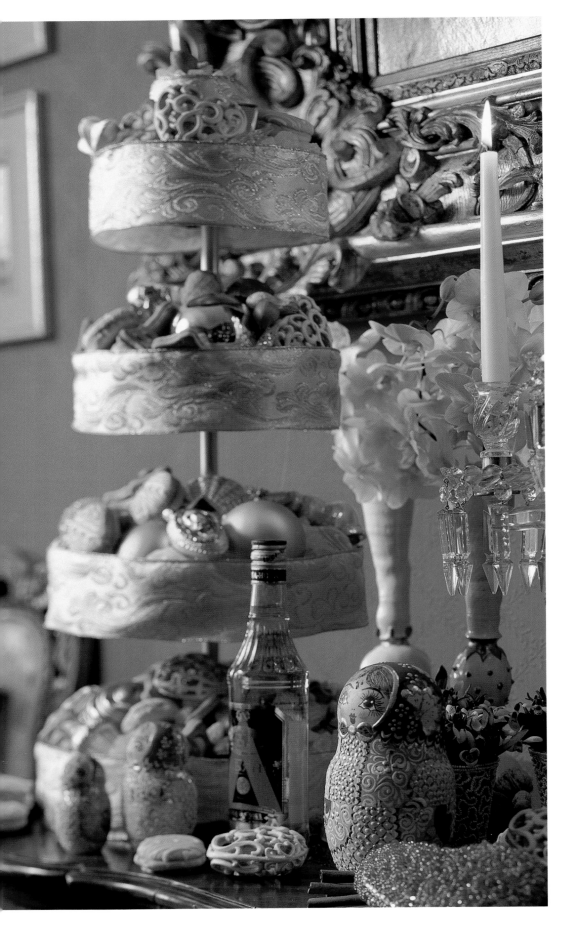

Eine mit breitem Dekoband verzierte Etagere nimmt Naschwerk und Nüsse auf. Schneeglöckchen in Töpfen bereiten Vorfreude auf das Ende der kalten Jahreszeit.

An étagère, decorated with ribbon, holds sweets and nuts. Snowdrops in pots awaken anticipation of the end of the cold season.

Sur le dressoir décoré d'un large ruban on a posé des friandises et des noix. Les perce-neige plantés dans des pots annoncent déjà joyeusement la fin de la saison froide.

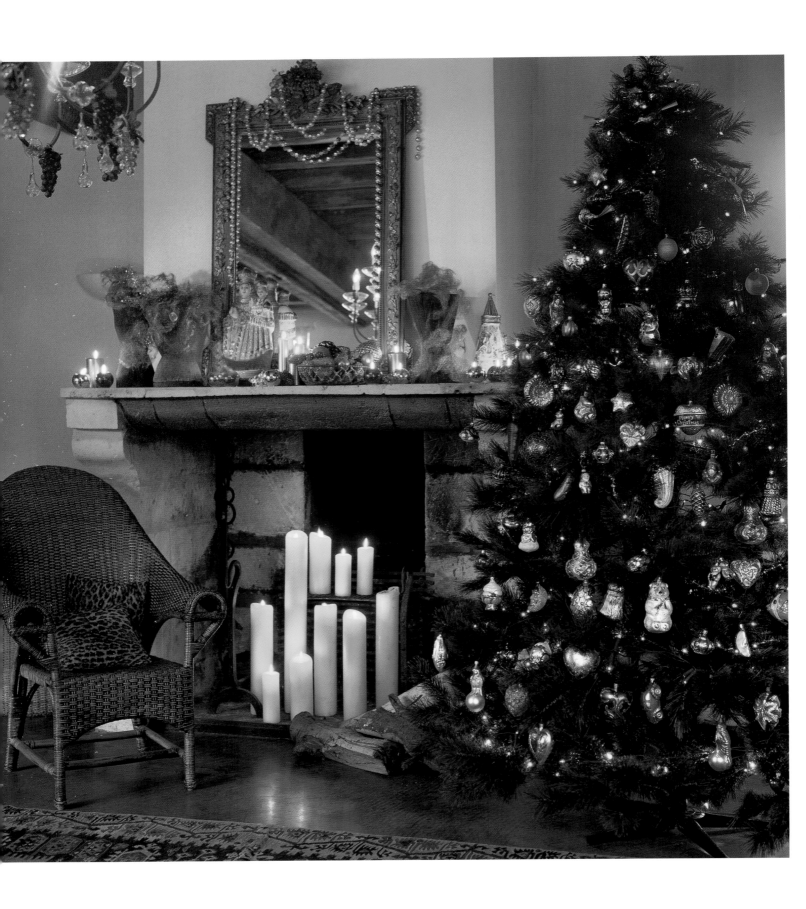

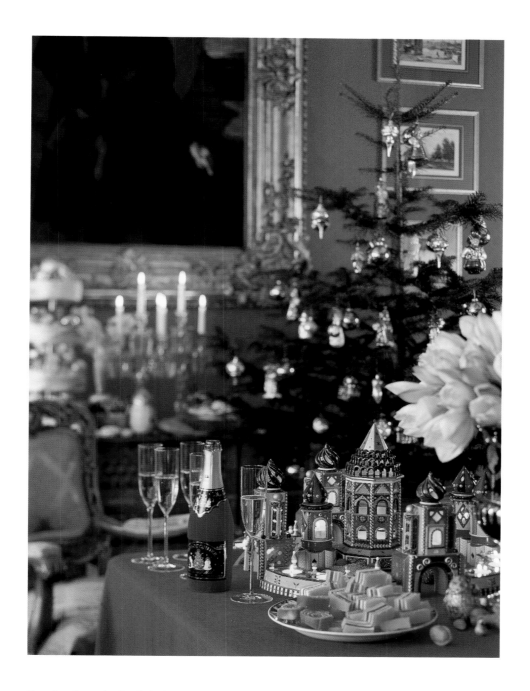

Es weihnachtet sehr: Das Licht lässt die Augen glänzen und vor Seligkeit schweigen.

Christmas is on its way: The light makes the eyes glow, and silence to reign in the season's bliss.

Noël est tout proche : la lumière fait briller les yeux et nous nous taisons de béatitude.

Second Edition

© 2007 teNeues Verlag GmbH & Co. KG, Kempen

© 2006 OvB Publishing

Photographs by

Erich François: 12, 13, 34 (photo on the left), 35 (photo on the right), 37, 46-49, 76, 79, 117, 130/131, 157-159

Frank Meltzer: 2-11, 14-19, 22-25, 30/31, 34/35 (photo in the middle), 36, 44/45, 50-75, 77, 78, 80-116, 118/119, 120-129, 132-147, 150-156, 160, 161, 164, 165, 167

Uschi von Fellner: 20, 21, 26-29, 32, 33, 38-43, 148, 149, 162, 163, 166

The authors and editors of the book Flower Design have worked diligently to include the correct assigning of the photographs. We would nevertheless like to apologize for any errors that may still appear.

Design by Peter Senger, Kaarst

Text by Ulrike Meiser, Mendlewitsch + Meiser, Düsseldorf

Translations by Stefanie von Wietersheim (French), Hannah Welp (English)

Translation Editing by SAW Communications, Dr. Sabine A. Werner, Mainz • Céline Verschelde (French), Cosima Talhouni (English)

Editorial coordination by Ute Laatz, Brigitte von Boch and Ulrike Meiser, Mendlewitsch + Meiser, Düsseldorf

Published by teNeues Publishing Group

teNeues Verlag GmbH & Co. KG
Am Selder 37
47906 Kempen
Germany
Tel.: 0049 / 02152 / 916 0
Fax: 0049 / 02152 / 916 111

teNeues International Sales Division
Speditionstraße 17
40221 Düsseldorf
Germany
Tel.: 0049 / 0211 / 99 45 97 0
Fax: 0049 / 0211 / 99 45 97 40

Press department: arehn@teneues.de

teNeues Publishing Company
16 West 22nd Street
New York, N.Y. 10010, USA
Tel.: 001 / 212 / 627 9090
Fax: 001 / 212 / 627 9511

teNeues Publishing UK Ltd.
P.O. Box 402
West Byfleet
KT14 7ZF, Great Britain
Tel.: 0044 / 1932 / 40 35 09
Fax: 0044 / 1932 / 40 35 14

teNeues France S.A.R.L.
93, rue Bannier
45000 Orleans, France
Tel.: 0033 / 2 / 38 54 10 71
Fax: 0033 / 2 / 38 62 53 40

www.teneues.com

Bibliographic information published by Die Deutsche Bibliothek. Die Deutsche Bibliothek lists this publication in the Deutsche Nationalbibliografie; detailed bibliographic data is available in the Internet at http://dnb.ddb.de.

ISBN-13: 978-3-8327-9169-8

Printed in Italy

teNeues Publishing Group
Kempen
Düsseldorf
London
Madrid
Milan
Munich
New York
Paris

teNeues